TRUE NORTH THE CANADIAN SONGBOOK

Eleanor McCain

TRUE NORTH

THE CANADIAN SONGBOOK

RETRIEVER RECORDS

Retriever Records Limited
Toronto, Ontario

Cataloguing data available from Library
and Archives Canada
ISBN 978-0-9953423-0-9 (hardcover)
ISBN 978-0-9953423-1-6 (ebook)

Produced by Page Two
www.pagetwostrategies.com
Printed and bound in Canada by Friesens

15 16 17 18 19 5 4 3 2 1

Eleanor McCain

visit www.eleanormccain.ca

Front cover photo: **V. TONY HAUSER** | Banff National Park, Lake Minnewanka, Alberta

Contents

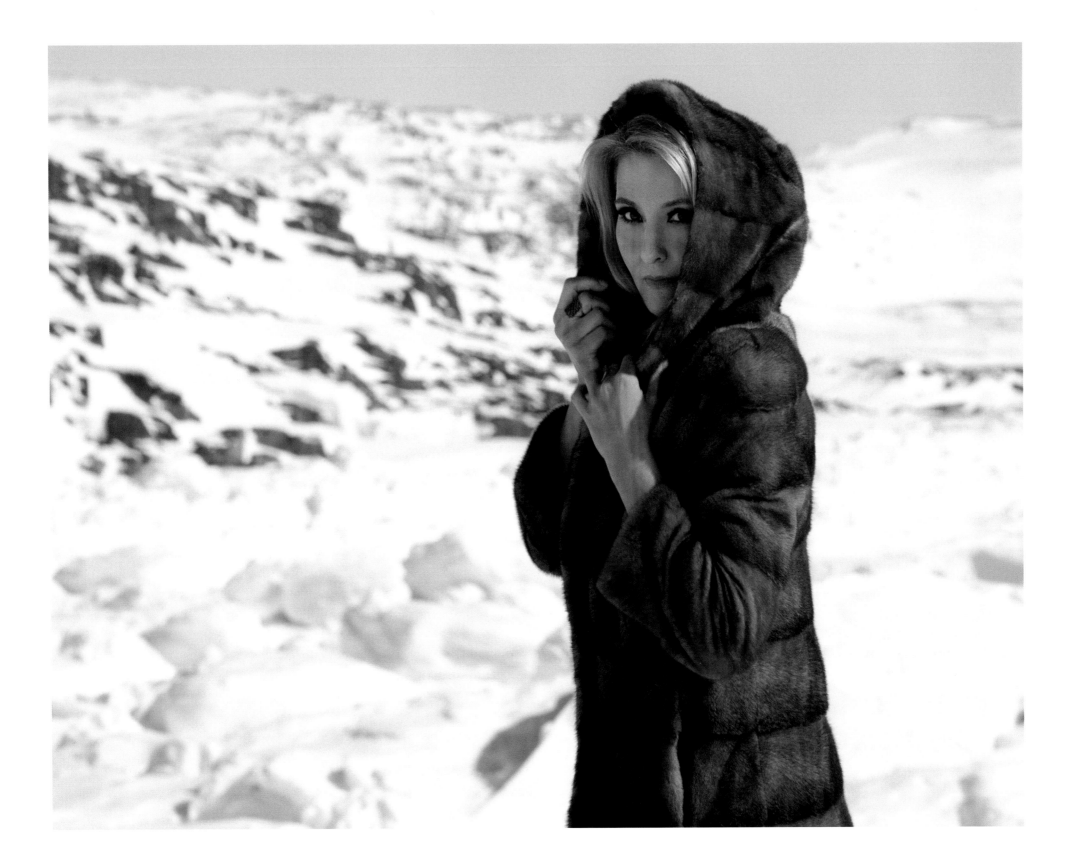

V. TONY HAUSER | Iqaluit, Nunavut

The Birth of True North: The Canadian Songbook

I'VE BEEN SINGING since I was two years old. My mother, whom I adore, played the piano and the organ at church and often accompanied me when I was young. She was my greatest musical influence in my formative years (and my biggest supporter, for which I will be eternally grateful) and because of her I went on to Mount Allison University to get my Bachelor of Music degree.

My roots were classical, but I quickly realized my heart was drawn to more contemporary music. I connected with the raw emotion and freedom of expression I found in pop, folk and jazz. So I embarked on a career in a classical cross-over style that fused together many genres of contemporary music while honouring my classical beginnings.

Since then, I've realized that it's the emotion behind the music that speaks to me more than the genre itself. For me, music is cathartic. It can heighten our emotions and deepen our connection to our feelings, relationships and cherished memories. This is what inspires me in music and is why I sing. Expressing my emotions and experiences through music is therapeutic for me, and it has been a gift to be part of this rewarding arts sector.

I have grown considerably as an artist over the years through collaborating with others, performing in concerts and recording five albums. But I would say my best teacher has been life itself, with its many ups and downs. My life experiences are part of every performance, every recording, every creative inspiration. Drawing on these experiences brings honesty and authenticity, both of which are paramount for me as a person and as an artist.

The songs

Much has been said about the American Songbook. Yet have we ever stopped to consider that we have our own incredible body of work to be proud of—our own Canadian Songbook?

On this, Canada's 150th birthday, I believe it is important to highlight the Canadian Songbook, the collection of music created over many decades that is unique and significant to our voice as a nation. I believe we should celebrate our songs, our songwriters, the musicians who created them and those who will interpret them in the years to come. These beliefs have fuelled my passion for creating *True North: The Canadian Songbook*.

There are so many wonderful Canadian songs that there was no way to include them all on this album. Some may feel there are songs missing. There are certainly some missing for me. But the 32 songs in this collection have not just captured the hearts of people of their generation—they have lived on and will continue to do so for years to come. In many ways, they define who we are as a people. I have lived closely with these songs for the last three years, and my love for them has only grown. So many of them have spoken to me and provided a release from what I was experiencing in my own life, more than any other music ever has.

I've never written my own songs and I deeply admire those who can capture profound emotions through music and lyrics. Canada has created some of the best songwriters in the world. They bring to their work a depth of feeling and authenticity that I've never found anywhere else.

The honesty within their music inspires me, and solidifies my belief that our Canadian values and landscape have influenced our music in a unique way.

This album is also inspired by my work with symphonies. There is nothing like performing with an orchestra. To stand in the midst of such beautiful sound, on stage or in the studio, is like being wrapped in a warm, soothing blanket. To me, symphonic music is one of the most moving ways to convey the meaning of a song. Recording this album with 10 remarkable orchestras, from St. John's to Victoria, was a career dream come true.

As a song interpreter, I know the importance of an inspired arrangement. But I think that arrangers, like songwriters, are often unsung heroes. Arrangers can take a beloved song and reimagine it in ways that defy description, leading both the singer and the listener down roads untravelled. For *True North: The Canadian Songbook*, 14 extraordinary arrangers crafted 32 stunning orchestrations, each a masterpiece with its own unique beauty and style.

I feel very privileged to have recorded these iconic Canadian songs with such a talented team. The cross-country account of the people involved, and how together we pulled off this monumental project, is a story all its own, one that's told in the Coda at the end of this book.

The idea

As with so many monumental projects, the idea for this one came at the right time. As John Bailey, the exceptional engineer I've worked with on five of my six albums, said during

vocals for this one, "Everything that you've done throughout your career and that has happened in your life has brought you to this point."

It happened late on a snowy night in January 2014. I'd just finished recording my fifth CD, *Runaway*, a collection of classic love songs with full symphony. During a discussion of ways to develop new shows for me with orchestras, the idea of doing an album of Canadian songs came up. A few years earlier I'd considered a recording of iconic Maritime music. The idea of expanding it to a national concept was instantly exciting. A lightning bolt went off in my brain, and the idea for *True North: The Canadian Songbook* was born.

I had just recorded the orchestral parts for *Runaway* outside Canada, a trend that was becoming a sad reality of the music scene. Feeling guilty about that, I knew that if I did this project, it would have to be recorded in Canada. But with whom? I'd established relationships with some of our country's finest orchestras, and I knew it would be difficult (if not impossible) to select one.

My mind raced until an idea struck me, one that never let go. What if I recorded with orchestras from coast to coast? And what if I asked arrangers from across the country to take this Canadian music and reimagine it for full orchestra? In a single moment I was both captivated and energized by this pan-Canadian concept. What an amazing story it could tell about Canadian music, and just in time for the nation's 150th birthday in 2017.

I was so pumped about the idea that it began to consume my every thought. A playlist of songs started compiling itself

in my head. I sat down and mapped out a preliminary list immediately, then researched for hours to find songs that were not only well known but would fit my personal and musical style and would represent all regions of the country. The initial list of songs came together easily. Most have remained in the final collection.

Then I wondered, does anyone actually buy CDs anymore? Downloading, streaming and other electronic applications have transformed the music industry, and I knew that if I proceeded, I'd have to think of new and creative ways to release the album. My daughter had purchased only two physical CDs in 2014. What struck me was that both came in the form of a book, which allowed the artists to create a more enhanced experience to complement the music. I was intrigued. As I listened to my playlist, the Canadian landscape was such a fixture in my thoughts, each song evoking a certain image, that the idea of a book of landscape photos to accompany the music resonated with me. In keeping with the pan-Canadian music concept, the images would come from photographers across the country.

The more excited I got, the more fearful I became. Was this even doable? I had a cross-Canada project, a double album, the complexities of recording with orchestras from coast to coast—and now I was going to add a book?

Thoughts of how to pull it off plagued me for much of 2014. I knew the challenges that lay ahead and debated whether the project was too insane to even consider let alone tackle. I quietly discussed the idea with close family and friends. How much would it cost? What would the

logistics look like? Who could help me? Moreover, who could produce a mammoth recording of this kind? As the year wound down, I knew I had to decide; 2017 was not far away.

Then, in the early days of 2015, my life took a dramatic and unexpected turn. My marriage ended abruptly after only eight months, and I went from believing I was living a fairytale to being absolutely devastated. I was reeling from grief. At the same time, I was profoundly grateful for the people who have stood solidly by my side for most of my life. The love and support I've shared with so many wonderful family members and friends came sharply into focus and gave me the strength and courage to go on.

I knew, despite my intense heartache, that I had to go forward with this project. I knew my energy was best spent not wallowing in my grief but moving towards something rewarding, fulfilling and cathartic. I would direct my energy to expressing my love of Canada, and the music I had been living with for a year already, through *True North: The Canadian Songbook*.

And I knew my heart would heal. It would heal through music.

Celebration

The songs in this collection are, to me, the soundtrack for a film depicting the Canadian landscape. As this project took shape, I couldn't stop thinking about the majestic, rugged beauty and the dramatic differences that exist from coast to coast. Our diverse landscape symbolizes who we are as a

AN AMERICAN FRIEND of mine, who has been incredibly supportive of this project, mentioned to her iconic British pop star friend (who shall remain nameless) that I was creating an album in honour of the Canadian Songbook. His reaction: "Canadian music? Really?"

While I have great admiration for this kind and respectful artist, his response highlighted for me how important it is for Canada, as a nation, to celebrate our music both within our country and abroad.

UNE AMIE AMÉRICAINE, qui m'a énormément encouragée dans ce projet, a mentionné à son ami britannique (une vedette pop emblématique dont je tairai le nom) que je préparais un album honorant la chanson canadienne. Sa réaction : « La musique canadienne ? Vraiment ? »

Même si j'éprouve une grande admiration pour cet artiste gentil et respectueux, sa réaction m'a fait comprendre à quel point il est important pour nous, Canadiens, de mettre en valeur notre musique, à la fois dans notre pays et à l'étranger.

country: a collection of cultures brought together by a sense of common values and ideals. We are authentic and down to earth. We believe in social justice for all. We believe in nurturing connections with our fellow citizens, connections that are genuine and sincere.

As I crossed Canada, experiencing it in all its seasonal glory, I couldn't help but be in awe of the range of dramatic vistas we are blessed with, many of which are captured in this book. How often my breath was taken away at a new location or when a song from the playlist, with its sincere sentiment, entered my head. My Canadian pride grew with each passing day. We have an abundance of riches in our people and in the way we express ourselves through our wide-ranging music, culture and art.

I love that modesty is one of our nation's trademarks, but I can't help but wonder if it's a trait we might rethink. Now, as we celebrate our 150th year, it's the perfect time to show the world the unique country we have come to be. It's the perfect time to stand back and consider Canada as a whole, and rather than focus on our differences, celebrate the diversity of people and landscapes that make up this beautiful quilt we live under. Having experienced our nation coast to coast through *True North: The Canadian Songbook*, I have a deeper realization of what an incredible gift it is to be Canadian, and my heart is filled with gratitude.

My greatest hope for this album is that it inspires people to passionately champion Canada. I hope we celebrate our people, our musicians and our artists, our values and

our culture, our diversity and our breathtaking landscape. I especially hope this album creates more awareness about the reality of our Canadian Songbook. We need to show the world that we have a body of work to celebrate—for its depth, its authenticity and the unique Canadian voice that shines through the music.

Prélude : l'origine de True North: The Canadian Songbook

JE CHANTE DEPUIS l'âge de deux ans. Ma mère, que j'adore, jouait du piano et de l'orgue à l'église, et je l'accompagnais souvent quand j'étais enfant. C'est elle qui a eu l'influence musicale la plus marquante sur moi lors de mes années d'apprentissage (sans oublier qu'elle est mon admiratrice numéro un, ce dont je lui serai éternellement reconnaissante). Grâce à elle, j'ai obtenu un baccalauréat en musique à l'Université Mount Allison.

Malgré ma formation classique, je me suis rapidement rendu compte que j'étais davantage attirée par la musique moderne. Je me sentais branchée à l'émotion brute et à la liberté d'expression que je trouvais dans le pop, le folk et le jazz. J'ai donc entrepris une carrière dans un style qui mariait le classique à de nombreux genres de musique d'aujourd'hui, sans toutefois renier mes racines.

Au fil des ans, j'ai découvert que c'est l'émotion derrière la musique qui m'interpelle, plutôt que le genre lui-même. Pour moi, la musique est un exutoire. Elle intensifie ce que nous ressentons et approfondit nos rapports avec nos émotions, nos relations et nos souvenirs les plus chers. C'est ce qui m'inspire et me motive à chanter. Exprimer mes réflexions et mes expériences à travers la musique a un effet thérapeutique sur moi, et évoluer dans le domaine des arts me procure une satisfaction inestimable.

Je me suis beaucoup développée professionnellement en collaborant avec d'autres artistes lors de concerts et de l'enregistrement de cinq albums. Toutefois, je dirais que mon meilleur professeur a été la vie elle-même, avec ses hauts et ses bas. Mes expériences imprègnent chacune de mes interprétations, chacun de mes disques, chacune de mes idées créatives. En m'inspirant de ce que j'ai vécu, j'apporte de l'honnêteté et de l'authenticité, deux qualités de première importance pour moi, comme personne et comme chanteuse.

Les chansons

On a beaucoup parlé de l'*American songbook*. Pourtant, avons-nous pensé à colliger notre propre recueil de chansons canadiennes, dont nous aurions toutes les raisons d'être fiers ?

À l'occasion du 150e anniversaire de la Confédération, j'ai cru qu'il serait important de faire connaître les chansons créées depuis de nombreuses décennies : elles sont uniques et constituent la voix de notre pays. Il faut, selon moi, rendre hommage à nos chansons, aux musiciens qui les ont écrites et à ceux qui les interpréteront à l'avenir. Ce sont ces objectifs qui ont alimenté ma passion pour créer *True North: The Canadian Songbook*.

Il s'est composé tant de merveilleuses chansons au Canada qu'il était impossible de les inclure toutes sur cet album. Certains, comme moi, auront l'impression qu'il en manque. Toutefois, les trente-deux œuvres que nous avons choisies n'ont pas seulement saisi le cœur des gens de leur génération. Elles vivent et continueront à vivre des années durant. À plusieurs égards, elles définissent ce que nous sommes comme peuple. Je baigne dans cette musique depuis trois ans et je l'aime chaque jour davantage. Bon nombre de ces chansons

THE FINAL SONG tally was 31 until 10 days before we recorded the studio bed tracks in February 2016. As I was driving to a rehearsal for a concert with the Kitchener-Waterloo Symphony, I was listening to one of my favourite albums. It included the song "Get Me Through December," which I knew intimately and had loved for years. With the stresses in my personal life, which continued and seemed to multiply, the lyrics and music hit me hard. I spent an hour and a half listening to the song on repeat, with tears streaming down my face.

Finally, I called my assistant, Shelley Bunda, and asked her to confirm that it was Fred Lavery and Gordie Sampson who wrote the song. I had a feeling it was a Canadian piece, and indeed it was. When I arrived in Kitchener-Waterloo, I texted producer Don Breithaupt: "You're going to kill me…" Don later said he knew what this meant before I even uttered a word. I said, "I have to record this song."

We had 10 days to determine the arrangement. In the end the band wrote charts the day of the recording and we played it off the floor. Aaron Davis, a remarkable musician and arranger I'd worked with on my first album, created an arrangement based on that bed track. Not only would this become song 32, it would be the only orchestral arrangement created after the bed tracks were recorded as opposed to determining the arrangement before the recording sessions.

EN FÉVRIER 2016, dix jours avant l'enregistrement des pistes maîtresses, nous avions établi la liste complète des chansons de l'album. Je me rendais en auto à une répétition pour un concert avec l'Orchestre symphonique de Kitchener-Waterloo et j'écoutais un de mes albums préférés, sur lequel se trouve la chanson *Get Me Through December*. Je la connais par cœur depuis des années. Mais là, à cette époque où mes problèmes personnels semblaient se multiplier, les paroles et la musique ont eu un effet percutant. J'ai écouté la chanson en boucle pendant une heure en pleurant à chaudes larmes.

J'avais l'impression que la chanson avait été composée ici et j'ai appelé mon assistante, Shelley Bunda, pour lui demander de faire des vérifications. Les auteurs, Fred Lavery et Gordie Sampson, sont bel et bien canadiens. En arrivant à Kitchener-Waterloo, j'ai immédiatement texté ce message au producteur Don Breithaupt : « Tu vas me tuer, mais… » Don m'a dit plus tard qu'il a tout de suite su ce que je voulais lui annoncer : « Il faut que j'enregistre cette chanson. »

Nous avions dix jours pour concevoir les arrangements. Les musiciens ont écrit les partitions le jour même de l'enregistrement et nous avons aussitôt interprété la chanson. Aaron Davis, un musicien et arrangeur exceptionnel avec qui j'avais travaillé pour mon premier disque, a créé des arrangements à partir de cette piste maîtresse. Cette chanson est la seule dont les arrangements pour orchestre ont été créés après l'enregistrement de la piste maîtresse, alors que normalement on les fait avant d'entrer en studio.

m'interpellent et m'ont permis de m'évader de ce que je vivais personnellement, plus que toute autre musique.

Je n'ai jamais composé et j'admire profondément ceux qui réussissent à transmettre des émotions intenses grâce à la musique. Le Canada a vu naître certains des meilleurs auteurs-compositeurs au monde. Leur œuvre communique un sentiment de profondeur et une authenticité que je n'ai trouvés nulle part ailleurs. Elle est d'une sincérité qui m'inspire et me porte à croire que nos valeurs et notre paysage ont influencé notre musique d'une manière tout à fait unique.

Cet album est également le fruit de mon travail avec des orchestres symphoniques. Rien ne vaut la sensation de se produire en concert ou en studio, au milieu de sons aussi riches. C'est comme être emmitouflé dans une couverture chaude et réconfortante. La musique symphonique est pour moi l'une des façons les plus émouvantes de transmettre le message d'une chanson. J'ai réalisé le rêve de ma carrière en enregistrant cet album avec dix des meilleurs orchestres de partout au Canada, de St. John's à Victoria.

Je sais d'expérience l'importance que peut avoir un arrangement sur l'inspiration d'un interprète. Toutefois, je crois que les arrangeurs, au même titre que les auteurs-compositeurs, sont des héros méconnus. Ils peuvent *réimaginer* une chanson aimée d'une façon qui défie toutes les attentes et transporter l'interprète et l'auditeur sur des chemins nouveaux. Quatorze musiciens extraordinaires ont réalisé trente-deux arrangements pour orchestre à la beauté et au style étonnants, et chacun est un chef-d'œuvre.

Je me sens très privilégiée d'avoir enregistré ces chansons emblématiques avec une équipe d'un tel talent. Le récit de cette aventure pancanadienne et des moyens mis en œuvre pour la mener à bien est une épopée. Nous la racontons dans la section *Coda*, à la fin de cet ouvrage.

L'idée

Comme de nombreux projets de grande envergure, le nôtre a vu le jour juste au bon moment. John Bailey, l'ingénieur du son exceptionnel qui a travaillé à cinq de mes six albums, l'exprime de cette façon : « Tout ce que tu as fait au cours de ta carrière et ce qui t'est arrivé dans ta vie t'a menée là où tu te trouves maintenant. »

Tout a commencé tard un soir de janvier 2014. Il neigeait et je venais de terminer l'enregistrement de mon cinquième album, *Runaway,* une compilation de chansons d'amour classiques avec orchestre symphonique. Lors d'une discussion pour élaborer de nouveaux spectacles avec orchestre, l'idée nous est venue de faire un disque d'œuvres canadiennes. Quelques années auparavant, j'avais pensé enregistrer des chansons mythiques des Maritimes. Élargir ce concept à l'ensemble du pays m'a immédiatement enthousiasmée. En un éclair est venue l'idée de *True North: The Canadian Songbook*, le recueil de chansons canadiennes.

Je venais d'enregistrer les parties orchestrales de *Runaway* à l'étranger, une situation qui devient une triste réalité dans le milieu de la musique. Je me sentais coupable et je savais que, si je réalisais mon projet, il serait enregistré au Canada. Mais

avec qui ? J'avais établi de bonnes relations avec plusieurs des meilleurs orchestres du pays et je me doutais bien qu'il serait difficile, voire impossible, d'en choisir un seul.

Tout à coup, j'ai pensé : et si je faisais appel à des orchestres des quatre coins du pays ? Et si je demandais à des musiciens de partout au Canada de prendre ces chansons et de les adapter pour un grand ensemble ? En un instant, j'ai été à la fois obsédée et stimulée par ce concept pancanadien qui relaterait l'histoire extraordinaire de la musique de chez nous et, de surcroît, juste à temps pour souligner le 150e anniversaire du pays en 2017.

J'étais tellement enthousiaste que cette idée occupait toutes mes pensées. J'ai dressé une liste préliminaire de chansons, puis pendant des heures j'en ai cherché d'autres qui étaient moins connues, mais qui convenaient à mon style personnel et musical, tout en représentant l'ensemble des régions du pays. Les premiers titres me sont venus rapidement à l'esprit. D'ailleurs, la plupart des chansons pressenties à l'origine figurent toujours dans la compilation.

Ensuite, je me suis demandé s'il y avait encore des gens qui se procuraient des disques depuis que le téléchargement, l'écoute en continu et les applications électroniques ont bousculé l'industrie de la musique. Je savais que, pour réussir la diffusion de mon album, il me faudrait trouver des méthodes nouvelles et créatives. En 2014, ma fille n'a acheté que deux CD. Ce qui m'a frappée, c'est qu'ils étaient tous deux vendus sous forme de coffret avec un livret qui permettait aux artistes de créer une expérience améliorée, de compléter en quelque sorte la musique. Cette présentation m'a intriguée. Chacune des chansons sélectionnées évoquait une image particulière et les paysages du Canada étaient omniprésents dans mon esprit. C'est ainsi que j'ai eu l'idée d'accompagner la musique d'un album de photos de paysages. Et je ferais appel à des professionnels de tous les coins du pays, comme nous l'avions fait pour l'équipe musicale du projet.

Plus j'étais enthousiaste, plus j'avais peur. Était-il réalisable, ce projet d'album double, en tenant compte de la complexité de parcourir le pays pour enregistrer avec différents orchestres ? Et je voulais publier un livre par-dessus le marché ?

Ma réflexion sur la façon de mener à bien cette entreprise m'a obsédée durant une bonne partie de l'année 2014. Je savais quelles complications nous allions affronter et je me demandais si c'était trop fou pour l'envisager, et pour s'y consacrer. J'en ai discuté avec des parents et des amis. Combien coûterait cette aventure ? À quoi faudrait-il s'attendre en matière de logistique ? Qui pourrait m'aider ? Et, surtout, qui pourrait produire un enregistrement aux proportions monumentales comme celui-ci ? L'année tirait à sa fin et je devais me décider : 2017 arrivait à grands pas.

Puis, au début de 2015, ma vie a pris un virage dramatique et inattendu. Mon mariage a pris fin abruptement après seulement huit mois. Je suis passée du conte de fées au cauchemar. J'étais ravagée par le chagrin. En même temps, j'étais très reconnaissante envers tous ces gens qui étaient demeurés à mes côtés depuis si longtemps. L'amour et le soutien que j'ai reçus de tant de personnes merveilleuses, parents et amis, m'ont aidée à y voir clair et m'ont donné le courage et la force de continuer.

Malgré ma douleur intense, je savais que je devais aller de l'avant. Je savais qu'il valait mieux éviter de canaliser mon énergie dans la douleur, et plutôt avancer vers quelque chose de gratifiant et d'enrichissant pour évacuer ma peine. J'exprimerais mon amour pour mon pays et la musique en me consacrant à un projet qui m'habitait depuis un an déjà : *True North: The Canadian Songbook*.

J'ai su que mon cœur guérirait. Grâce à la musique.

Une fête

Les chansons qui font partie de cette collection sont, pour moi, la bande sonore d'un film illustrant les beautés majestueuses et sauvages du Canada. Tandis que mon projet prenait forme, je ne pouvais les chasser de mon esprit. Les différences profondes qui existent d'un océan à l'autre symbolisent ce que nous sommes comme pays : une collection de cultures réunies par un ensemble de valeurs et d'idéaux communs. Nous sommes authentiques et terre à terre. Nous croyons à la justice sociale pour tous. Nous croyons à l'importance de créer des rapports fructueux avec nos concitoyens, des rapports empreints de sincérité.

Quelle que soit la saison, quand je voyage au Canada, je ne peux m'empêcher d'admirer la variété de paysages époustouflants que nous avons la chance de voir ici. Bon nombre de ces paysages se retrouvent dans ce livre. J'ai eu si souvent le souffle coupé en découvrant un lieu ou quand une chanson de la liste, par sa profondeur et sa sincérité, s'installait dans ma tête. La fierté que j'éprouvais pour mon pays grandissait de jour en jour. Nous possédons une grande richesse grâce à notre peuple et à la façon dont nous nous exprimons par le biais de notre musique, de notre culture et de notre art.

J'admire notre modestie proverbiale, mais je ne peux m'empêcher de croire que nous devrions peut-être nous affirmer davantage. Notre 150e anniversaire est le moment idéal pour montrer au monde le pays unique que nous formons, pour prendre du recul afin de voir le Canada dans son ensemble. Plutôt que de nous concentrer sur nos différences, le temps est venu de rendre hommage à la diversité de personnes et de paysages qui composent la courtepointe dans laquelle nous nous enveloppons. Après avoir traversé le pays d'un océan à l'autre avec le projet *True North: The Canadian Songbook*, je comprends mieux la valeur de ce cadeau extraordinaire d'être canadien, et mon cœur s'emplit de gratitude.

Le plus grand espoir que je nourris pour cet album, c'est qu'il inspire mes concitoyens à défendre leur pays avec passion. J'espère que nous célébrerons nos gens, nos musiciens et nos artistes, nos valeurs et notre culture, notre diversité et nos paysages à couper le souffle. Et j'espère particulièrement que cet album nous rendra plus sensibles aux réalités exprimées dans notre recueil de chansons. Nous devons montrer au monde que nous avons une œuvre dont nous pouvons être fiers pour sa profondeur, son authenticité et la voix unique qui s'élève grâce à la musique.

V. TONY HAUSER | Cathedral Grove, Vancouver Island, British Columbia

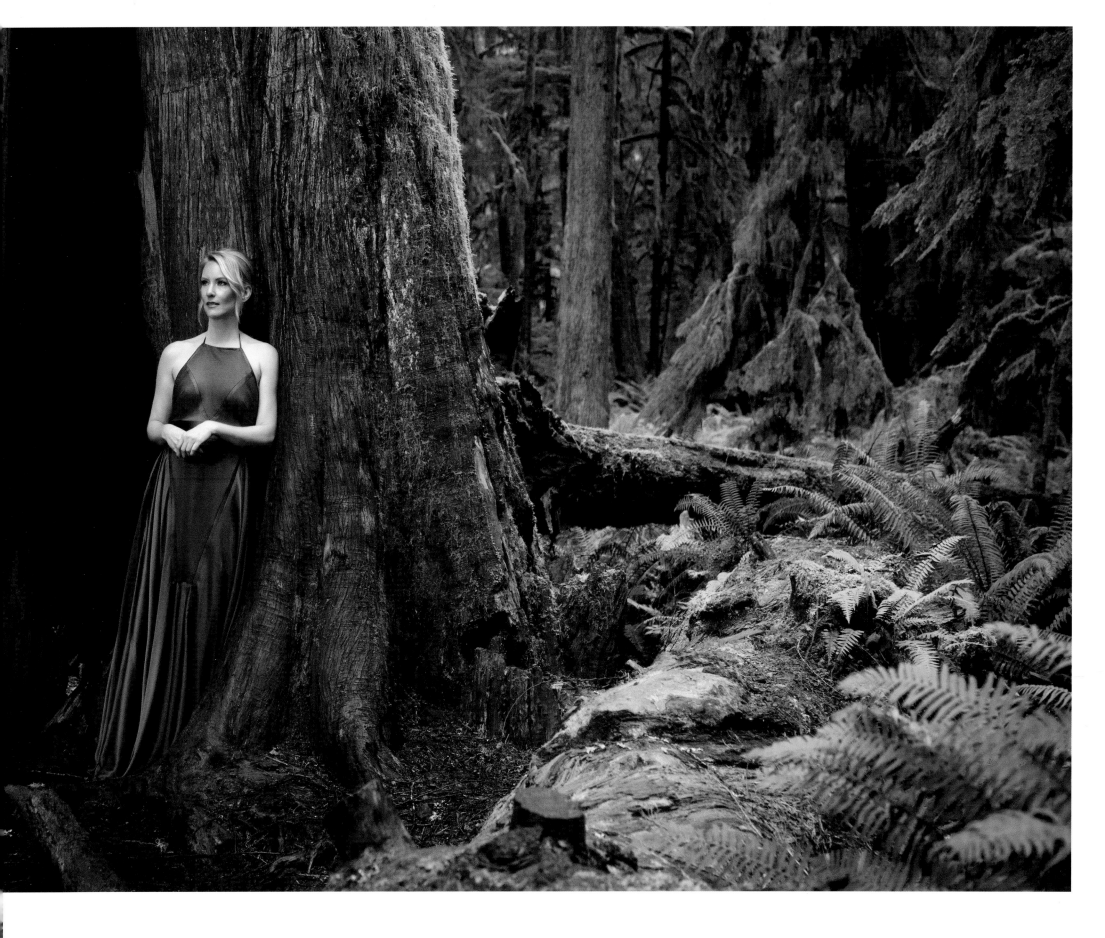

All the diamonds in this world
That mean anything to me
Are conjured up by wind and sunlight
Sparkling on the sea

Two thousand years and half a world away
Dying trees still grow greener when you pray

All The Diamonds In The World

BRUCE COCKBURN

I ran aground in a harbour town
Lost the taste for being free
Thank God He sent some gull-chased ship
To carry me to sea

Silver scales flash bright and fade
In reeds along the shore
Like a pearl in a sea of liquid jade
His ship comes shining
Like a crystal swan in a sky of suns
His ship comes shining

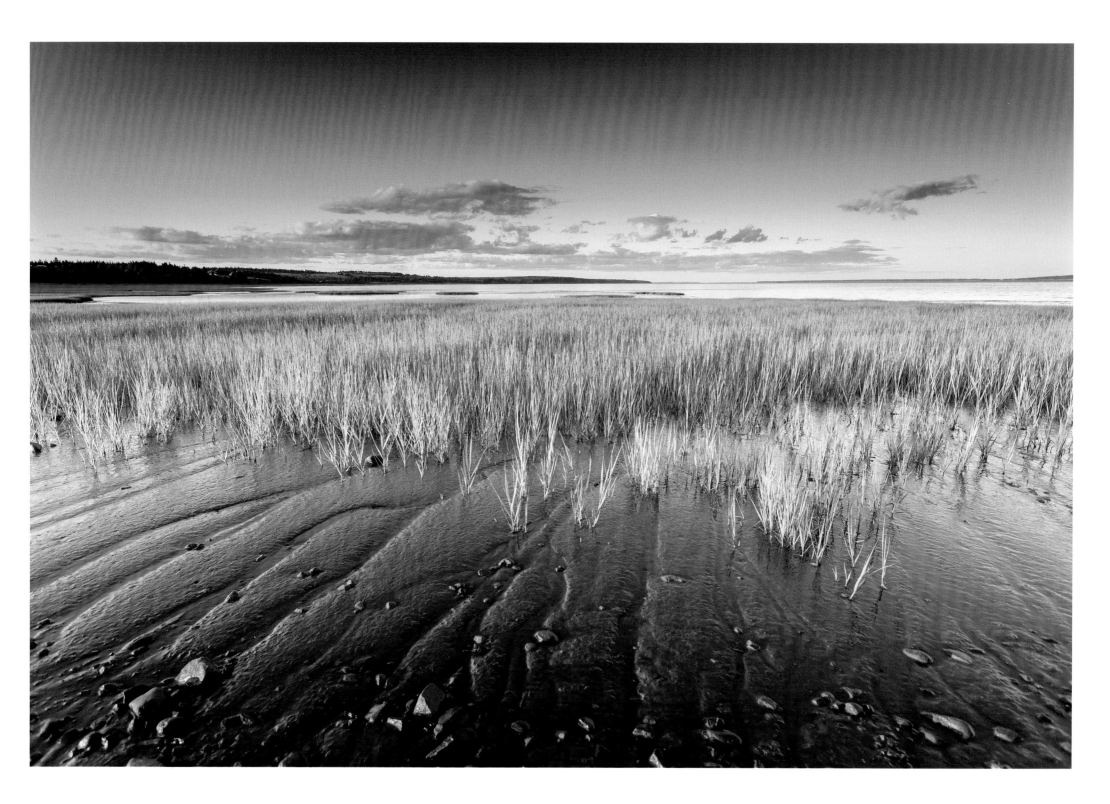

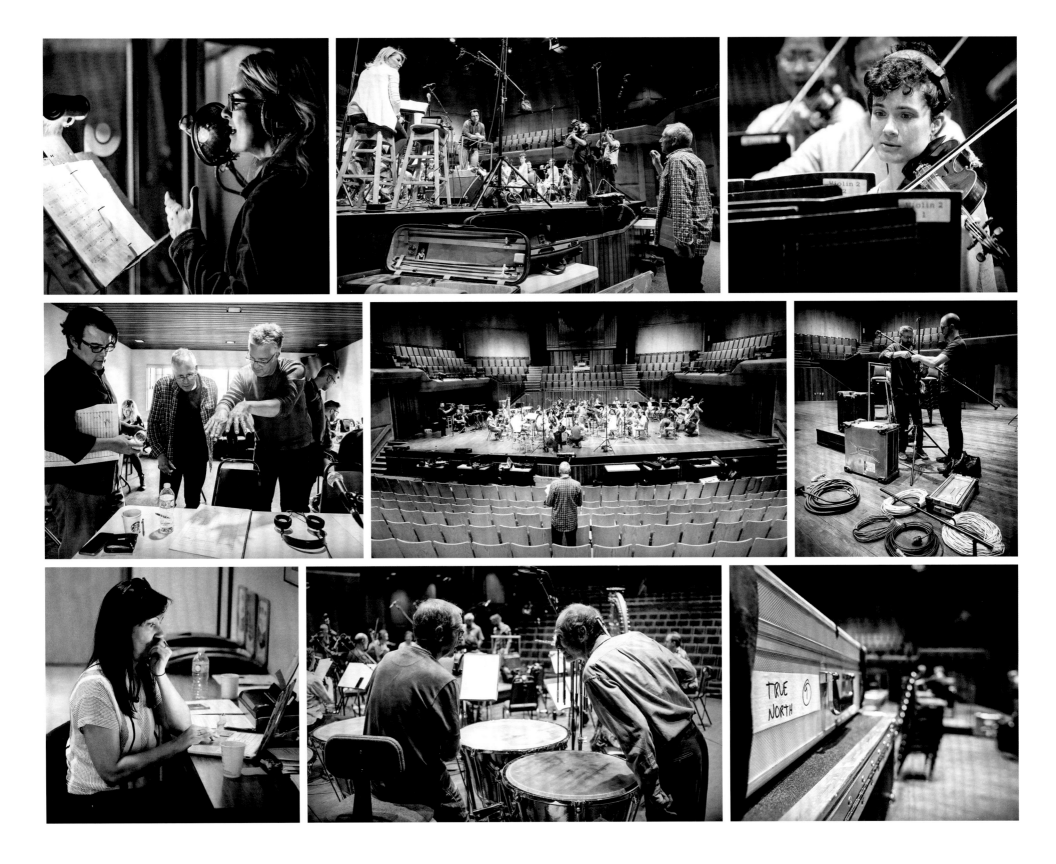

Bruce Cockburn on All The Diamonds In The World

My then-wife and I were in Stockholm. We'd been travelling for an extended period that summer, and tensions that had been with us for a long time came to a head. We did our best to navigate them, but I realized that I didn't have the resources in me to deal with my part of the state of crisis we came to.

At this point I was on the brink of thinking of myself as a Christian, so I prayed. I prayed to Jesus to take my crap on himself—and I felt the prayer was answered. The next afternoon we went on a cruise through the Stockholm archipelago. It was beautiful, the sun sparkling on the water the way it did, the fresh breeze. I became filled with a sense of timelessness and renewal. There seemed to be an equation between what we were seeing and the previous night's more internal experience; that hit me in a big way.

Back at our lodgings I started writing the words of what became "All The Diamonds." As they took shape, I felt that they called out for something hymn-like in a melody.

It's one of those songs people have taken to heart: played at weddings, funerals and church services. In the late '80s, when I happened to be back in Sweden on tour, a guy who owned an outdoor clothing store appeared after a show, bearing gifts.

"Why?" I asked.

"Because your song 'All The Diamonds' saved me from killing myself and I want to say thanks," he replied.

He had been on the verge of committing suicide when he heard it and something in it made him change his mind. I had never imagined a song could have that kind of effect. It was humbling. It reinforced for me the wondrous value, and the responsibility, of sharing the experience of being alive. We can all use other people's insights, whether they come through music, painting or conversation.

Bruce Cockburn parle de All The Diamonds In The World

Je me trouvais à Stockholm avec ma femme de l'époque. Nous avions passé une grande partie de l'été à voyager et les tensions qu'il y avait entre nous depuis longtemps étaient à leur comble. Nous avons fait de notre mieux pour apaiser la situation, mais je me suis rendu compte que je n'avais pas en moi les ressources nécessaires pour régler ma part des problèmes qui avaient causé la crise.

À cette époque, je me considérais presque comme étant chrétien, alors j'ai prié. J'ai prié pour que Jésus me sorte de ma merde — qu'il la prenne pour lui — et j'ai senti qu'il avait exaucé mon vœu. Le lendemain après-midi, nous avons fait une croisière dans l'archipel de Stockholm. Les rayons du soleil étincelaient sur l'eau, c'était magnifique. J'ai été frappé de plein fouet par le parallèle entre ce que nous voyions et l'expérience spirituelle qui m'avait aidé à surmonter notre épreuve.

Dès mon retour à l'hôtel, j'ai commencé à écrire les paroles, et ces mots imposaient une mélodie qui évoquait un hymne.

All The Diamonds est devenue l'une de ces chansons qui touchent le cœur des gens et que l'on entend dans les mariages, les funérailles et les messes. À la fin des années 1980, je suis reparti en tournée en Suède. Un spectateur, propriétaire d'une boutique de vêtements de plein air, est venu m'apporter des cadeaux après un spectacle. Intrigué, je lui ai demandé pourquoi il était si généreux.

— Je voudrais vous remercier parce que *All The Diamonds* m'a empêché de me suicider, m'a-t-il répondu.

Il était sur le point de commettre l'irréparable lorsqu'il a entendu ma chanson et, d'une façon ou d'une autre, elle l'a fait changer d'idée. Je n'avais jamais imaginé qu'une chanson pouvait produire un tel effet. C'était une leçon d'humilité. Elle a renforcé en moi la valeur merveilleuse — et la grande responsabilité que l'on a — d'une expérience de vie partagée. Nous pouvons tous profiter des expériences des autres, qu'elles nous soient transmises par la musique, la peinture ou par une simple conversation.

Spend all your time waitin'
For that second chance
For a break that would make it okay
There's always some reason
To feel not good enough
And it's hard at the end of the day

So tired of the straight line
And everywhere you turn
There's vultures and thieves at your back
Storm keeps on twistin'
Keep on buildin' the lies
That you make up for all that you lack

I need some distraction
Oh beautiful release
Memory seep from my veins
Let me be empty
Oh and weightless and maybe
I'll find some peace tonight

It don't make no difference
Escaping one last time
Easier to believe
In this sweet madness
Oh this glorious sadness
That brings me to my knees

Angel

SARAH McLACHLAN

In the arms of the angel
Fly away from here
From this dark, cold hotel room
And the endlessness that you fear
You are pulled from the wreckage
Of your silent reverie
You're in the arms of the angel
May you find some comfort here

In the arms of the angel
Fly away from here
From this dark, cold hotel room
And the endlessness that you fear
You are pulled from the wreckage
Of your silent reverie
You're in the arms of the angel
May you find some comfort here

You're in the arms of the angel
May you find some comfort here

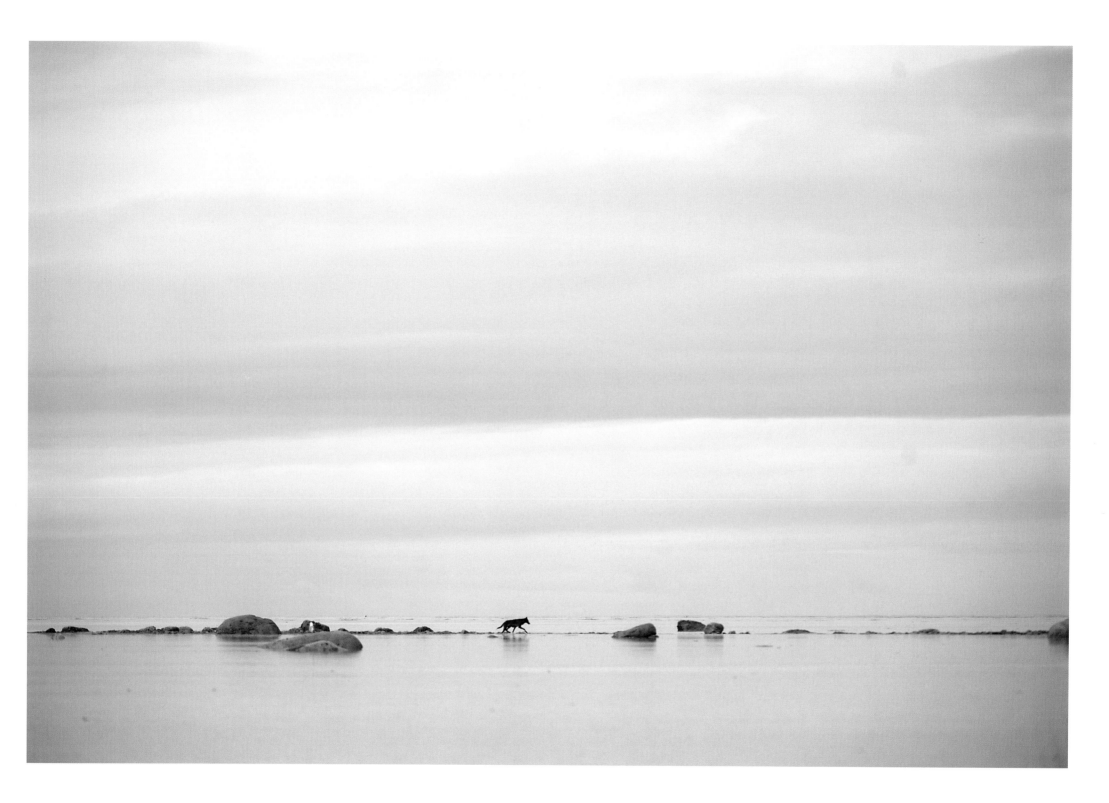

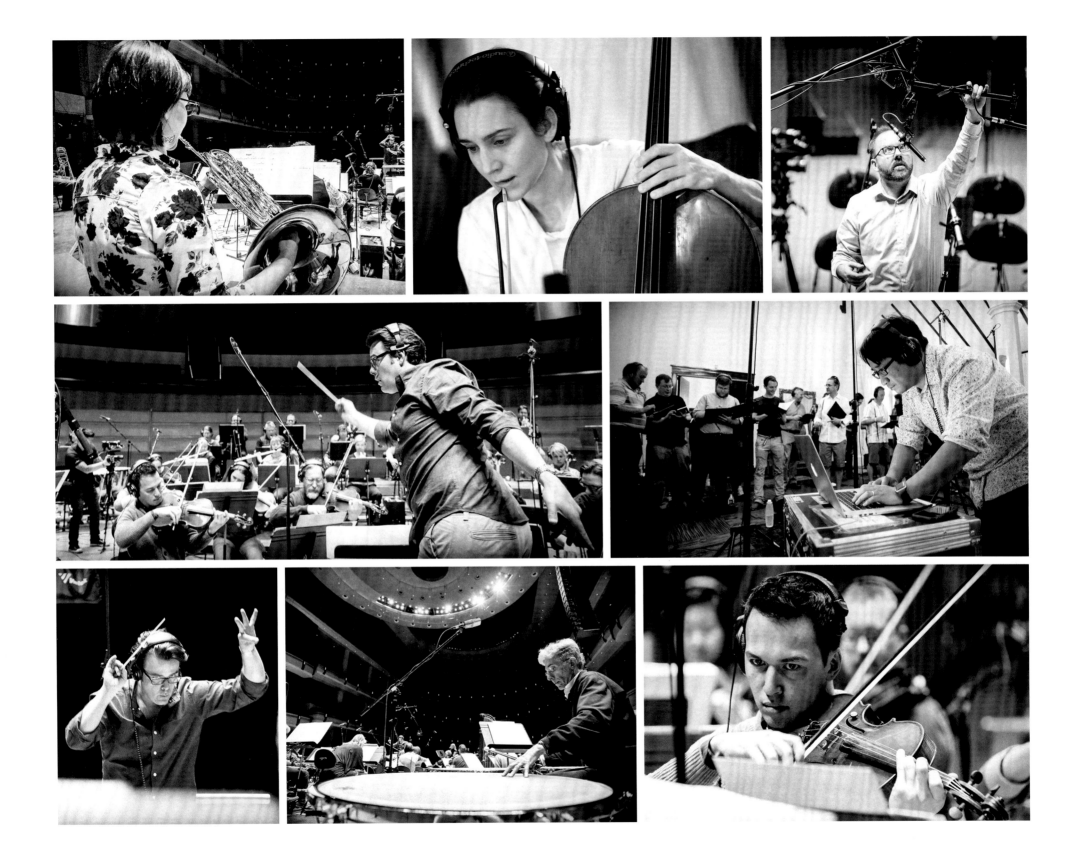

Sarah McLachlan on Angel

I'd been on the road for two years, living on a tour bus with 12 other people. It was like I'd been sucked dry. The worst part was standing on stage and having thousands of people scream that they loved me, because I hated myself. I didn't even like the music anymore.

When the tour ended, my record label was pushing for another album and I had nothing to give. Needing to be alone, I ended up staying in a little guest cottage north of Montréal. There I read a story in *Rolling Stone* about the keyboard player for the Smashing Pumpkins, who'd overdosed on heroin in a hotel room. I felt this wave, a flood of empathy and recognition. While I've never done heroin, I knew what it was like to be out there for so long and looking desperately for an escape from expectations. And that's when "Angel" came to me. It was one of those divine experiences: I didn't write the song. It came through me.

There are always dark moments in a writer's life when you think, "Whatever I've already done is the best I'm ever going to do," that you're over and done with and will never write another song, period. With "Angel," I knew it was a good song. And if I had to choose, it would be my favourite song, because I never tire of performing it. So many people have come up to me and said it helped them get through a parent's funeral, a son's death or other life crisis.

This the best validation one can have as an artist and a human being, to know that people find meaning and comfort in something you created. That's my validation: I'm living my purpose.

Sarah McLachlan parle de Angel

J'étais en tournée depuis deux ans et je vivais littéralement dans un autobus avec douze autres personnes. J'étais vidée. Le pire, c'était de me tenir sur scène devant des milliers de spectateurs qui me criaient leur amour, alors que je me détestais. Je n'aimais même plus ma musique.

Une fois la tournée terminée, ma maison de disques a insisté pour que j'enregistre un autre album, mais je n'avais plus rien à donner. J'avais besoin d'être seule. Je me suis donc installée dans un petit chalet au nord de Montréal. Là-bas, j'ai lu un article dans le *Rolling Stone* au sujet du claviériste des Smashing Pumpkins qui était mort d'une overdose d'héroïne dans une chambre d'hôtel. J'ai senti monter en moi une vague d'empathie et de reconnaissance. Même si je n'avais jamais consommé cette drogue, je savais ce que c'était, occuper la scène depuis longtemps et chercher désespérément à échapper aux attentes des autres. C'est à cette époque que la chanson *Angel* s'est imposée à moi. C'était comme une expérience divine : je n'ai pas composé cette chanson, elle est venue à travers moi.

Dans la vie d'un auteur, il y a toujours des moments sombres où l'on se dit : « Je ne réussirai rien de mieux que ce que j'ai déjà fait. » On a carrément l'impression qu'on n'écrira plus aucune chanson. Je savais qu'*Angel* était une bonne chanson. Et si on me demandait de choisir ma préférée, je dirais que c'est celle-là, parce que je ne me lasse jamais de l'interpréter. Beaucoup de gens m'ont dit qu'elle les a aidés lors des funérailles d'un parent, de la mort d'un fils ou d'une autre crise dans leur vie.

C'est la plus grande marque de reconnaissance que l'on puisse recevoir comme artiste et comme être humain : savoir que quelque chose que l'on a créé réconforte les gens et a une signification pour eux. C'est ça qui justifie ce que je fais : je remplis ma mission.

Et l'attente qui m'avait si bien prédit
Où tout est mort et presque rien n'est dit
J'ai regardé si loin que je n'ai rien compris
Il fallait bien un jour que j'en sorte à tout prix

On cherche toujours quelques lettres à graver
D'abord dans son coeur puis sur un vieux pavé
J'ai regardé si loin que je n'ai rien trouvé
Au début d'un refrain le matin s'est levé

Aujourd'hui, je dis bonjour à la vie

SERGE FIORI

Aujourd'hui je dis bonjour à la vie
Demain je ne perdrai plus mes nuits

Aujourd'hui je dis bonjour à la vie
Demain je ne perdrai plus mes nuits

Il est trop tard
Pour comprendre
Il fait trop noir
Pour attendre

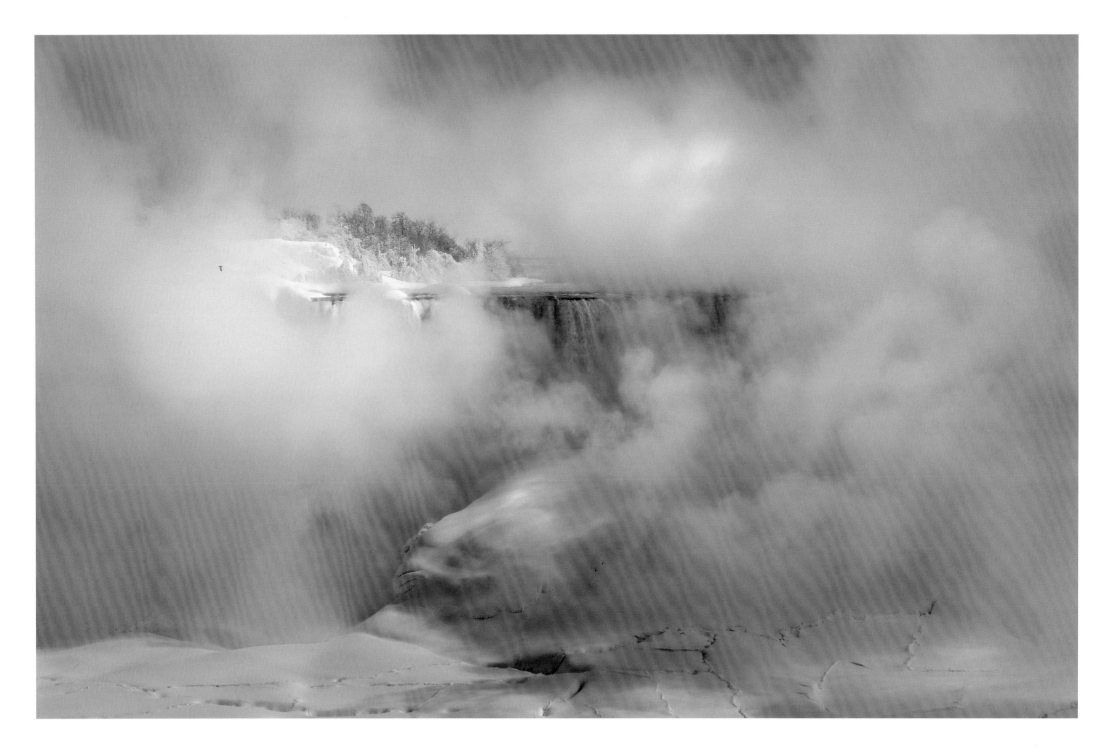

Serge Fiori on Aujourd'hui, je dis bonjour à la vie

I had just moved to an apartment in Outremont and there were kids playing in the schoolyard across the street. I loved the sound so I took my 12-string guitar, went out on the balcony and tried to blend it all together—the chords, the harmonics and the kids. That's how the first pattern in the song was created, and the rest took maybe 30 minutes to write. It was spring. It was sunny. Everything fit.

It's a song about having the chance each day to start afresh, to defeat the limits we impose on ourselves and go for your dreams. The line "Demain, je ne perdrai plus mes nuits" illustrates that determination. When you can't sleep, life becomes hard. Then you have moments like that one on the balcony, where you can fit in and everything fits around you. It's amazing.

I would always open shows with the song because it created an atmosphere of freedom. Improvising the first chords put me in a fluid state of mind. It was our way of telling the audience that the performance they were about to see was not all planned and mapped out. Then in 1980 my panic attacks started. It happened one night on stage for no reason. Afterwards I didn't play the song for a long time. Now when I listen to it, I understand and appreciate it all over again.

Serge Fiori parle de Aujourd'hui, je dis bonjour à la vie

Je venais d'emménager dans un appartement à Outremont. J'adorais entendre les enfants qui jouaient dans la cour d'école de l'autre côté de la rue. Alors, un jour, je suis sorti sur le balcon avec ma guitare douze cordes. J'ai essayé de mélanger tout ça : les accords, les harmonies et les voix des petits. C'est comme ça que j'ai créé le premier thème de la chanson et j'ai mis à peu près une demi-heure à composer le reste. C'était le printemps. Il faisait soleil. Tout allait bien ensemble.

C'est une chanson qui parle de la chance que l'on a chaque jour de pouvoir recommencer à neuf, de franchir les limites qu'on s'impose et d'essayer de réaliser nos rêves. La phrase « Demain, je ne perdrai plus mes nuits » illustre cette détermination. La vie devient difficile quand on n'arrive pas à dormir. Puis, on vit des moments comme celui-là, sur le balcon, où on peut tout intégrer et où tout s'intègre autour de nous. C'est merveilleux.

Je commençais tous les spectacles avec cette chanson parce qu'elle créait une ambiance de liberté. Quand j'improvisais les premiers accords, je me plongeais dans un état d'esprit fluide. C'était notre façon de dire aux spectateurs que le concert qu'ils allaient voir n'était pas entièrement prévu et planifié. Mais, en 1980, j'ai commencé à souffrir de crises de panique. Ça m'est arrivé un soir sur scène, sans raison, et j'ai cessé de jouer cette chanson pendant longtemps. Aujourd'hui, quand je l'écoute, je la comprends et je recommence à l'aimer.

Who else is gonna bring you a broken arrow
Who else is gonna bring you a bottle of rain
There he goes moving across the water
There he goes turning my whole world around

Do you feel what I feel
Can we make that so it's part of the deal
I gotta hold you in these arms of steel
Lay your heart on the line this time

Can you see what I see
Can you cut behind the mystery
I will meet you by the witness tree
Leave the whole world behind

I want to come when you call
I'll get to you if I have to crawl
They can't hold me with these iron walls
We've got mountains to climb

ROBBIE ROBERTSON

Broken Arrow

I want to breathe when you breathe
When you whisper like that hot summer breeze
Count the beads of sweat that cover me
Didn't you show me a sign this time

Who else is gonna bring you a broken arrow
Who else is gonna bring you a bottle of rain
There he goes moving across the water
There he goes turning my whole world around

Who else is gonna bring you a broken arrow
Who else is gonna bring you a bottle of rain
There he goes moving across the water
There he goes turning my whole world around

Turning my whole world around
Turning my whole world around
Turning my whole world around
Turning my whole world around

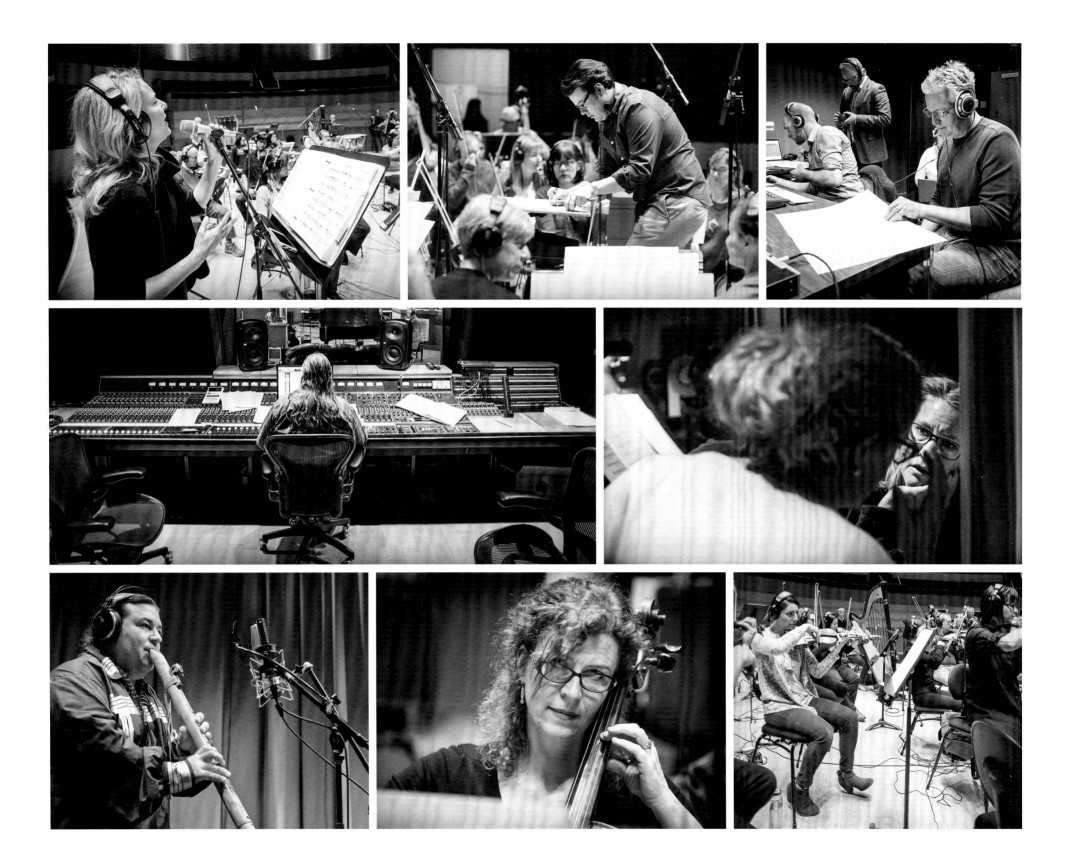

Don Breithaupt on Broken Arrow

When you look at the lead sheet of "Broken Arrow," the first seven notes are all the same. That's how it starts on paper—the same seven notes—and so it's incumbent on the singer to make them granular, to separate them and create a soundscape. Eleanor's version does that. It's elemental, spare and full of emotion, and features a Native American flute played by Paul Pike, a wonderful musician, a member of the Mi'kmaq Nation from the island of Ktaqmkuk (Newfoundland). Paul's flute performance gives the track such a cool colour, marking it off, helping to distinguish it from the dozens of other songs and flavours on the album.

I'm happy the song is here, because if you're going to do a Canadian songwriting retrospective, Robbie Robertson is one of the core people you have to include. He's in the conversation with Joni Mitchell, Leonard Cohen and Neil Young, especially in terms of influence.

The penny dropped for Eleanor and me when we played and sang "Broken Arrow" through several times in her key. Immediately there was a nice flow, and that led into conversations about the specifics of the arrangement. A lot of people think that record production means showing up at the studio, waiting for the red light to go on and that's it. But it's not. There's a lot of pre-production involved, a lot of forethought. And it's always worth it.

Don Breithaupt parle de Broken Arrow

Quand on lit la partition de *Broken Arrow*, on remarque que les sept premières notes sont pareilles. C'est avec ces sept notes identiques que la chanson commence sur papier et il revient au chanteur de les égrener, de les séparer pour créer un paysage sonore. C'est ce qu'Eleanor réussit à faire. C'est élémentaire, dénudé et rempli d'émotion. On entend de la flûte amérindienne jouée par Paul Pike, un merveilleux musicien qui fait partie de la nation micmaque de l'île de Ktaqmkuk (Terre-Neuve). Le jeu de Paul donne une couleur *cool* à cette œuvre. Il la délimite, il contribue à la distinguer des dizaines d'autres chansons et saveurs de l'album.

Je suis heureux que *Broken Arrow* figure sur cet album, parce que Robbie Robertson est un des artistes clés que l'on doit inclure dans une rétrospective de la chanson canadienne. Il se situe au même niveau que Joni Mitchell, Leonard Cohen et Neil Young, surtout pour l'influence qu'ont ces artistes.

Eleanor et moi avons eu une révélation après avoir joué et interprété *Broken Arrow* à plusieurs reprises dans sa tonalité. Tout de suite, nous avons senti une belle fluidité et nous nous sommes mis à discuter des particularités de l'arrangement. Beaucoup de gens croient que produire un disque consiste à se présenter en studio et à attendre que s'allume le voyant rouge pour commencer l'enregistrement. Un point, c'est tout. Mais ce n'est pas le cas. Il y a beaucoup de travail de préproduction, et beaucoup de réflexion aussi. Ça en vaut toujours la peine.

Just before our love got lost you said
"I am as constant as a northern star"
And I said "Constantly in the darkness
Where's that at
If you want me I'll be in the bar"

On the back of a cartoon coaster
In the blue TV screen light
I drew a map of Canada
Oh Canada
With your face sketched on it twice

I remember that time you told me you said
"Love is touching souls"
Surely you touched mine
'Cause part of you pours out of me
In these lines from time to time

Oh, you're in my blood like holy wine
You taste so bitter and so sweet
Oh I could drink a case of you darling
And I would still be on my feet
I would still be on my feet

JONI MITCHELL

A Case Of You

Oh you're in my blood like holy wine
You taste so bitter and so sweet
Oh I could drink a case of you darling
Still I'd be on my feet
Oh I would still be on my feet

Oh I am a lonely painter
I live in a box of paints
I'm frightened by the devil
And I'm drawn to those ones that ain't afraid

I met a woman
She had a mouth like yours
She knew your life
She knew your devils and your deeds
And she said
"Go to him, stay with him if you can
But be prepared to bleed"

Oh but you are in my blood
You're my holy wine
You're so bitter, bitter and so sweet
Oh I could drink a case of you darling
Still I'd be on my feet
I would still be on my feet

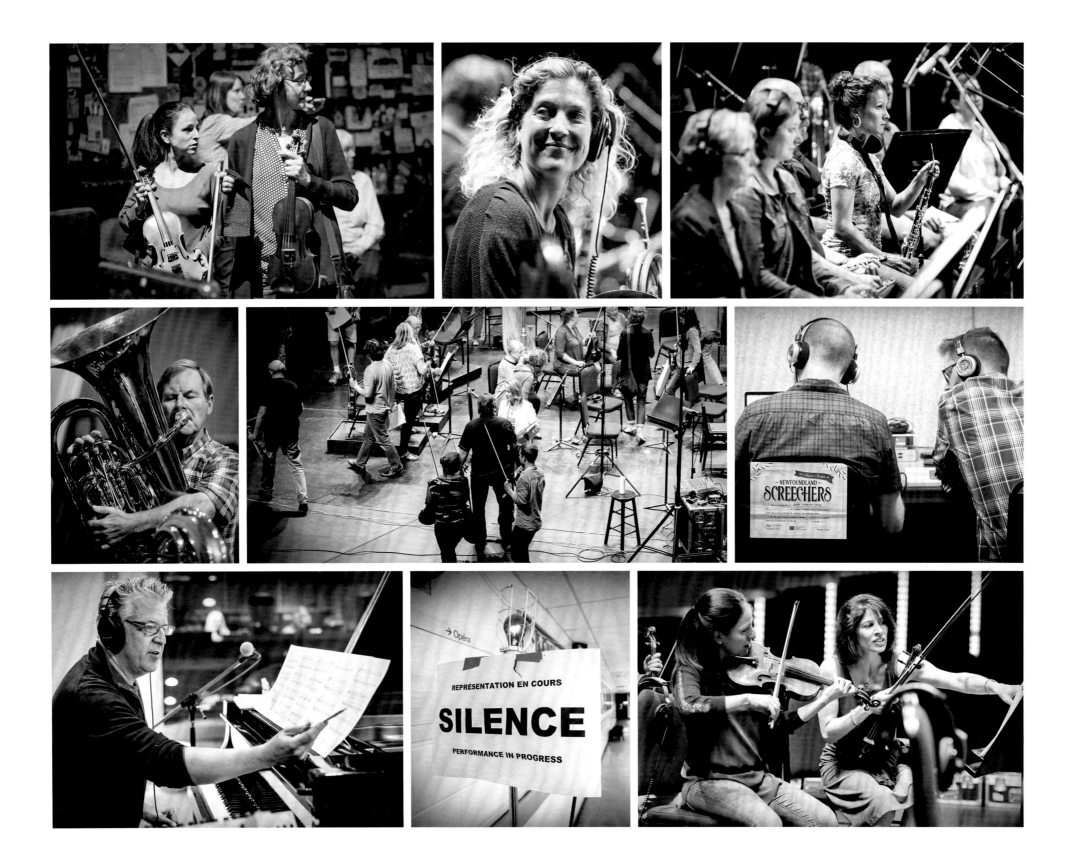

Eleanor McCain on A Case Of You

I am an interpreter of songs rather than a songwriter. As a result, it is important for me to choose songs that reach me on a deeply personal level. "A Case Of You," like much of Joni Mitchell's music, is full of raw emotion and because of this I was very drawn to it. She's the kind of storyteller who never hits a dishonest note, no matter how raw and exposed her subject material is.

For me, this was the most challenging song on the album and I consulted my vocal coach, Lorraine Lawson, about it a lot. The raw emotional and conversational aspect of the song is very exposed. I had to find that place within myself—to sink into those moments to be able to communicate the drama happening in the song in an honest way. There is clearly something so deep and personal in the song, so intimate and unfiltered, it's like you're right there in the middle of an emotional drama between two people. If you don't connect to the song on that level, it's hard to convey its true meaning. Then, as a salute to this project and the country's 150th, the reference to Canada in the lyrics also seemed to make this song a fitting choice.

I chose Shelly Berger to arrange "A Case Of You" because, as he did for his arrangement of Joni's "Both Sides Now" on my last album, I knew he would understand how to capture the song's emotional rawness with beauty and depth.

Eleanor McCain parle de A Case Of You

Je suis plutôt une interprète qu'une auteure-compositrice. C'est pourquoi il est important pour moi de choisir des chansons qui me touchent profondément. Comme beaucoup d'œuvres de Joni Mitchell, *A Case Of You* déborde d'émotion brute et c'est ce qui m'a le plus attirée. Quand Joni Mitchell raconte une histoire, elle reste toujours vraie, peu importe à quel point elle s'expose et à quel point le sujet de sa chanson est à fleur de peau.

C'est la chanson de l'album qui m'a donné le plus de difficultés techniques, ce qui m'a obligée à consulter mon professeur de chant, Lorraine Lawson, à plusieurs reprises. J'ai dû plonger en moi pour retrouver ces moments qui m'ont permis de transmettre avec sincérité le drame raconté dans la chanson. On s'y met à nu sur le ton d'une conversation. De toute évidence, il se passe quelque chose de si profond et de si personnel, de si intime et de « non filtré » que nous avons l'impression de nous trouver au beau milieu d'une tragédie émotionnelle entre deux personnes. Si on n'aborde pas cette chanson de cette façon, il est difficile de communiquer sa signification réelle. En outre, la référence au Canada dans les paroles m'a semblé convenir parfaitement à ce projet soulignant le 150e anniversaire du pays.

J'ai choisi de faire appel à Shelly Berger pour les arrangements, parce que je savais qu'il saurait capter l'émotion brute de la chanson avec élégance et profondeur, comme il l'avait fait pour mon dernier album avec *Both Sides Now*, une autre chanson de Joni.

Constant craving has always been

Craving
Ah ha, constant craving
Has always been
Has always been

Even through the darkest phase
Be it thick or thin
Always someone marches brave
Here beneath my skin

Constant craving
Has always been

And constant craving has always been

Constant Craving

K.D. LANG

BEN MINK

Maybe a great magnet pulls
All souls towards truth
Or maybe it is life itself
Feeds wisdom to its youth

Constant craving
Has always been

Craving
Ah ha, constant craving
Has always been
Has always been
Has always been

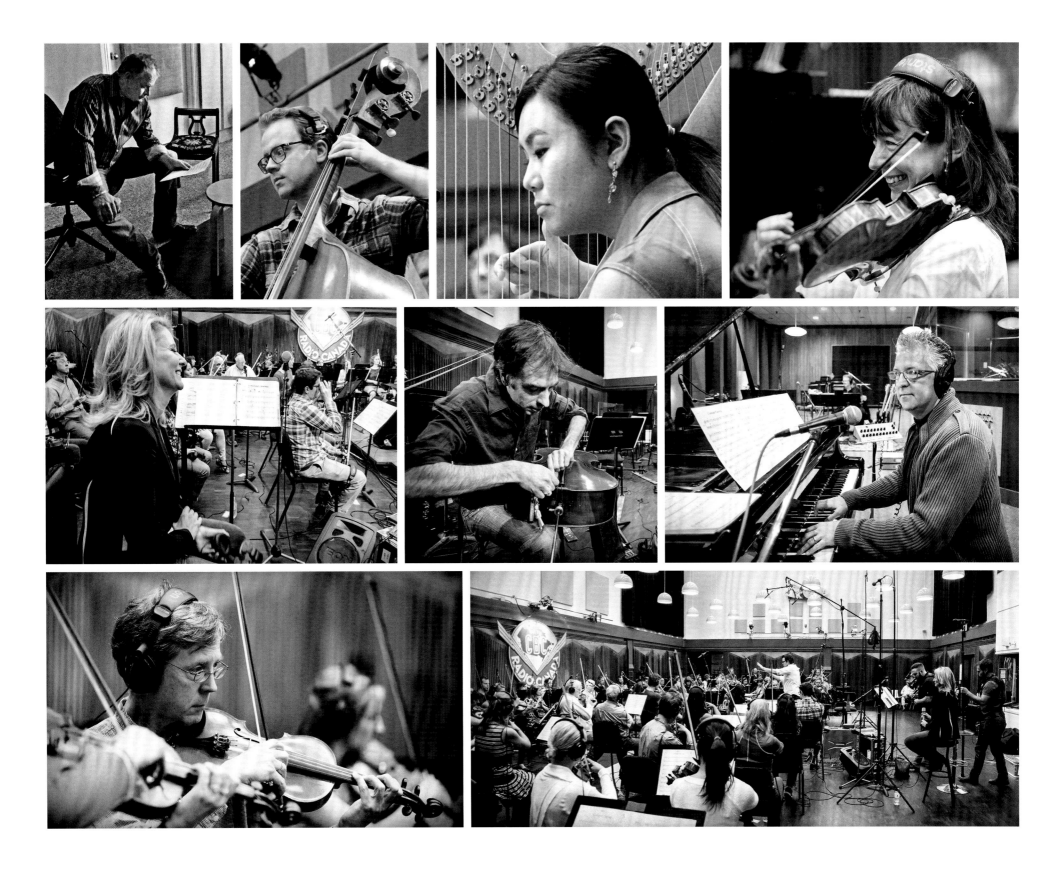

Ben Mink on Constant Craving

The song almost didn't exist, period. That's the irony. It was the last vocal recording and mix on the record [*Ingénue*], with no expectations. I think the public often imagines that an artist loves their new song as they would a newborn child, one they can't wait to proudly display to the world. But it wasn't like that at all. The scenario was closer to the birth of a new litter of puppies, and suddenly, "Wait, there's one more!" And you don't really know what to make of this "one more." It's the runt—the pup you're not even sure will fit in the family.

With certain songs, co-writers will have different opinions during the creative process, and you have to just duke it out. But that's what honest collaboration is. Not to simply reach a compromise, but to revise, rebuild and make it better.

We agonized over the chorus for days. There was a timeless eastern feeling to it, based upon an ancient Jewish music scale, very likely because klezmer music is a big part of my ancestry. During early studio tracking, we found the key not really working for k.d.'s voice. I stayed late that night with our engineer and retracked the guitar parts to where it ended up. Consequently, it stayed in the running.

As well, the song's tempo is brisker than many of the others on *Ingénue*. We were somewhat concerned about it sounding too "exotic," until the guitar solo was added. Whatever we did obviously worked. The rest is history.

Ben Mink parle de Constant Craving

Ironiquement, *Constant Craving* a failli ne jamais exister. Il ne restait qu'à enregistrer les voix et à mixer cette dernière chanson pour terminer le disque *Ingénue*, et nous n'avions aucune attente. Selon moi, le public s'imagine souvent que les auteurs-compositeurs aiment toujours leur plus récente chanson autant qu'un nouveau-né qu'ils seraient impatients de présenter au monde entier. Mais cela n'a pas du tout été le cas pour *Constant Craving*. L'histoire de sa création me fait plutôt penser à la naissance d'une portée de chiots, lorsqu'on s'exclame « Attendez, il y en a un de plus ! » et qu'on ne sait vraiment pas quoi faire de ce petit chien « de plus ». Nous craignions que cette chanson soit comme le petit avorton qui ne s'intègrerait jamais bien dans la famille.

Lorsque des auteurs-compositeurs collaborent à la création d'une chanson, il arrive qu'ils aient des opinions différentes lors du processus créatif et ils doivent défendre leurs idées. Mais c'est la nature d'une vraie collaboration. Il ne s'agit pas simplement d'arriver à un compromis, mais de réviser la chanson, de la reconstruire et de l'améliorer.

Nous nous sommes tourmentés durant des jours à propos du refrain. Il avait un certain air exotique oriental, inspiré de la musique juive ancienne, fort probablement parce que la musique klezmer occupe une grande place dans mon héritage. Nous nous sommes assez vite rendu compte, lors des séances d'enregistrement, que la tonalité ne convenait pas à la voix de k.d. Ce soir-là, je suis resté tard en studio avec notre ingénieur du son pour réenregistrer les pistes de guitare. Et nous avons finalement conservé la chanson sur le disque.

Le tempo est aussi plus rapide que bon nombre des autres chansons d'*Ingénue*. Nous avons craint que la chanson soit trop « exotique », jusqu'à ce que nous ajoutions le solo de guitare. Mais peu importe ce que nous avons fait, ça a fonctionné. On connaît la suite . . .

Four strong winds that blow lonely
Seven seas that run high
All those things that don't change come what may
Our good times are all gone
I'm bound for movin' on
I'll look for you if I'm ever back this way

If I get there before the snow flies
If things are looking good
You could meet me if I send you down the fare
But by then it will be winter
Not enough for you to do
And the winds sure blows cold way out there

Four strong winds that blow lonely
Seven seas that run high
All those things that don't change come what may
Our good times are all gone
I'm bound for movin' on
I'll look for you if I'm ever back this way

Four Strong Winds

IAN TYSON

Think I'll go out to Alberta
Weather's good there in the fall
Got some friends that I can go to workin' for
Still I wish you'd change your mind
If I asked you one more time
But we've been through that a hundred times or more

Four strong winds that blow lonely
Seven seas that run high
All those things that don't change come what may
Our good times are all gone
I'm bound for movin' on
I'll look for you if I'm ever back this way
I'll look for you if I'm ever back this way

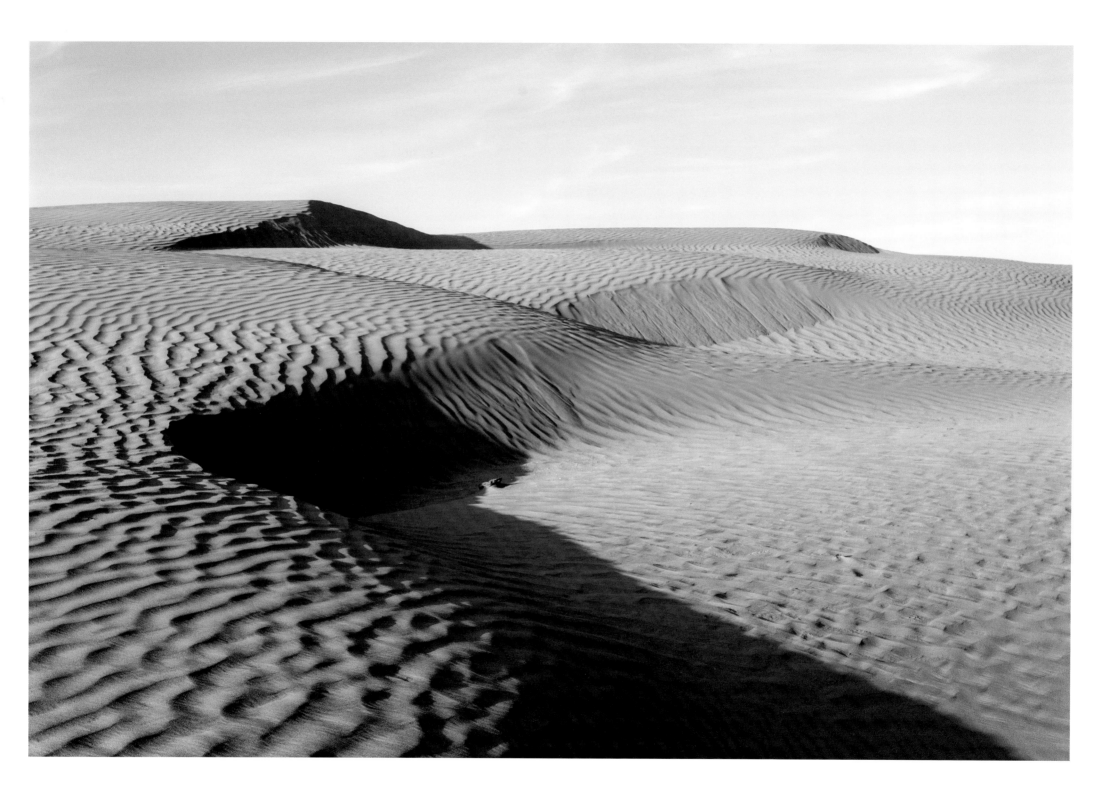

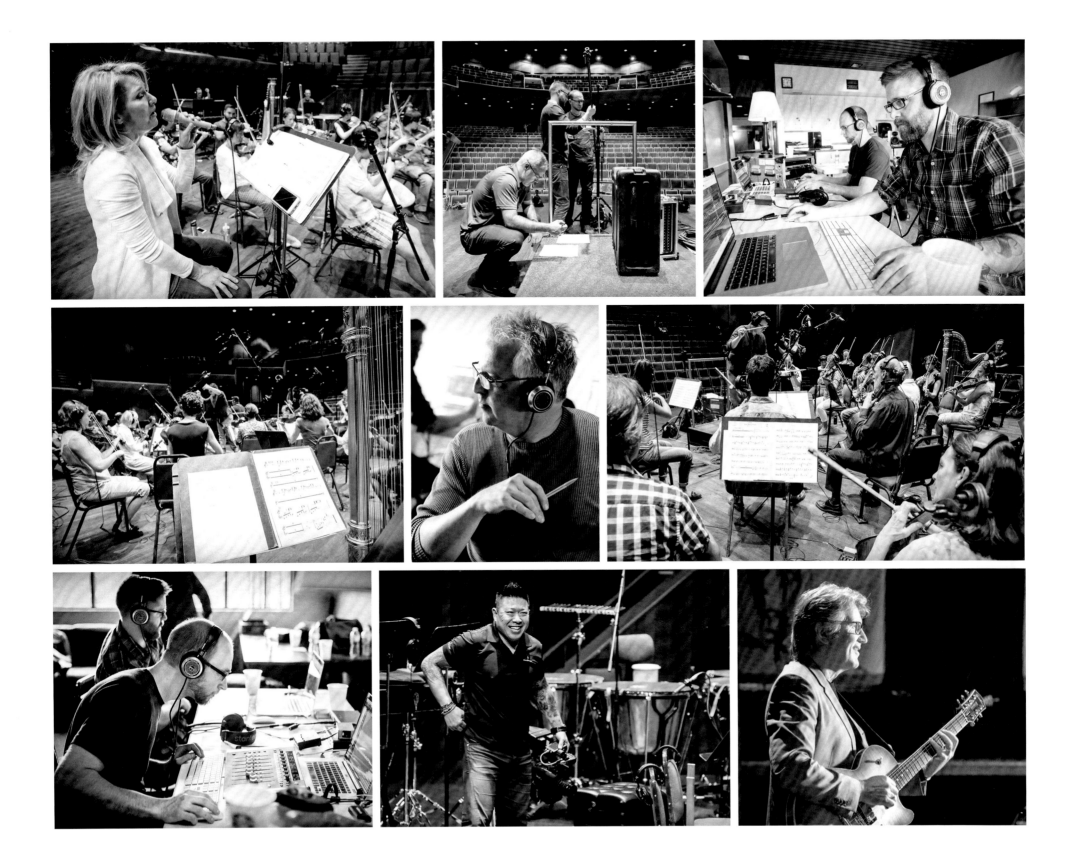

Ian Tyson on Four Strong Winds

I was 29 and in New York City. It was a rainy autumn afternoon and I was thinking about a girl who was out west, in BC. We were young lovers and I wanted to see her, even though I knew it wasn't possible. I was also thinking about Alberta, about the plains and snow and where I came from, and the song sort of came to the surface. That was it. Art is like that: an amalgamation of different experiences and people and landscapes, and you cobble them into a song or a novel or a poem or whatever.

When I wrote "Four Strong Winds," the folk genre felt totally new, experimental and fresh. Bob Dylan's songwriting influence was just beginning to be felt on the Greenwich Village folk scene. I thought the way I could write a song was to use my western beginnings and background and go from there. How hard could it be? I had no idea how difficult writing songs would become later on. To do it, you have to draw upon a multitude of personal experiences, and when you're young you haven't used them up yet. Back then it was new, it was exciting, and even if we didn't necessarily know what we were doing all the time, it was fun doing it anyway.

Since then I've performed the song so many times I could do it in my sleep. But it has become bigger than me, a musical expression that's not really mine anymore, but rather on loan to the country. It's part of the Canadian landscape.

Ian Tyson parle de Four Strong Winds

J'avais vingt-neuf ans et j'étais à New York. Par un après-midi d'automne pluvieux, je me suis mis à penser à une fille qui vivait dans l'Ouest, en Colombie-Britannique. Nous étions amoureux depuis peu et je voulais la voir, même si je savais que c'était impossible. Je pensais aussi à l'Alberta, aux plaines, à la neige, à l'endroit d'où je viens et cette chanson a émergé, le plus simplement du monde. L'art, c'est comme ça : un amalgame d'expériences, de gens et de paysages variés que l'on assemble dans une chanson, un roman ou un poème.

Quand j'ai composé *Four Strong Winds,* le folk était un genre complètement nouveau. C'était frais et expérimental. On commençait à sentir l'influence de Bob Dylan dans le milieu folk à Greenwich Village. J'imaginais que, pour écrire une chanson, il me fallait puiser dans mes origines western et partir de là. Où était la difficulté ? Je n'avais aucune idée à quel point il deviendrait ardu de composer des chansons plus tard. Pour y arriver, il faut s'inspirer d'une multitude d'expériences personnelles, mais quand on est jeune, on ne les a pas encore vécues. À l'époque, c'était nouveau, c'était stimulant. Et même si nous ne savions pas toujours ce que nous faisions, nous avons eu du plaisir à le faire.

Depuis, j'ai interprété cette chanson si souvent que je pourrais la jouer les yeux fermés. Mais, aujourd'hui, elle me dépasse. Elle est devenue une expression musicale qui ne m'appartient plus vraiment. Elle est prêtée au pays, elle fait partie du paysage canadien.

GORDIE SAMPSON

FRED LAVERY

How pale is the sky that brings forth the rain
As the changing of seasons prepares me again
For the long bitter nights and the wild winter's day
My heart has grown cold my love stored away
My heart has grown cold my love stored away

Just get me through December
A promise I'll remember
Get me through December
So I can start again

No divine purpose brings freedom from sin
And peace is a gift that must come from within
I've looked for the love that will bring me to rest
Feeding this hunger beating strong in my chest
Feeding this hunger beating strong in my chest

Get Me Through December

I've been to the mountain left my tracks in the snow
Where souls have been lost and the walking wounded go
I've taken the pain no girl should endure
But faith can move mountains of that I am sure
Faith can move mountains of that I am sure

Get me through December
A promise I'll remember
Get me through December
So I can start again

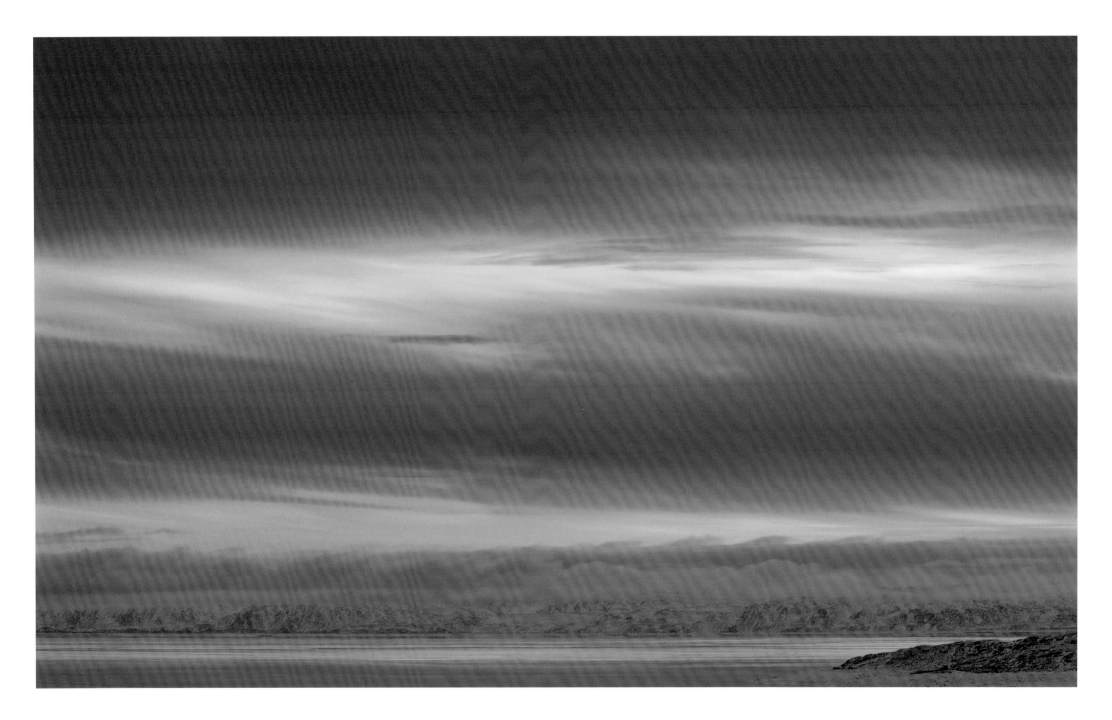

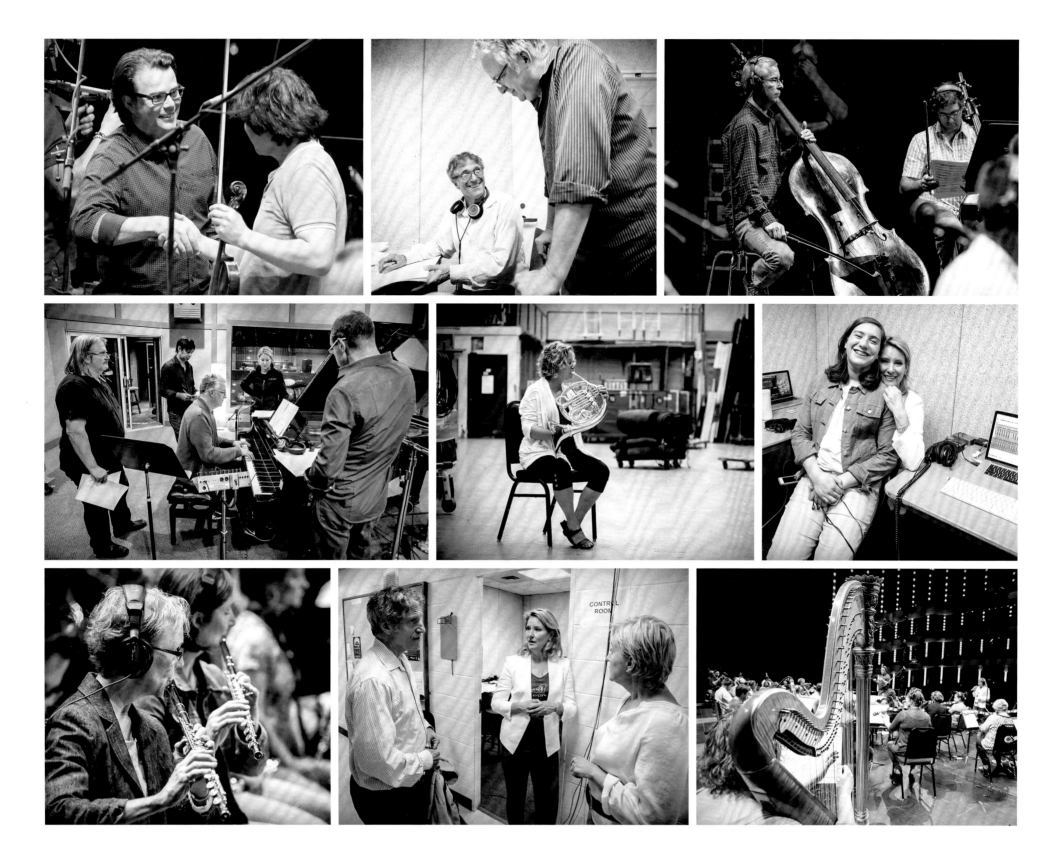

Fred Lavery and Gordie Sampson on
Get Me Through December

FRED: It started out as a poem. I had written a couple of verses, but Gordie was producing a record for Natalie MacMaster and was looking for songs. He liked what I'd written and we decided to work on it. Once we had a rough draft, he had the idea to base the music on a traditional Scottish fiddle tune.

GORDIE: It was "Niel Gow's Lament For The Death Of His Second Wife." There was something about it that made it seem right. We did a demo of the song with Cookie Rankin, which is floating around somewhere. It's all about the long winter—a real winter for me, especially in remote areas. Being from Cape Breton Island, I know that winters can be fierce and lonely.

FRED: At first I thought it might be too dark and introverted for people to relate to as a song, but I was wrong. We all go through dark times—the death of loved ones, the breakup of relationships.

GORDIE: The chorus doesn't have anything to do with Niel Gow's traditional tune. I was finishing up taping TV shows with Rita MacNeil in Toronto. After a long day on the set, one of the tired cast members said, "Oh, get me through December."

FRED: At that moment, we knew we had the title of the song and the chorus. It stuck.

Fred Lavery et Gordie Sampson parlent de
Get Me Through December

FRED : Au début, c'était un poème. Gordie, qui était en train de produire un disque pour Natalie MacMaster, cherchait des chansons. Je n'avais écrit que quelques vers, mais il les a aimés et nous avons décidé de travailler le texte ensemble. Quand nous avons eu une version préliminaire, il a eu l'idée d'y associer une musique inspirée d'un air de violon traditionnel écossais.

GORDIE : Cette chanson, c'était *Niel Gow's Lament For The Death Of His Second Wife*. Il y avait quelque chose dans cette complainte qui convenait parfaitement. Nous avons fait, avec Cookie Rankin, un démo qui doit exister encore quelque part. La chanson parle du long hiver, du vrai hiver selon moi, celui qu'on a dans les régions éloignées. À l'île du Cap-Breton, là d'où je viens, les hivers peuvent être violents et nous isoler.

FRED : Au début, je trouvais la chanson trop sombre et introspective pour que les gens s'y attachent, mais je me trompais. Nous traversons tous des périodes difficiles, la mort d'êtres chers, des ruptures amoureuses...

GORDIE : Le refrain n'a rien à voir avec la pièce musicale traditionnelle de Niel Gow. J'achevais l'enregistrement d'une série d'émissions de télévision avec Rita MacNeil, à Toronto. Après une longue et épuisante journée de studio, un des acteurs a lancé : « Oh, pourvu que je passe à travers le mois de décembre ! » (« *Oh, get me through December* »)

FRED : À ce moment-là, nous avons su que nous avions trouvé le titre de la chanson et le refrain. Nous n'avons pas changé d'idée.

I know it doesn't seem that way
But maybe it's the perfect day
Even though the bills are piling
And maybe Lady Luck ain't smiling

But if we'd only open our eyes
We'd see the blessings in disguise
That all the rain clouds are fountains
Though our troubles seem like mountains

And if we'd get up off our knees
Why then we'd see the forest for the trees
And we'd see the new sun rising
Over the hills on the horizon

There's gold in them hills
There's gold in them hills
So don't lose faith
Give the world a chance to say

Gold In Them Hills

RON SEXSMITH

There's gold in them hills
There's gold in them hills
So don't lose heart
Give the day a chance to start

Every now and then life says
"Where do you think you're going so fast"
We're apt to think it cruel but sometimes
It's a case of cruel to be kind

A word or two, my friend
There's no telling how the day might end
And we'll never know until we see
That there's gold in them hills

There's gold in them hills
So don't lose heart
Give the day a chance to start
There's gold in them hills
There's gold in them hills

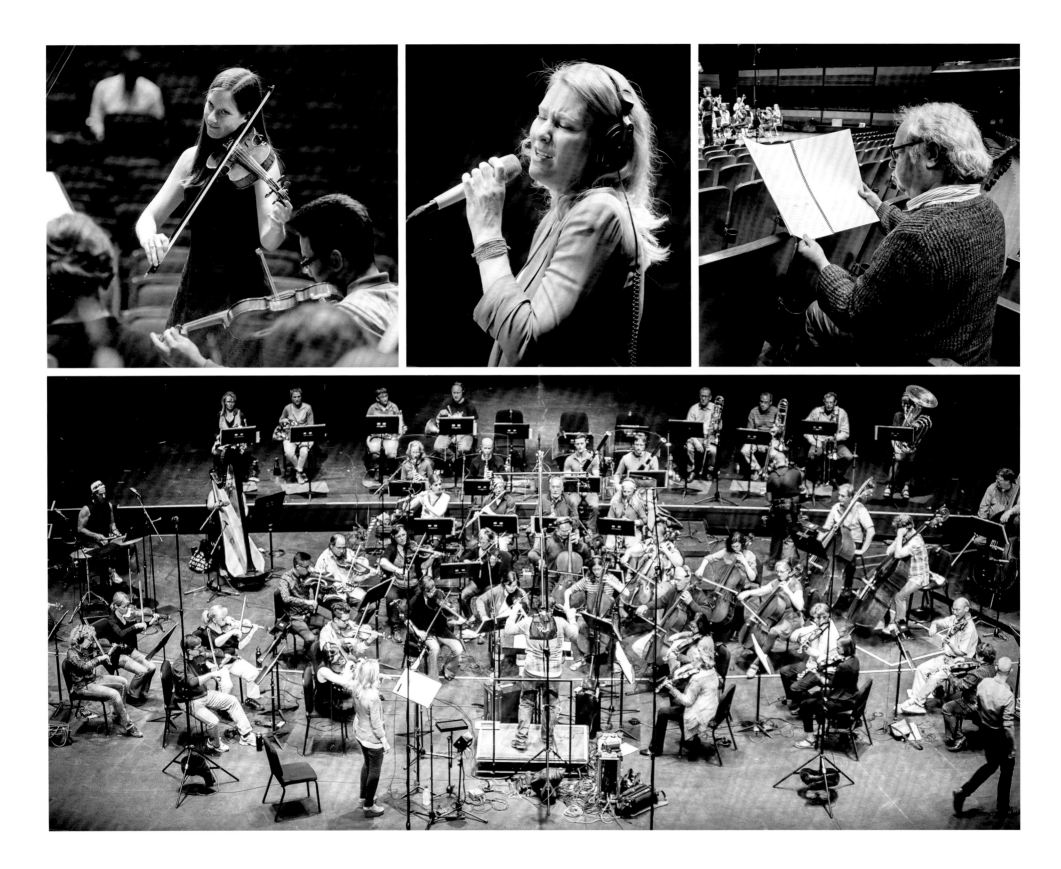

Ron Sexsmith on Gold In Them Hills

I was living with my accountant because everything in my life had fallen apart. All my possessions were crammed into one room. But then a cool thing happened: a friend asked if he could store his piano at the house because it had lots of space. I'd always wanted to play the piano; it had been my first love even though I never had one as a kid. Now there was one, and every day I'd come downstairs and pick out this riff, over and over again. The only words that seemed to go with it were "There's gold in them hills." I worked at it every day, thinking of performers I loved like Bing Crosby and songs like "Pennies From Heaven." It was an old-fashioned song, something to cheer myself up with.

It took six, maybe seven months to write, and even when I went to record it at the studio in London, England, I was still pulling my hair out over a missing bridge lyric. In the end I was so proud of having written a song on the piano.

A couple of years later, my drummer bought me a piano for my 40th birthday. Somehow they snuck it into the house while I was down the street at the laundromat. I don't know how they did it without me seeing, but it was the best thing anyone gave me—ever.

Ron Sexsmith parle de Gold In Them Hills

Tout s'écroulait dans ma vie, alors je m'étais installé chez mon comptable. Tout ce que je possédais était entassé dans une pièce. Mais une chose *cool* est arrivée : un ami m'a demandé d'entreposer son piano dans la maison, qui était très grande. J'avais toujours voulu jouer de cet instrument. C'était mon premier amour, mais je n'en avais pas, quand j'étais enfant. Maintenant, j'avais un piano à ma disposition. Tous les matins, je descendais et je reprenais un riff sans arrêt. Les seuls mots qui semblaient convenir étaient « There's gold in them hills » (« Il y a de l'or dans ces montagnes »). J'y travaillais chaque jour en pensant à Bing Crosby, aux autres interprètes que j'aimais et à mes chansons préférées, comme *Pennies From Heaven*. C'était une chanson à l'ancienne qui me mettait de bonne humeur.

J'ai dû mettre six ou sept mois à l'écrire. Même une fois arrivé au studio de Londres, je me cassais encore la tête pour trouver des paroles pour un pont. Au bout du compte, j'étais immensément fier d'avoir composé une chanson au piano.

Quelques années plus tard, mon batteur m'a offert un piano neuf pour mon quarantième anniversaire. Des complices et lui l'ont installé chez moi pendant que j'étais à la buanderie, plus loin dans la rue. Je ne sais toujours pas comment ils ont réussi ce coup à mon insu, mais c'est le plus beau cadeau que j'ai reçu de toute ma vie.

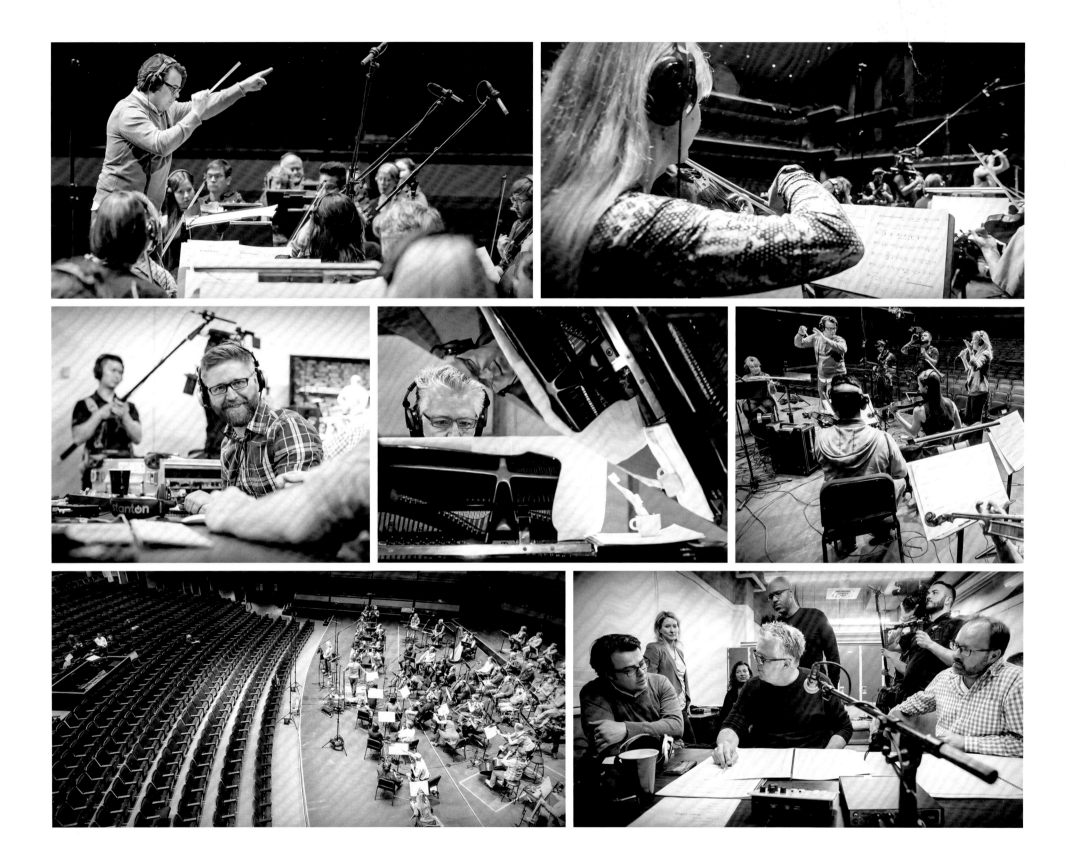

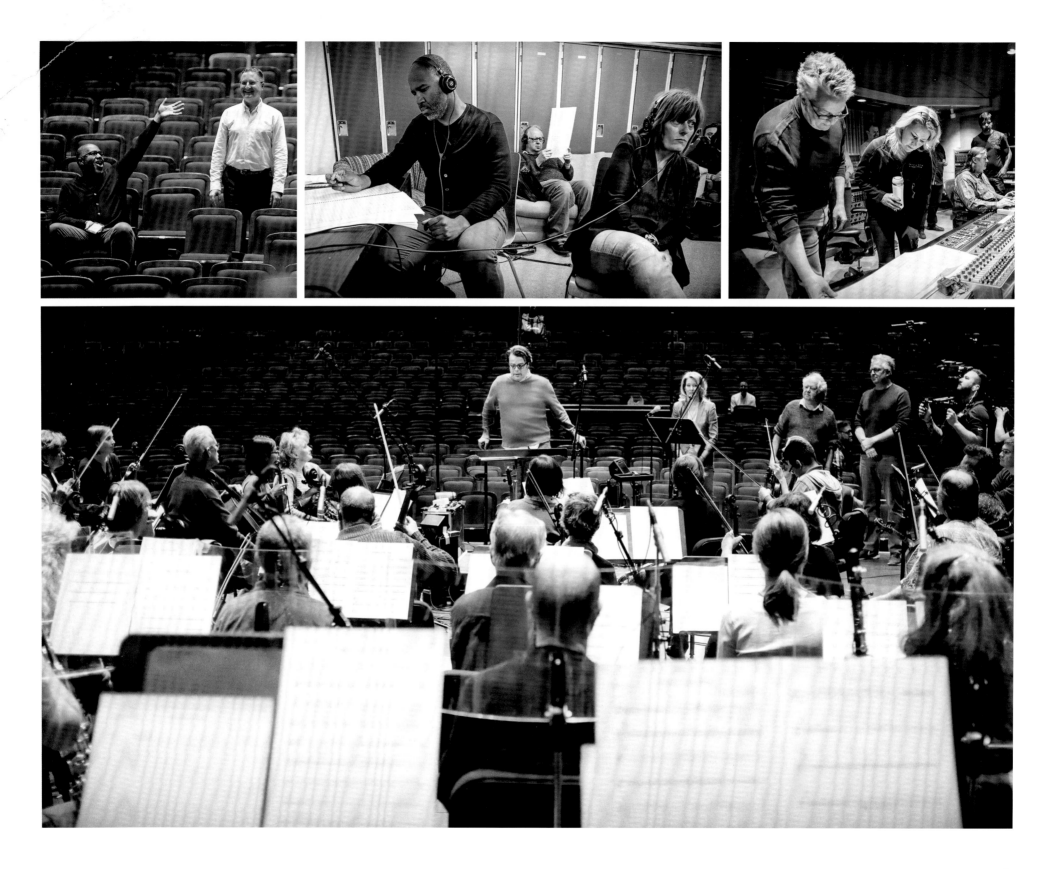

V. TONY HAUSER | Saint John River, Florenceville, New Brunswick

I've got money in my pocket
I like the colour of my hair
I've got a friend who loves me
Got a house, I've got a car
I've got a good mother
And her voice is what keeps me here

Feet on ground
Heart in hand
Facing forward
Be yourself
I've never wanted anything
No I've, no I've, I've never wanted anything
So bad, so bad

Feet on ground
Heart in hand
Facing forward
Be yourself
I've never wanted anything
No I've, no I've, I've never wanted anything
So bad, so bad

I've got money in my pocket
I like the colour of my hair
I've got a friend who loves me
Got a house, I've got a car
I've got a good mother
And her voice is what keeps me here

Good Mother

JANN ARDEN

ROBERT FOSTER

Cardboard masks of all the people I've been
Thrown out with all the rusted, tangled
Dented goddamned miseries
You could say I'm hard to hold
But if you knew me you'd know
I've got a good father
And his strength is what makes me cry

Feet on ground
Heart in hand
Facing forward
Be yourself

Heart in hand
Feet on ground
Facing forward
Be yourself
Just be yourself
Just be yourself

Feet on ground
Heart in hand
Feet on ground
Heart in hand

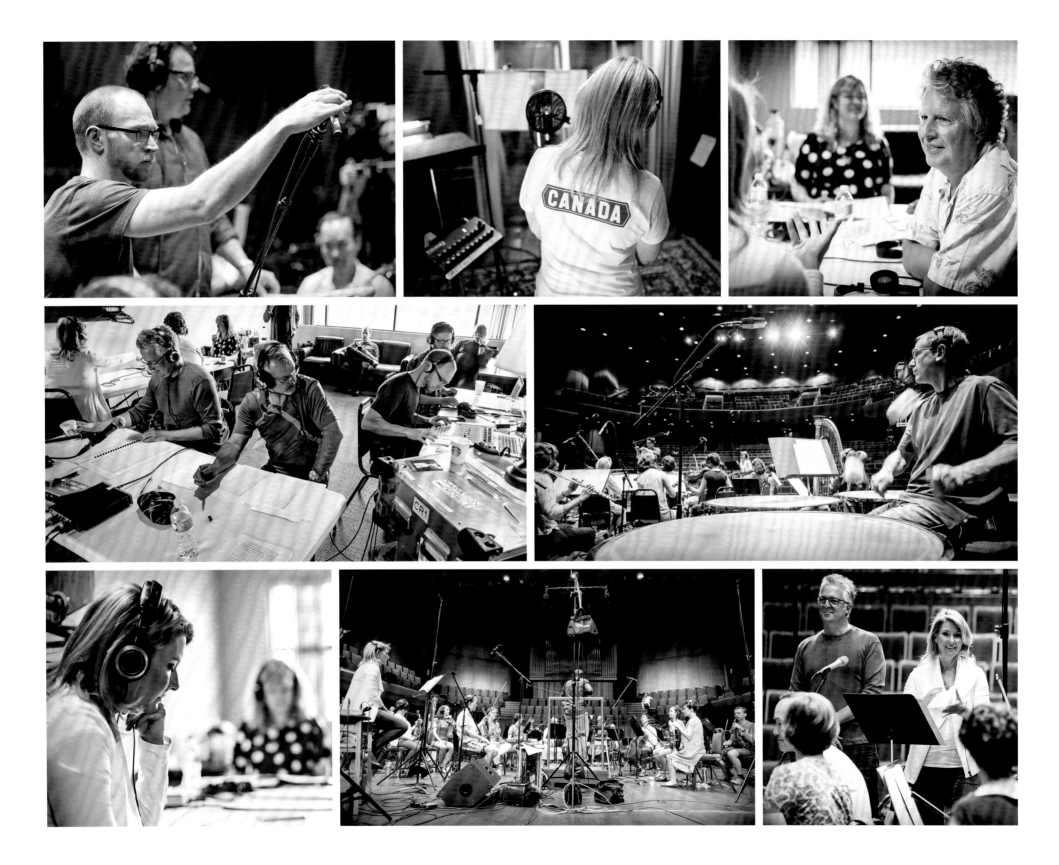

Jann Arden on Good Mother

I was sitting in my Monte Carlo with the white vinyl roof that got about one mile per gallon. It was idling in the parking lot of the Mount Royal Village mall in Calgary, behind my friend's hair salon. The smell of gasoline permeated everything. I had $20 in my pocket, I really liked the colour of my hair and I think I used an eyeliner pencil to write down on the back of a cigarette package what I was feeling at that moment.

Never in a million years did I dream the song would make it onto a record and that people would respond to it, making it their own. It's one of the only songs I do in concert where the audience sings along!

I learned a lesson from that. I learned that I don't have to paint poetic rainbows across the sky. I learned that I can be simple, straightforward and speak from the heart.

Jann Arden parle de Good Mother

J'étais assise dans ma Monte Carlo au toit de vinyle blanc qui consommait environ un gallon au mille. J'étais garée dans le terrain de stationnement du centre commercial Mount Royal Village à Calgary, derrière le salon de coiffure de mon amie. Le moteur tournait et l'odeur d'essence imprégnait tout. J'avais 20 $ dans les poches, j'aimais vraiment la couleur de mes cheveux et je pense que j'ai utilisé un crayon pour les yeux pour noter au dos d'un paquet de cigarettes ce que je ressentais à ce moment-là.

Jamais je n'aurais osé rêver que cette chanson puisse se retrouver sur un disque ni que les gens y réagiraient au point de se l'approprier. C'est l'une des seules que le public chante avec moi quand je l'interprète en concert !

J'en ai tiré une leçon. J'ai appris que je n'ai pas à dessiner des arcs-en-ciel poétiques dans le firmament. J'ai appris que je peux être simple, directe et parler du fond du cœur.

I've heard there was a secret chord
That David played and it pleased the Lord
But you don't really care for music, do ya
It goes like this
The fourth, the fifth
The minor fall, the major lift
The baffled king composing Hallelujah
Hallelujah, hallelujah, hallelujah, hallelujah

Maybe I have been here before
I know this room
I've walked this floor
I used to live alone before I knew ya
I've seen your flag on the marble arch
Love is not a vict'ry march
It's a cold and it's a broken Hallelujah
Hallelujah, hallelujah, hallelujah, hallelujah

Hallelujah

LEONARD COHEN

Your faith was strong but you needed proof
You saw her bathing on the roof
Her beauty and the moonlight overthrew ya
She tied you to a kitchen chair
She broke your throne
She cut your hair
And from your lips she drew the Hallelujah
Hallelujah, hallelujah, hallelujah, hallelujah

Maybe there's a God above
And all I ever learned from love
Was how to shoot at someone who outdrew ya
And it's not a cry you can hear at night
It's not somebody who's seen the light
It's a cold and it's a broken Hallelujah
Hallelujah, hallelujah, hallelujah, hallelujah

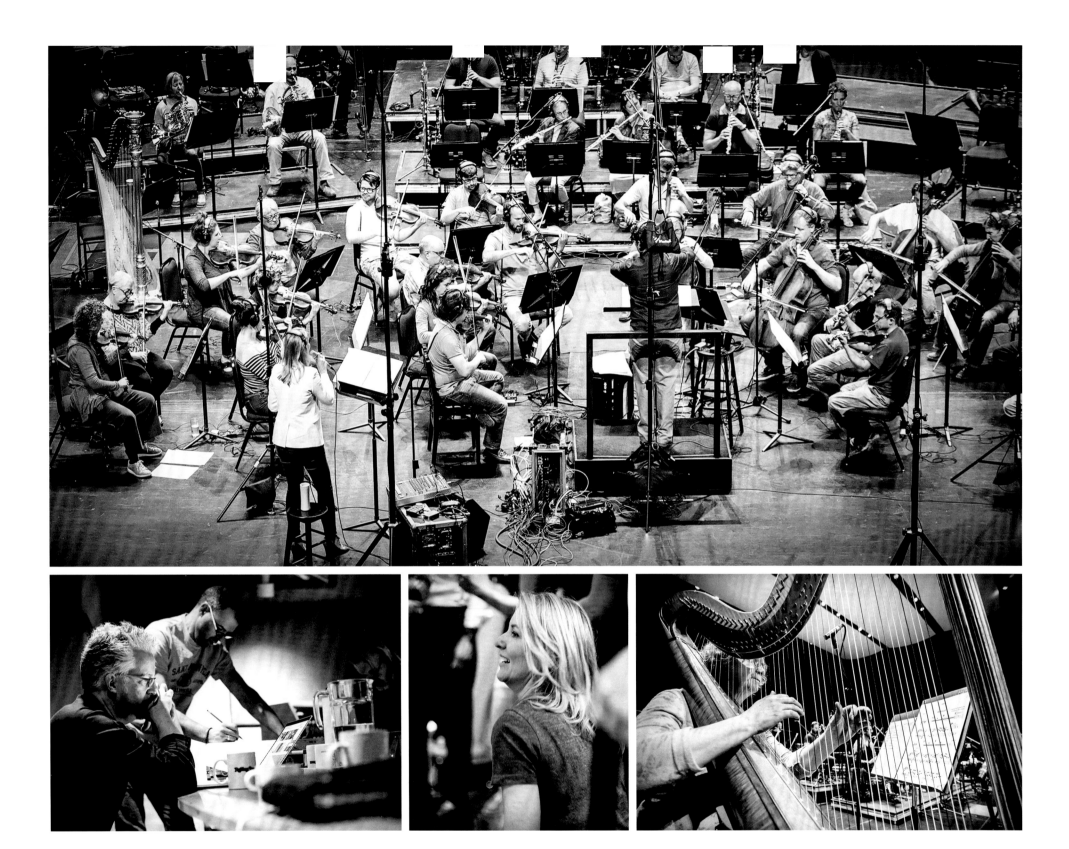

Eleanor McCain on Hallelujah

"Hallelujah" is one of the most beloved songs in the history of recording. Some even say it's perfect. Ironically, the song was at first rejected by Cohen's record company, and it took at least a decade before it was ever noticed by anyone. There are many gorgeous versions; for me, the definitive one is by the inimitable Canadian singer-songwriter k.d. lang.

When I was asked which Cohen song I was planning for the album, a few people said, "Well, of course you're doing 'Hallelujah.'" And then others said, "Oh, you're not doing 'Hallelujah,' are you?" It was a plea either to leave this sacred piece alone or to cover it for this collection of iconic Canadian songs. The song is so deeply personal, and for every listener or performer it means something different. It took Cohen five years to complete and 80 draft verses, which were reduced first to 15 verses and then to four for the original recording. The verses I chose are the ones that resonate most with me personally.

Cohen used to say the song underscores that many kinds of Hallelujahs exist, and that all the perfect and broken Hallelujahs have equal value. As he wrote in one verse: "The holy and the broken Hallelujah." Each verse and chorus reflects this. Each Hallelujah is a release of the emotion portrayed in the verse that precedes it. And each time it is said, it holds a different meaning.

Eleanor McCain parle de Hallelujah

Hallelujah est l'une des chansons les plus aimées de l'histoire du disque. Certains considèrent même qu'elle atteint la perfection. Ironiquement, la compagnie de disques de Cohen l'avait refusée à l'origine et il a fallu au moins dix ans avant qu'on la remarque. Il en existe beaucoup de belles réinterprétations, mais, à mon avis, la version de référence demeure celle, inimitable, de l'auteure-compositrice-interprète canadienne k.d. lang.

Lorsqu'on m'a demandé laquelle des chansons de Cohen je souhaitais enregistrer pour cette compilation d'œuvres canadiennes emblématiques, certains m'ont encouragée à proposer ma version de *Hallelujah*, alors que d'autres m'imploraient de ne pas toucher à cette pièce sacrée. Cette chanson est tellement intime que chaque personne qui l'écoute ou l'interprète y trouve un sens différent. Cohen a mis cinq ans à l'achever et sa version originale comportait quatre-vingts couplets, qui sont passés à quinze, puis à quatre pour la version qu'il a enregistrée. J'ai choisi ceux qui m'interpellent le plus.

Cohen a expliqué que sa chanson montre qu'il existe des alléluias de toutes sortes, et que les alléluias « parfaits » et « brisés » sont d'égale valeur, comme il l'a chanté dans un couplet : « L'alléluia saint et l'alléluia brisé » (« *The holy and the broken Hallelujah* »). Tous les couplets et tous les refrains en témoignent. Chaque alléluia exprime l'émotion décrite dans le couplet précédent. Et chaque fois qu'il est chanté, il a un sens différent.

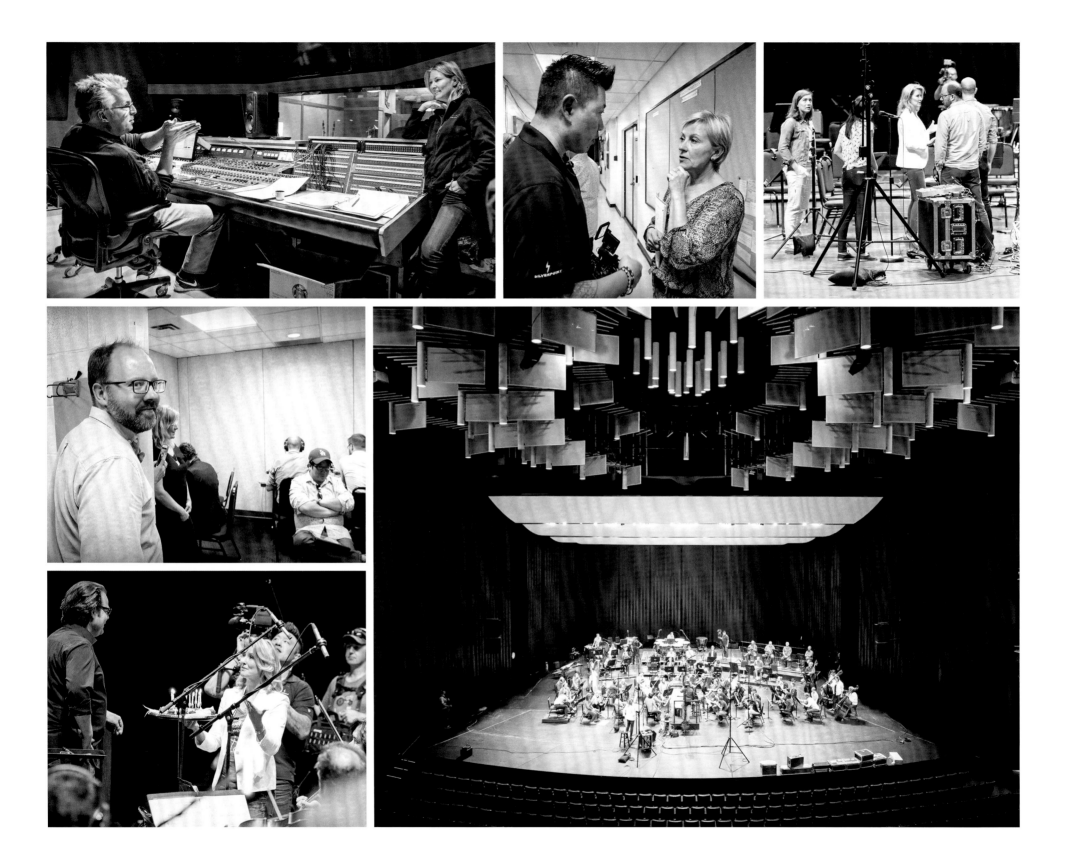

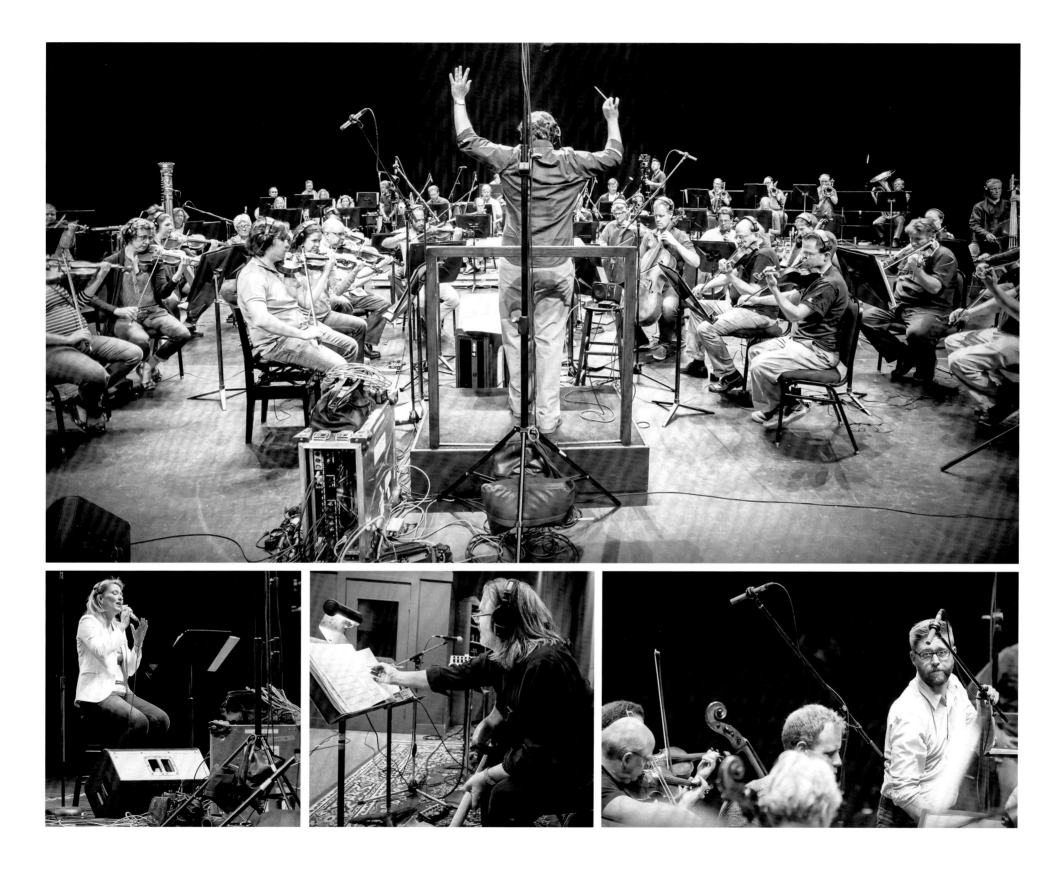

And it's only love, and it's only love
That can wreck a human being and turn him inside out
That can wreck a human being and turn him inside out

When harm is done no love can be won
I know this happens frequently
What I can't understand
Oh please God hold my hand
Is why it should have happened to me

Some say a heart is just like a wheel
When you bend it, you can't mend it
And my love for you is like a sinking ship
And my heart is like that ship out in mid ocean

Heart Like A Wheel

ANNA McGARRIGLE

They say that death is a tragedy
It comes once and it's over
But my only wish is for that deep dark abyss
'Cause what's the use of living with no true lover

And it's only love and it's only love
And it's only love and it's only love
Only love, only love
Only love, only love

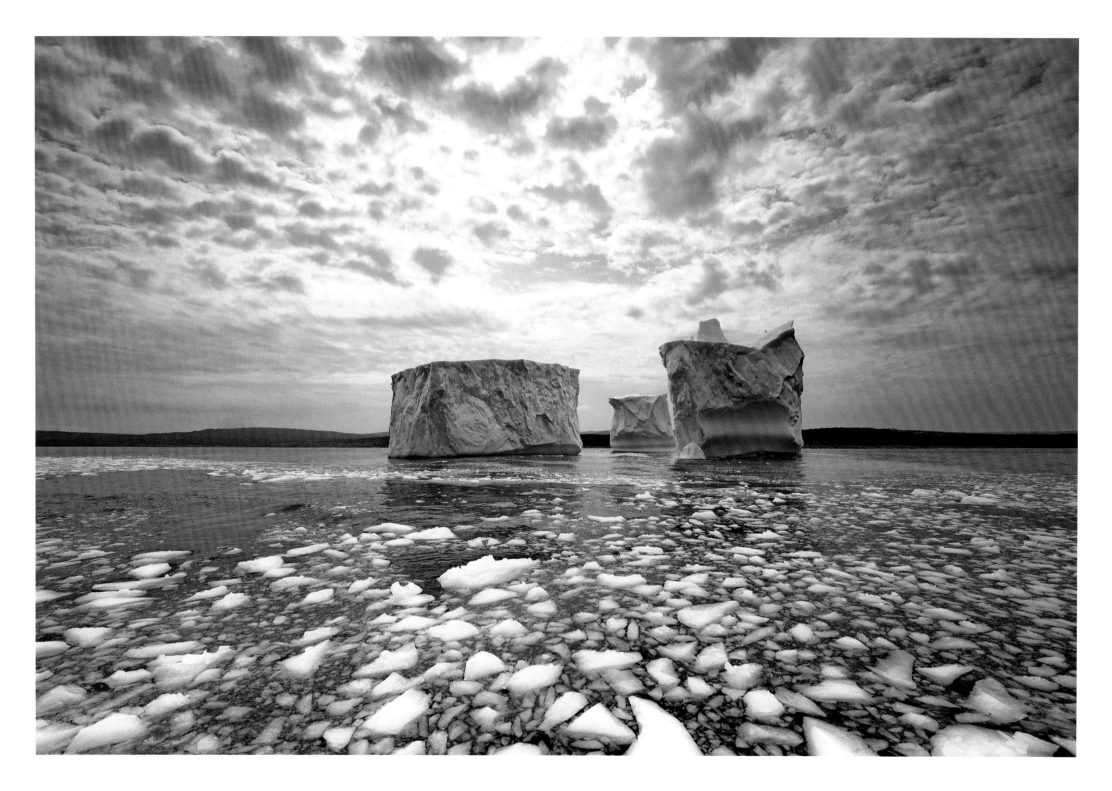

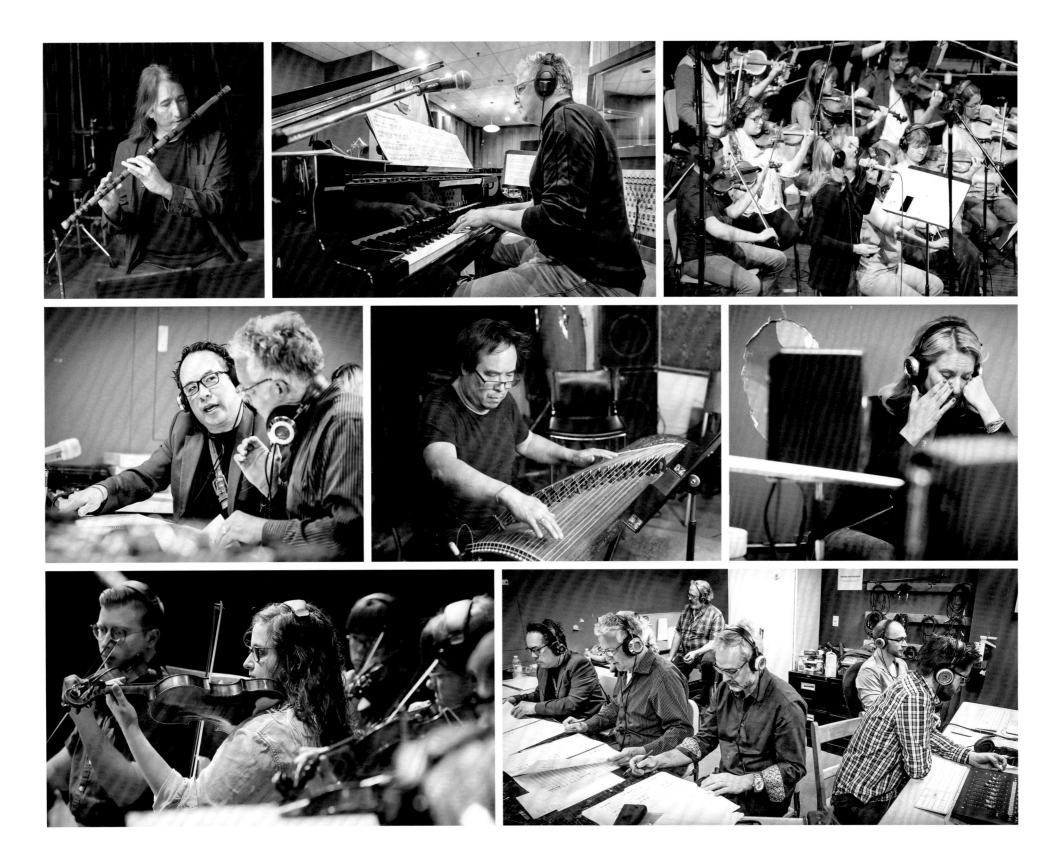

Anna McGarrigle on Heart Like A Wheel

The song is about the lasting effects of heartbreak on the human frame. When I wrote it in 1969, I wasn't paying attention to poetic style or songwriting conventions. I just needed to get some truths out. Poetry is about truths, or so I'm told.

I mixed metaphors, but they work: a heart like a wheel, now bent, is steering the sinking ship that is love, steering the whole sorry mess into the deep, dark abyss. One critic described it as artless, and I think it is.

After hearing me play the song on our family's 1880 Steinway upright, my sister, Kate, and her friend, Roma Baran, arranged it for piano and cello, with Kate singing lead. They took it on the road, performing in small clubs in the New York City area. Eventually they cut a haunting demo, and it took on a life of its own, swapped around the folk scene as if it were a popular groupie. The best-known version is by Linda Ronstadt, who released it in 1974. Sometimes a verse is dropped or a chord or word is changed, but it doesn't really change the song.

Neither folk nor pop, I like to imagine it now as some medieval madrigal sung long ago by a wandering minstrel in a velvet hood. There is something curative about someone taking your pain away and playing it for strangers.

Anna McGarrigle parle de Heart Like A Wheel

Cette chanson parle des effets lancinants d'une peine d'amour sur l'être humain. Quand je l'ai composée, en 1969, je n'accordais pas d'importance au style poétique ni aux conventions d'écriture propres à la chanson. J'éprouvais simplement le besoin de dire certaines choses telles qu'elles étaient. La poésie parle de vérité, du moins c'est ce qu'on m'a dit.

J'ai mêlé les métaphores, mais elles fonctionnent : un cœur, comme une roue faussée, dirige un bateau en train de couler, qui est l'amour, et entraîne tout ce gâchis dans les abysses sombres et profondes. Un critique a dit que c'était une chanson un peu ingénue, et je crois que c'est bien le cas.

Après m'avoir entendue la jouer sur notre vieux piano droit Steinway 1880, ma sœur Kate et son amie Roma Baran en ont fait un arrangement pour piano, violoncelle et voix (c'est Kate qui chantait). Elles l'ont interprétée en tournée, dans de petits clubs de la région de New York. Elles en ont fait une maquette envoûtante et la chanson a eu une existence à part entière sur toutes les scènes folk, comme si elle était une groupie populaire. La version la plus connue est celle enregistrée par Linda Ronstadt en 1974. Parfois, un interprète laisse tomber un couplet ou change un accord ou un mot, mais ça ne transforme pas vraiment la chanson.

Elle n'est ni folk ni pop. Maintenant, je me plais à l'imaginer comme un madrigal du Moyen-Âge, chanté il y a des siècles par un ménestrel itinérant portant un bonnet en velours. Il y a quelque chose de réparateur quand quelqu'un nous décharge de notre douleur pour la jouer devant des étrangers.

There is a town in north Ontario
With dream comfort memory to spare
And in my mind I still need a place to go
All my changes were there

Baby, can you hear me now?
The chains are locked and tied across the door
Baby, sing with me somehow

Helpless

NEIL YOUNG

Blue, blue windows behind the stars
Yellow moon on the rise
Big birds flying across the sky
Throwing shadows on our eyes
Leave us

Helpless, helpless, helpless

Blue, blue windows behind the stars
Yellow moon on the rise
Big birds flying across the sky
Throwing shadows on our eyes
Leave us

Helpless, helpless, helpless
Helpless, helpless, helpless

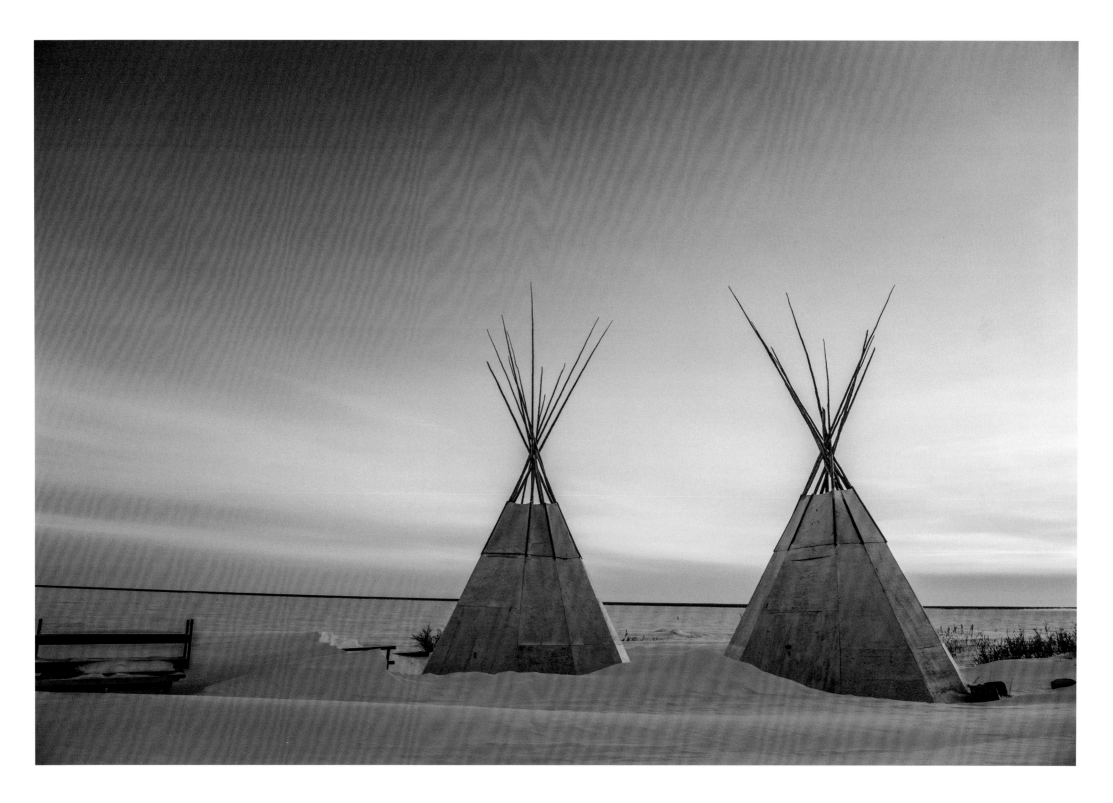

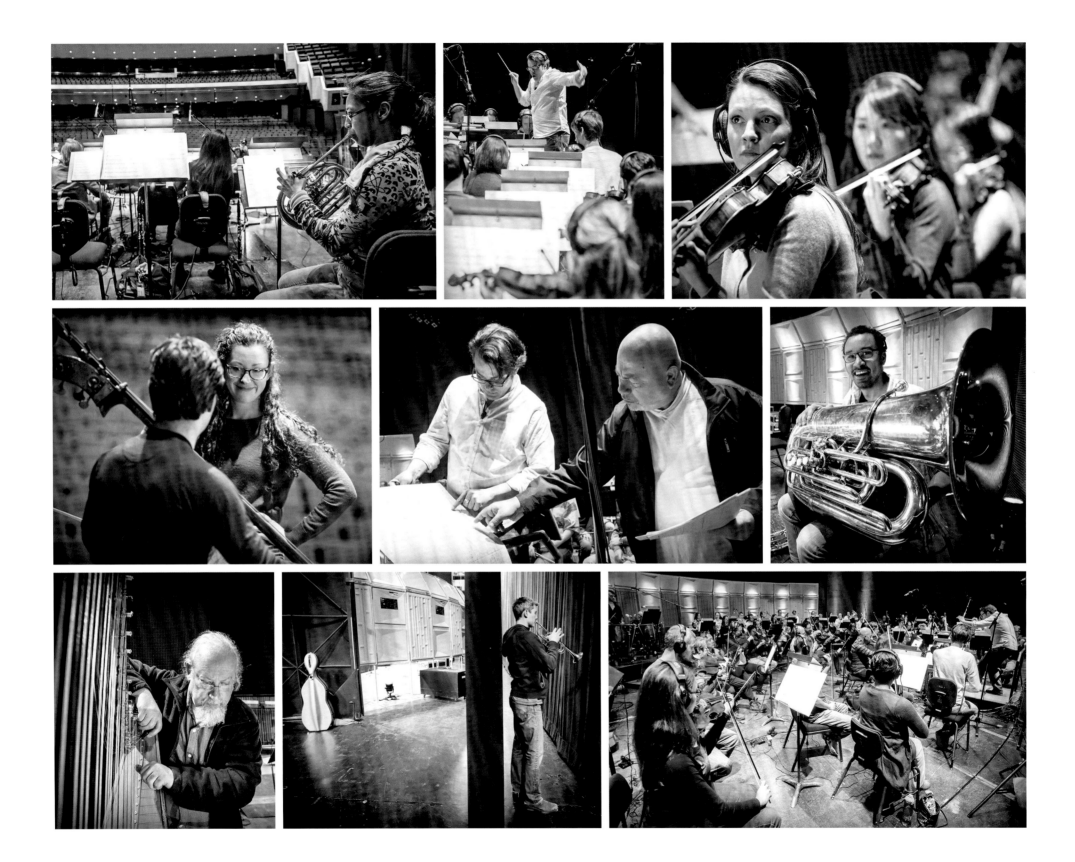

Peter Cardinali on Helpless

"Helpless" is such a great yet simple song, only three chords, with a lot of sameness in the verses and chorus. But it's deceptive, for simple songs can be the most difficult for an arranger. You really need to distinguish the verses and the chorus—not make them different exactly, but create and build emotion from start to finish. I think of it as creating an emotional roller coaster. That may sound dramatic, but the song starts off very simply, just starting the voyage, then the first verse builds up to the first chorus, which has an even bigger lift. And you continue that pattern—building it up and bringing it back down via orchestration, movement and dynamics, not quite to where you were at the beginning but to a point where listeners can feel they've been on an emotional ride.

Working with Eleanor and Don [Breithaupt] was wonderful. They didn't really ask me for anything in particular, other than to create an original treatment of the song. Arranging it for orchestra gave me a palette of colours to bring "Helpless" to life with some serious added dimensions.

The opening musical lines make a strong statement; Neil had the hook right off the top. I'm proud of how the orchestra and vocals are integrated here, not just as a sweetener but in a way that complements Eleanor's vocal throughout. In the past, I got to hang out with Neil a bit. If he was sitting across from me right now and listening to the arrangement, I think he'd say, "Right on."

Peter Cardinali parle de Helpless

De prime abord, avec ses trois accords et le grand nombre de ressemblances dans les couplets et le refrain, *Helpless* est d'une simplicité désarmante, mais trompeuse. En effet, les chansons simples s'avèrent parfois les plus difficiles pour un arrangeur. Il faut vraiment rendre distincts les couplets et le refrain : il ne s'agit pas de les différencier, mais de faire naître et croître l'émotion, comme des montagnes russes selon moi. Cela peut sembler exagéré, mais la chanson commence très simplement. On part en voyage, puis le premier couplet s'intensifie jusqu'au premier refrain qui est lui-même intense. Et ce motif se poursuit : on monte puis on redescend, pas exactement où on se trouvait au début, mais jusqu'au moment où les auditeurs sentent qu'ils ont fait un voyage émotif.

Ma collaboration avec Eleanor et Don [Breithaupt] a été une expérience merveilleuse. Ils ne m'ont pas demandé de faire quoi que ce soit de particulier, rien d'autre que de donner à la chanson un traitement différent de l'original sans empêcher la création d'une grande œuvre. En travaillant avec un orchestre, j'ai eu accès à une palette de couleurs qui m'a permis de faire renaître *Helpless* en y ajoutant des dimensions marquantes.

Les phrases musicales du début s'imposent fortement dès le départ : Neil nous accroche tout de suite. Je suis fier de la façon dont les paroles et la mélodie s'intègrent, pas seulement pour adoucir la partie vocale, mais aussi pour la compléter. J'ai déjà côtoyé Neil dans le passé. S'il était assis face à moi, en train d'écouter mes arrangements, je pense qu'il dirait : « C'est en plein ça. »

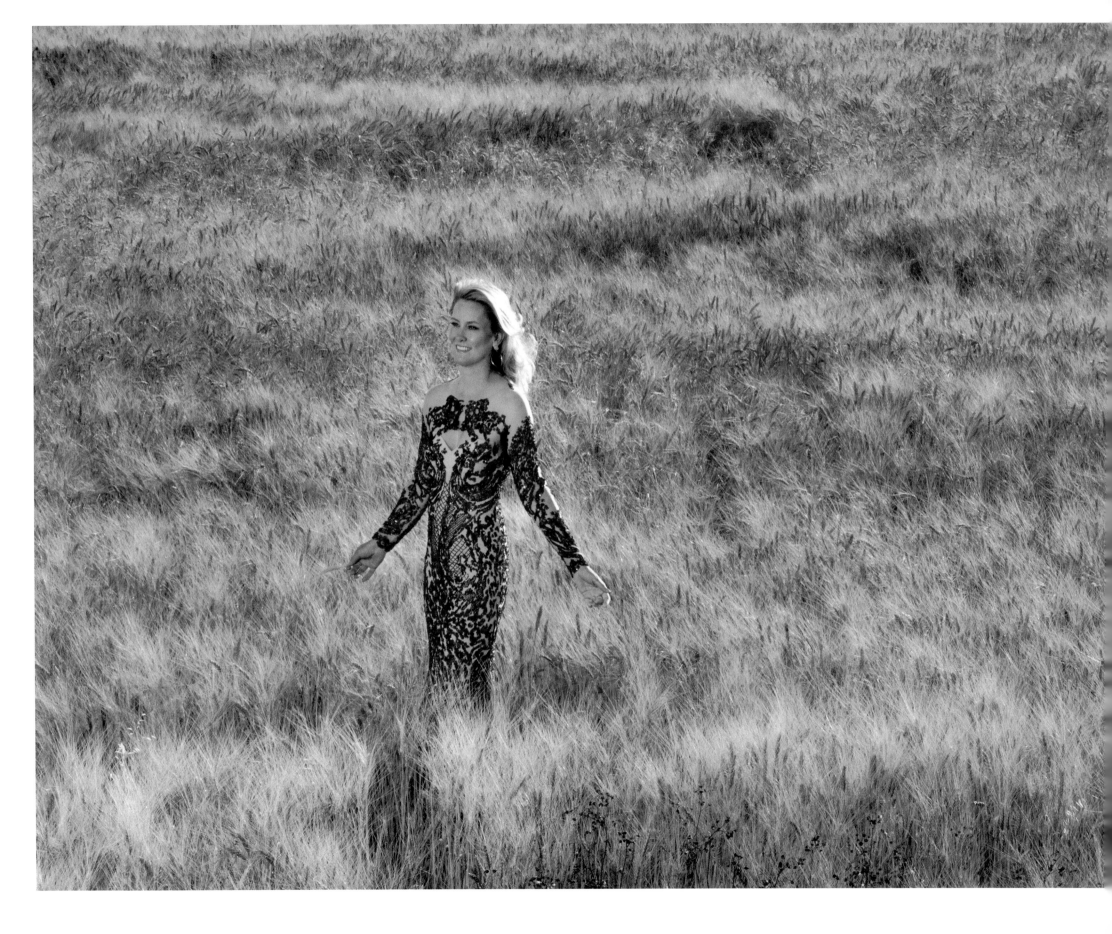

Take me back to sleep
Drop me anywhere
Woods are dark and deep
But I'll find you there
I'll close my eyes
And you'll reappear
It's been a hard day
Yeah, it's been a hard year
But I can see hope from here

DON BREITHAUPT
JEFF BREITHAUPT

Dreaming and stars might
Bring light from the past
But here it is midnight
A new day at last

I Can See Hope From Here

Wish we'd had the chance
At just a few more days
Life's a lovely dance
While the music plays
It spins you 'round
Then it pulls you near
It promises more
But the floor is soon clear
Still I can see hope from here

Night can give and take
Brings you back and then
Every time I wake
You are gone again
So no more sleep
Let the dawn appear
It's been a long night
Yeah, it's been a long year
But I can see hope from here

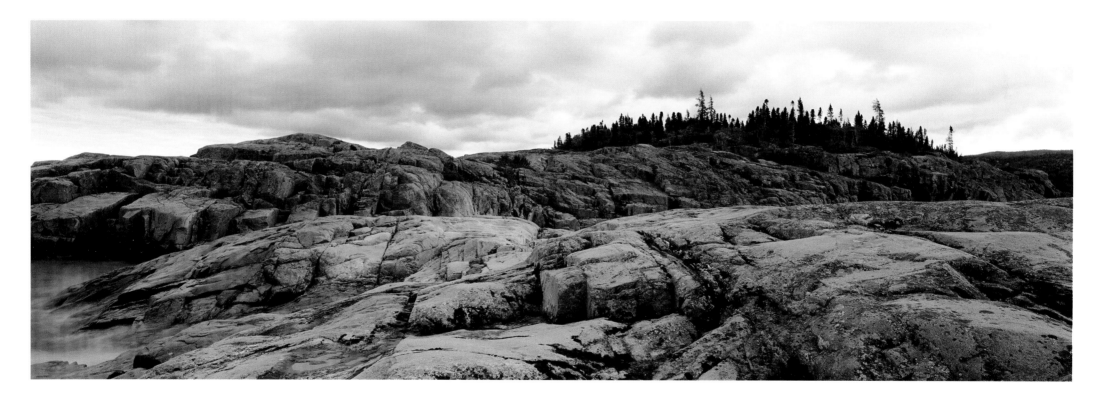

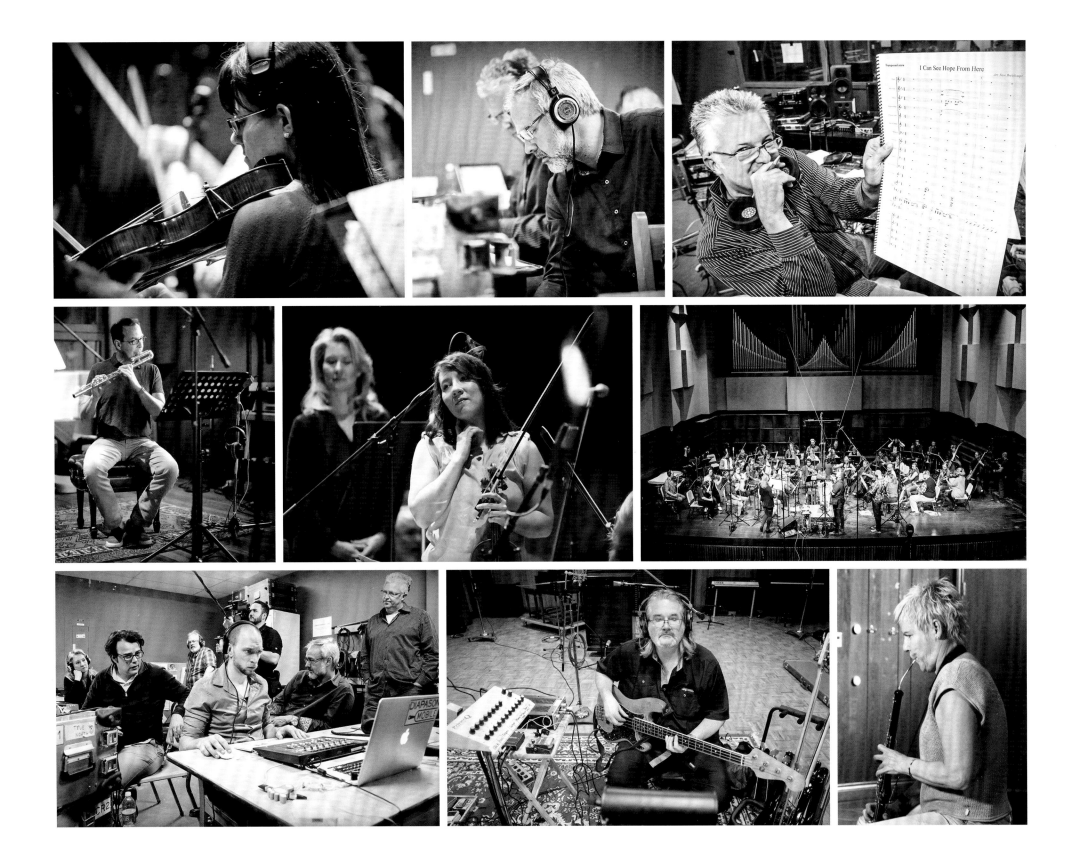

Don Breithaupt and Jeff Breithaupt
on I Can See Hope From Here

DON: We grew up cottaging on southern Georgian Bay, and one way or another we still get up there every summer. In 2014 I rented a place, and Ross, the third of the Breithaupt brothers, was sitting on the dock admiring the view. He could see Giants Tomb Island, a little bit of Christian Island and then, referring to a little uninhabited island in the distance, he said, "I can see Hope from here." I said, "That's a great song title! I'm writing it down." And it stayed in our potential song file until Eleanor commissioned us to write something original for the album. It was perfect for a Canada-themed project, with a title that reflects Ontario geography. Jeff and I wrote it the way we always do, as a traditional music-and-lyrics team, like Rodgers and Hart or the Gershwins.

JEFF: Unlike most of our collaborations, which start with either fully realized melody or lyrics, this song grew piece by piece: a bit of music, then lyric, then music, then more lyric. It's a song about living through a dark night of the soul and coming into the dawn—the light. The singer yearns to sleep because she wants to go back into a dream to see the person she has lost, but by the last verse she's able to say, "It's been a long night, it's been a long year, but I can see hope from here."

DON: There's an image in the first line of the bridge, of dreams and stars bringing light from the past. As an astronomy nerd, I love that one.

Don Breithaupt et Jeff Breithaupt
parlent de I Can See Hope From Here

DON : Quand nous étions enfants, nous passions l'été dans le sud de la baie Georgienne et, encore aujourd'hui, nous y séjournons chaque année. En 2014, mon frère Ross, le troisième de la famille, est venu me rendre visite au chalet que j'avais loué. Il s'est assis sur le quai pour admirer la vue. Il apercevait l'île Giants Tomb et une partie de l'île Christian. Puis, en désignant l'île Hope, un îlot inhabité au loin, il a dit : « Je peux voir Hope (l'espoir) d'ici. » (*I can see Hope from here.*)

J'ai immédiatement pensé que ce serait un super titre pour une chanson et je l'ai noté. Lorsque Eleanor nous a demandé d'écrire une œuvre originale pour l'album, j'ai trouvé que ce titre, qui évoque la géographie de l'Ontario, convenait parfaitement à un projet sur le thème du Canada. Jeff et moi avons procédé comme nous le faisons toujours : nous avons travaillé comme un duo conventionnel d'auteur et de compositeur, tels Rodgers et Hart ou encore les frères Gershwin.

JEFF : Contrairement à la plupart des œuvres que nous avons composées ensemble et que nous avons bâties, à partir d'une mélodie ou d'un texte achevés, cette chanson a évolué par fragments : un peu de musique, quelques mots, puis une mélodie et d'autres paroles. Cette chanson traite d'une âme qui aperçoit l'aube, la lumière, après avoir traversé l'obscurité de la nuit. La chanteuse souhaite se rendormir pour revoir en rêve la personne qu'elle a perdue, mais à la toute fin elle parvient à dire : « Ce fut une longue nuit et une longue année, mais je peux voir l'espoir d'ici. » (*It's been a long night, a long year, but I can see hope from here.*)

DON : Il y a une image dans le premier vers du pont : on y parle des rêves et des étoiles qui transportent la lumière du passé. Moi qui suis maniaque d'astronomie, j'adore cette image.

How will you know
Where you should go
Anywhere you want to, love is fast or love is slow
Falling through feelings, and falling through time
You won't know me to see me
But I'll come to you in rhyme

For I will play a rhapsody
Cleverly disguise it
So it's not been heard before
And I will sing a lullaby
Let you know I'm near you
Through the night to keep you warm

What will you see
What will you be
Anything you want to, love is easy
How will you know if I am for you
You won't know me to see me
But you'll know by what I do

BURTON CUMMINGS

I Will Play A Rhapsody

For I will play a rhapsody
Cleverly disguise it
So it's not been heard before
And I will sing a lullaby
Let you know I'm near you
Through the night to keep you warm

I will play a rhapsody
Cleverly disguise it
So it's not been heard before
And I will sing a lullaby
Let you know I'm near you
Through the night to keep you warm

I'll let you know I'm near you
Through the night to keep you warm
I will play a rhapsody

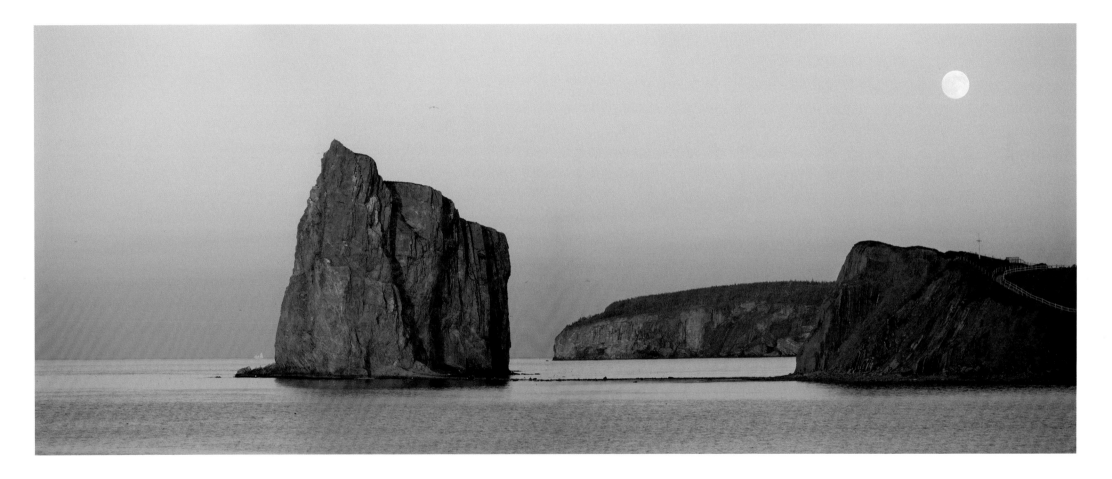

Eleanor McCain and Darren Fung
on I Will Play A Rhapsody

ELEANOR: When we workshopped this song, Don [Breithaupt] and I thought of playing off the title and incorporating a "rhapsody" into the arrangement. When pianist Jan Lisiecki agreed to participate, we asked Darren to work around that idea. At first we thought of using an existing classical rhapsody in the first few bars of the song. But in the end Darren created his own beautiful rhapsody for Jan and for the entire song. It's stunning.

DARREN: The first challenge for me, as arranger, was to do something new—to sound distinct from somebody just doing a cover—while remaining faithful to the song. If you listen to the original song, you'll hear something a little faster. I made it into more of a ballad, taking back the tempo a bit to give Jan the space to perform. Without taking the focus away from Eleanor, I wanted to create something that would showcase his extraordinary talent. It was wonderful being in Ottawa with the National Arts Centre Orchestra to see it recorded. I love the chorus, especially the first two lines: "For I will play a rhapsody/Cleverly disguise it, so it's not been heard before." Those lines really sum up what I tried to do—disguise it and turn it into a song for Eleanor.

Eleanor McCain et Darren Fung
parlent de I Will Play A Rhapsody

ELEANOR : En travaillant la chanson, Don [Breithaupt] et moi avons eu l'idée de prendre le titre au pied de la lettre et d'inclure une rhapsodie dans les arrangements. Le pianiste Jan Lisiecki a accepté de participer au projet et nous avons demandé à Darren d'exploiter cette idée. Au début, nous pensions intégrer une rhapsodie classique dans les premières mesures, mais Darren a finalement composé sa propre rhapsodie pour toute la chanson. Et c'est magnifique.

DARREN : Mon premier défi, comme arrangeur, a été de faire quelque chose de neuf, de créer un son différent de celui d'un chanteur qui se contente d'interpréter une chanson en restant fidèle à l'original. La version de Burton Cummings est un peu plus rapide. Je l'ai transformée en ballade, en retenant légèrement le tempo pour donner à Jan l'espace nécessaire à son interprétation. J'ai voulu mettre en valeur son talent exceptionnel, sans toutefois détourner les projecteurs d'Eleanor. C'était merveilleux de faire l'enregistrement à Ottawa avec l'Orchestre du Centre national des Arts. J'adore le refrain, particulièrement les deux premiers vers : « For I will play a rhapsody/Cleverly disguise it, so it's not been heard before. » (« Je vais jouer une rhapsodie/Et je vais la déguiser habilement, pour qu'on ne l'ait jamais entendue. ») Ces vers résument exactement ce que j'ai tenté de faire : transformer la chanson pour en faire celle d'Eleanor.

You and I
Have followed the trace
Laid by the people of faith and pride
With hungry eyes

You and I
Could conquer the stars
If we tried
Or simply live by simpler vows
And let the storm go by

You and I
Have written the book
Line by line
And the few things it took to survive
Was your loving heart and mine

DAVID FOSTER
ROCH VOISINE

You and I
Will follow the trace
Laid by people of faith and pride
With angry eyes gone blind

You and I
Will show them the light
We live by
So never again will they try
To keep us apart

I'll always be there
There when the world and its promise is failing
I'll always be there
There when the frost of its winter is cursing
I'll always be there
There when the tears in your eyes
Keep on asking me why

I'll Always Be There

Should you go
Remember these words
As they show
Just how much I care
Don't you know
I'll always be there

I'll always be there
There when the world and its promise is failing
I'll always be there
There when the frost of its winter is cursing
I'll always be there
There when the tears in your eyes
Keep on asking me
I'll always be there

I'll always be there
There when the world and its promise is failing
I'll always be there
There when the tears in your eyes
Keep on asking me why
Asking me why

I'll always be there
There when the frost of its winter is cursing
I'll always be there
There when your loving is such
You keep burning alive

I'll always be there
I'll always be there
I'll always be there
I'll always be there

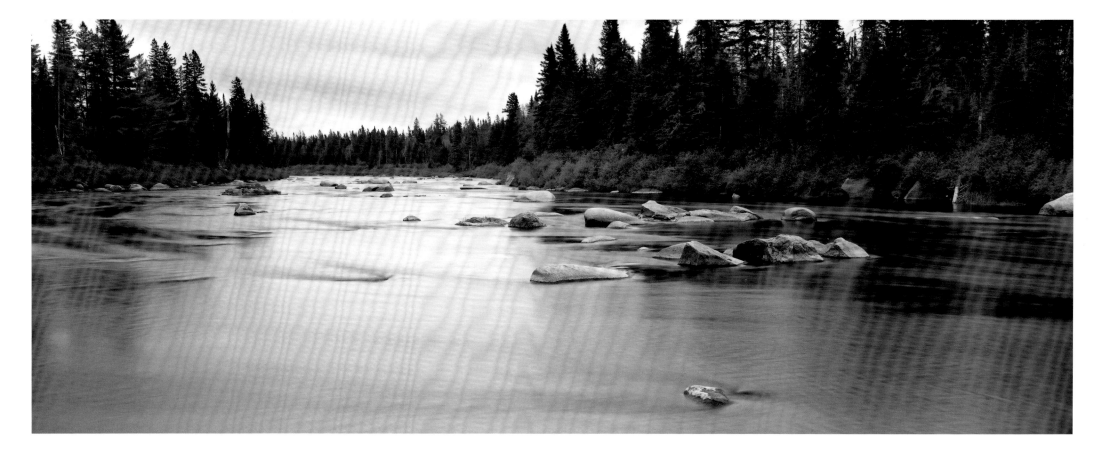

David Foster on I'll Always Be There

When you get together with someone new to write a song,
it can be like a blind date, and then suddenly you're married.
It's the weirdest thing—let's get these words and notes down,
let's get raw and try to write together. Some people just sit
there and give nothing, but Roch was all "Let's try this" and
"Let's try that," always giving and generous with his talent.
He came to my studio in Los Angeles and I really loved
his voice. The melodies just kind of poured out of him. He
was playing guitar, I was playing piano and the song didn't
take long to write.

The great stuff does come fast, *through* you rather than
from you. I don't mean that in a secret, heebie-jeebies kind
of way. But sometimes you go out there in the universe and
you tap into it. This was one of those times. It was my job
to take all that raw material and turn it into something that
would be loved by the masses. And it was fantastic that it
was first performed for Canada's 125th during the celebra-
tions on Parliament Hill. I think there were 100,000
people on the lawn that day. It was spectacular.

David Foster parle de I'll Always Be There

La première rencontre avec un collaborateur pour composer
une chanson ressemble à un rendez-vous amoureux arrangé,
immédiatement suivi d'un mariage. C'est la chose la plus
étrange. Écrivons ces paroles et cette mélodie, allons droit à
l'essentiel et essayons d'écrire ensemble. Certains ne font rien
et ne donnent rien, mais pas Roch. Il voulait constamment
essayer de nouvelles choses. Il était toujours généreux de son
talent. Quand il est venu à mon studio, à Los Angeles, j'ai tout
de suite aimé sa voix. En plus, les mélodies lui venaient tout
naturellement. Il jouait de la guitare pendant que j'étais au
piano et nous avons composé la chanson en un rien de temps.

Le bon matériel arrive rapidement à *travers* nous, plutôt
que de nous. Je ne révèle pas de secret et je ne délire pas,
mais parfois on s'ouvre à l'univers et on exploite ce qu'il nous
offre. C'est ce qui s'est passé lors de la création de cette
chanson. Mon travail a consisté à prendre toute cette matière
première et à la transformer en quelque chose qui plairait
aux masses. La chanson a été jouée pour la première fois
sur la colline du Parlement, à l'occasion des célébrations du
125e anniversaire du Canada, devant 100 000 personnes.
C'était extraordinaire. C'était spectaculaire.

I'd walk away like a movie star
Who gets burned in a three way script
Enter number two
A movie queen to play the scene
Of bringing all the good things out in me
But for now love let's be real
I never thought I could act this way
And I've got to say that I just don't get it
I don't know where we went wrong
But the feelin's gone
And I just can't get it back

If you could read my mind love
What a tale my thoughts could tell
Just like an old time movie
'Bout a ghost from a wishin' well
In a castle dark or a fortress strong
With chains upon my feet
You know that ghost is me
And I will never be set free
As long as I'm a ghost that you can't see

If You Could Read My Mind

GORDON LIGHTFOOT

If I could read your mind love
What a tale your thoughts could tell
Just like a paperback novel
The kind the drugstores sell
When you reach the part where the heartaches come
The hero would be me
But heroes often fail
And you won't read that book again
Because the ending's just too hard to take

If you could read my mind love
What a tale my thoughts could tell
Just like an old time movie
'Bout a ghost from a wishin' well
In a castle dark or a fortress strong
With chains upon my feet
But stories always end
And if you read between the lines
You'll know that I'm just tryin' to understand
The feelings that we lack
I never thought I could feel this way
And I've got to say that I just don't get it
I don't know where we went wrong
But the feelin's gone
And I just can't get it back

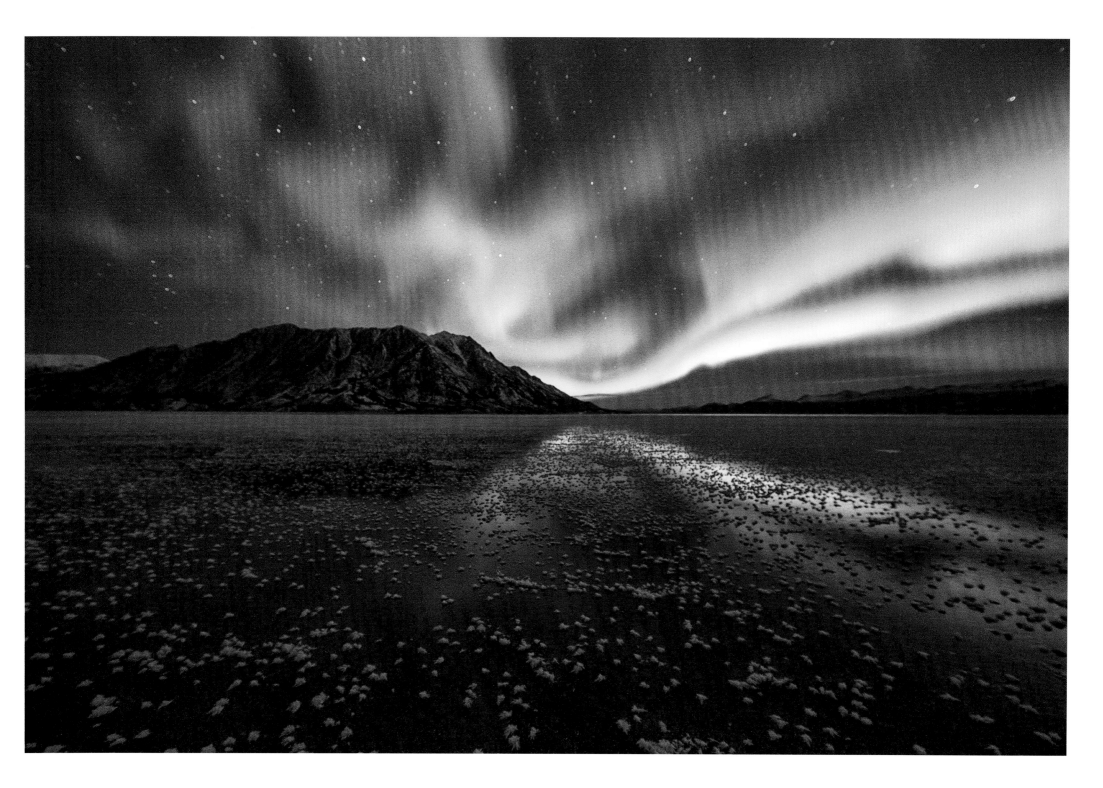

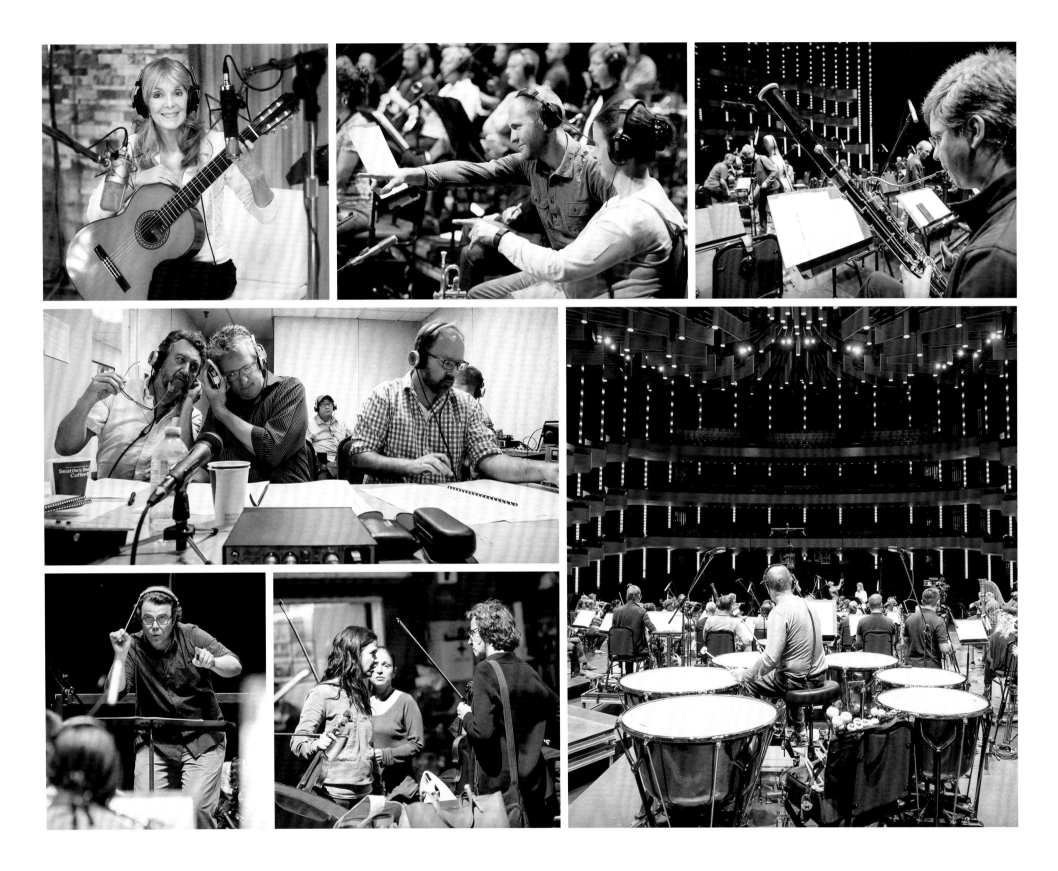

Martin MacDonald on If You Could Read My Mind

This song tells a raw and heavy story with such a beautiful and delicate melodic line. Gordon Lightfoot has said it was inspired by his divorce, thinking about it as he sat in his empty Toronto home one summer. At the same time, you can sort of throw into the lyrics and the music what's going on in your own life—your own thoughts and feelings and fears. It's at once a personal song and an iconic piece of Canadiana that you don't want to mess with very much.

The challenge for me as the conductor was finding a balance. We needed to make sure specific lines were pushed up front or pulled back. Lou Pomanti's arrangement does that perfectly; it never gets in the way of the lyrics. Then we wanted to create an "ocean" of sound behind the line, as if you're sitting by the sea with waves gently lapping onto the shore, not quite knowing they're there. This idea came about because the song doesn't have a bombastic or aggressive orchestra behind it. We could play with subtle nuances, and tweak them to complement both Eleanor's warm and generous voice and Liona Boyd's classical guitar work. Liona's performance enhances what we've done with the orchestration. We were so blessed to have her as a soloist on this song.

Martin MacDonald parle de If You Could Read My Mind

Cette chanson raconte une histoire crue et sombre, malgré sa belle ligne mélodique toute en délicatesse. Gordon Lightfoot a dit qu'il s'était inspiré de son divorce, un jour d'été où il s'est retrouvé seul dans sa maison de Toronto. En même temps, on peut presque y ajouter les paroles et la musique de ce qui se passe dans notre propre vie, nos pensées, nos sentiments, nos craintes. C'est à la fois une chanson personnelle et une œuvre qu'on ne veut pas trop transformer, parce qu'elle fait partie du répertoire canadien.

En tant que chef d'orchestre, mon défi a consisté à trouver un équilibre. Il fallait nous assurer que certaines phrases soient poussées et d'autres, au contraire, retenues. Les arrangements de Lou Pomanti le réussissent parfaitement. Ensuite, nous avons voulu créer un « océan sonore » derrière les vers, comme si on se trouvait au bord de la mer et que les vagues se brisaient doucement sur le rivage, sans que l'auditeur se rende vraiment compte de leur présence. Cette idée est venue parce qu'il n'y a pas d'orchestre puissant ou agressif en arrière-plan. Nous pouvions interpréter la chanson avec des nuances subtiles et les peaufiner pour compléter à la fois la chaleur et l'amplitude de la voix d'Eleanor, et la guitare classique de Liona Boyd. D'ailleurs, l'interprétation de Liona met en relief nos orchestrations. Nous sommes privilégiés qu'elle nous prête ses talents de soliste pour cette chanson.

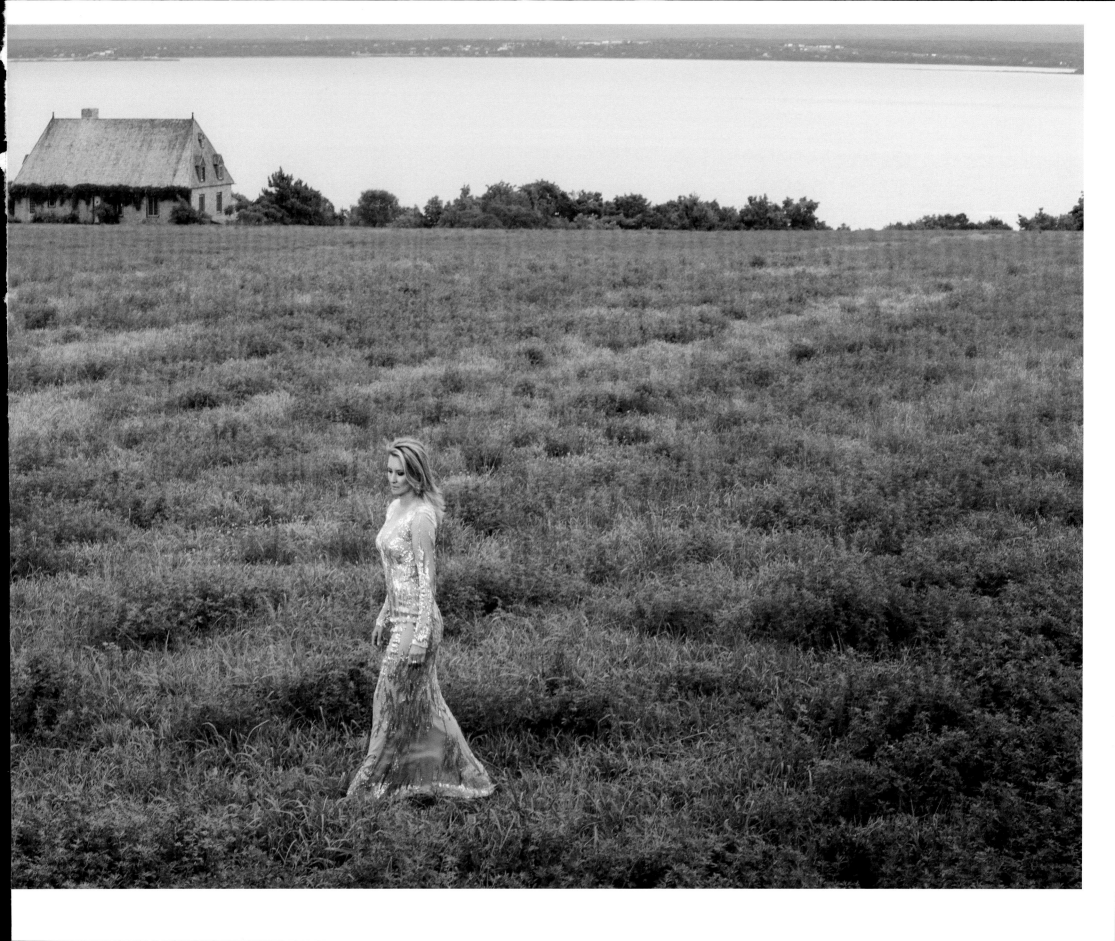

Over an ocean and over a sea
Beyond these great waters, oh what do I see
I see the great mountains which climb from the coastline
The hills of Cape Breton, this new home of mine
Oh, we come from the countries all over the world
To hack at the forest, to plow the land down
Fishermen, farmers and sailors all come
To clear for the future this pioneer ground

We are an island, a rock in a stream
We are a people as proud as there's been
In soft summer breeze or in wild winter winds
The home of our hearts, Cape Breton

KENZIE MacNEIL

We are an island, a rock in a stream
We are a people as proud as there's been
In soft summer breeze or in wild winter winds
The home of our hearts, Cape Breton

Over the highways and over the roads
Over the Causeway, stories are told
They tell of the coming and the going away
The cities of America draw me away
And though companies come and companies go
And the ways of the world we may never know
We'll follow the footsteps of those on their way
And still ask for the right to leave or to stay

The Island

Over the rooftops and over the trees
Within these new townships, oh what do I see
I see the black pitheads; the coal wheels are turning
The smoke stacks are belching and the blast furnace burning
And the sweat on the back is no joy to behold
In the heat of the steel plant or mining the coal
And the foreign-owned companies force us to fight
For our survival and for our rights

We are an island, a rock in a stream
We are a people as proud as there's been
In soft summer breeze or in wild winter winds
The home of our hearts, Cape Breton

We are an island, a rock in a stream
We are a people as proud as there's been
In soft summer breeze or in wild winter winds
The home of our hearts, Cape Breton

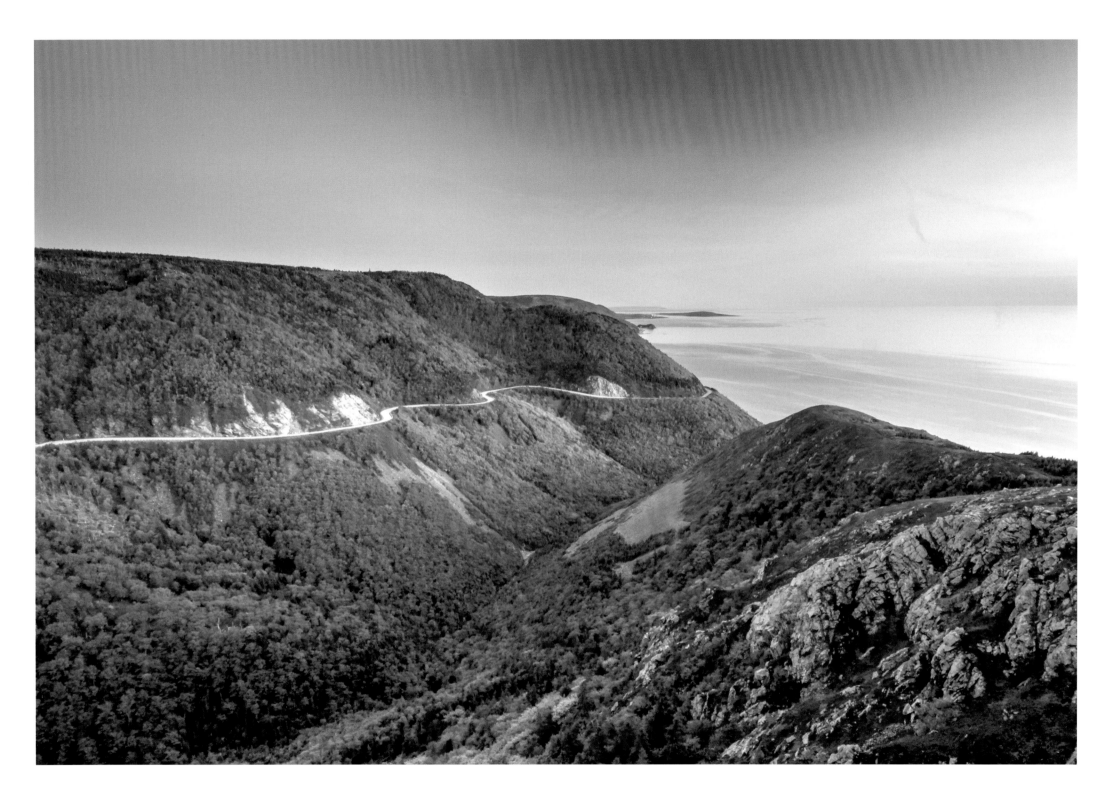

Kenzie MacNeil on The Island

When I was a teenager, my dad worked for three years for the Canadian government in southern Africa. Homesick for Cape Breton, I started to write songs. I remembered the green fields and the beauty. The day we landed back in Sydney, the air was chockablock with ore dust and I realized that home is just a place you love, no matter what. So I began to explore the island all over again. I studied its history, its close-knit communities with their intense code of hospitality and shared sense that we're all in the same boat. Life was never terribly easy for most folks, but still, you managed to get through.

In university a group of us had been involved in theatre and music. No one was doing anything to stop people from leaving the island for lack of work, so we created *The Rise and Follies of Cape Breton Island*. I wrote "The Island" while preparing for the first show. From the first time we played it, it became the people's song, their anthem, with lyrics that showed a willingness to fight for this place.

One day, while I was having coffee in a restaurant with a friend, a guy approached our table. I didn't know him from Adam but he said, "Are you Kenzie MacNeil?"

"Yeah," I said.

He asked, "Are you the guy who wrote 'The Island?'"

"Yeah," I said.

"Well, you could die right now," he told me.

It took a minute to figure out he was complimenting me. I began laughing and replied, "Thanks, but I'd like to keep going if I can."

Kenzie MacNeil parle de The Island

Quand j'étais adolescent, j'ai vécu trois ans en Afrique australe où mon père travaillait pour le gouvernement canadien. J'avais le mal du pays, l'île du Cap-Breton me manquait, alors j'ai commencé à composer des chansons. Je me souvenais des prés verts et de la beauté des paysages. Le jour de notre retour à Sydney, l'air était saturé de poussière de minerai et je me suis rendu compte que « chez soi », c'est simplement un endroit qu'on aime inconditionnellement. Je me suis donc mis à explorer l'île à nouveau. J'ai étudié son histoire, les villages et les communautés tissées serré, avec leurs règles d'hospitalité intenses et cette idée que nous sommes tous dans le même bateau. Pour la plupart des gens, la vie n'a jamais été très facile, mais ils arrivaient quand même à passer à travers.

À l'université, nous étions un groupe très actif en théâtre et en musique. Comme personne ne faisait rien pour retenir les gens sur l'île, malgré la pénurie d'emplois, nous avons créé la série télévisée *The Rise and Follies of Cape Breton Island*. J'ai composé *The Island* pendant que je me préparais pour la première émission. Dès notre première soirée, les spectateurs se sont approprié cette chanson. Ils en ont fait leur hymne, avec les paroles qui témoignaient de leur désir de se battre pour leur coin de pays.

Un jour, alors que je prenais un café au restaurant avec un ami, un type est venu à notre table. Je ne le connaissais ni d'Ève ni d'Adam, mais il m'a dit: « Êtes-vous Kenzie MacNeil ? »

— Ouais.

— Avez-vous composé *The Island* ?

— Ouais.

— Eh bien, vous pourriez mourir sur-le-champ.

J'ai mis une minute à comprendre qu'il me faisait un compliment. J'ai éclaté de rire et j'ai ajouté :

— Merci, mais j'aimerais bien revenir ici, si je peux.

Le monde est stone

MICHEL BERGER

LUC PLAMONDON

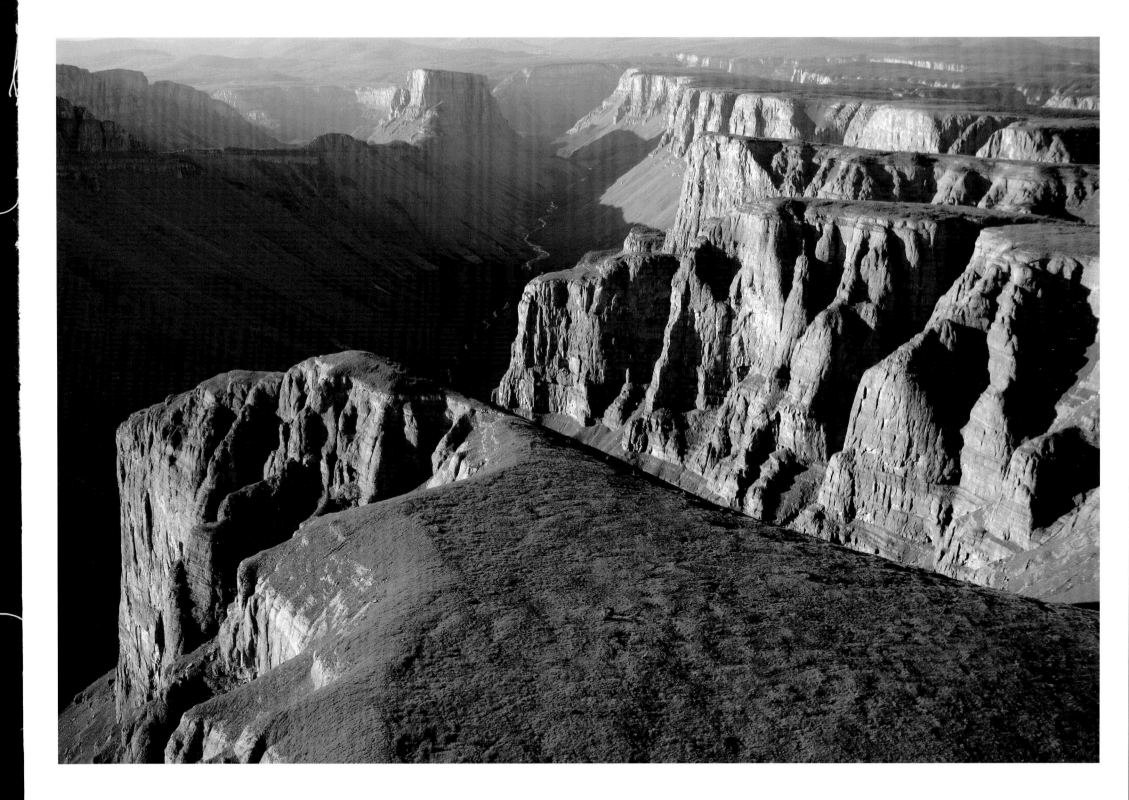

Benoit Groulx on Le monde est stone

I first heard this song when I was young, maybe around 15 years old. My parents played it a lot on our sound system at home and my older brother, a pianist, would play it too, on the piano. So for me, as an arranger, that was the challenge: to take a song that was well known and much loved, one sung by Fabienne Thibeault, by Céline Dion and, in an English version, by Cyndi Lauper, and create something personal and magic.

I was told to modify it but not too much, and I hardly changed the chords except for the first eight bars. I thought of it as working with the "colour" of the orchestra: the woodwind instruments and the brass. Each one has a chance to speak, entering one after the other. In the beginning there is the clarinet, then the flute, the trumpet, the other woodwind instruments and the bassoon. Each one has a colour, a flavour, but they complement, reflect and play off each other. The result is like a painting you listen to rather than look at.

While the original music is beautiful, it is very much rooted in its time, the late 1970s, early 1980s. And I love the lyrics. Luc Plamondon's words are poetry, and timeless. I think the Orchestre symphonique de Québec gives it all a new depth—and a new life.

Benoit Groulx parle de Le monde est stone

Je devais avoir quinze ans quand j'ai entendu cette chanson pour la première fois. Mes parents la faisaient souvent jouer sur notre chaîne stéréo à la maison et mon frère aîné l'interprétait aussi au piano. Mon défi, à titre d'arrangeur, était le suivant : prendre cette chanson très connue et très aimée, qui avait été interprétée par Fabienne Thibeault, Céline Dion et, en anglais, par Cyndi Lauper, pour en faire une création personnelle et magique.

On m'a demandé de la modifier, mais pas trop. J'ai donc à peine changé les accords, sauf pour les huit premières mesures. J'ai abordé la pièce en essayant de travailler avec la « couleur » de l'orchestre, à partir des bois et des cuivres. Tous les instruments ont l'occasion de s'exprimer, ils font leur entrée à tour de rôle. Au début, on entend la clarinette, puis la flûte, la trompette, les autres bois et le basson. Chacun a sa propre couleur, sa saveur, mais ils se complètent, se réfléchissent et s'opposent mutuellement. On obtient un genre de tableau sonore, que l'on écoute plutôt que de le regarder.

La musique originale est belle, mais elle est très ancrée dans son époque, soit la fin des années 1970 et le début des années 1980. Et j'adore les paroles. Les mots intemporels de Luc Plamondon sont de la vraie poésie. Je pense que l'Orchestre symphonique de Québec donne à cette chanson une nouvelle profondeur… et une nouvelle vie.

You could shoot off a cannon
Down the middle of Bond
And attract no attention in downtown St. John's
This getting nowhere is getting to me
Wondering where you can go to be all you can be

No regular Joe wants to pull up and go
Just to wind up homesick
Where there's no one you know
Just a smoke and a beer
And the sports on TV
Being sorry you left with no choice but to leave

You could shoot off a cannon
From the top of Long's Hill
And a Gulliver's Taxi might be all that you'd kill
We was promised the sun
And the moon and the stars
We got weathered old clapboard
And salt rusted cars

No Change In Me

RON HYNES

MURRAY McLAUCHLAN

No change in the weather
No change in me
I don't want to leave
But you can't live for free
You can't eat the air
And you can't drink the sea
No change in the weather
No change in me

So I'll join in the leaving
Like all of the rest
Montreal, Calgary, Vancouver west
Lay down on the sidewalk and kick off and die
Watch people not looking as they hurry by

No change in the weather
No change in me
I don't want to leave
But you can't live for free
You can't eat the air
And you can't drink the sea
No change in the weather
No change in me

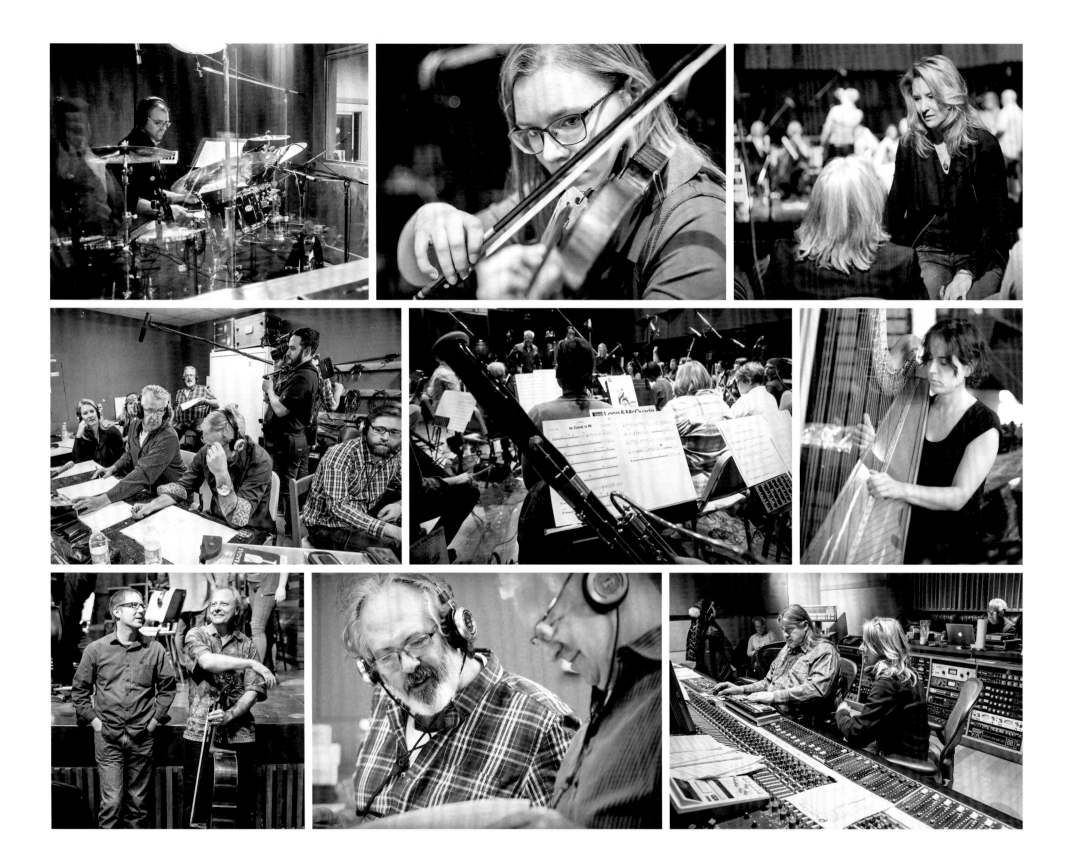

Murray McLauchlan on No Change In Me

Ron Hynes showed up at my house in Toronto one afternoon, homesick and carrying his guitar. We'd been put in touch with each other by my music publisher at the time, Frank Davies. In the parlance of publishing organizations, it was called "teeing you up." We worked at the dining-room table, and the afternoon stretched into the evening. We must've polished off a bottle of J&B, not just because of the song but because we were two Celts in a sociable mood.

Ron excelled in our writing partnership in terms of imagining *where* the song was about. He knew about missing Newfoundland. He knew about sitting in a bar somewhere, probably in one of those places that begin with "Fort," torn away from his home because he had to make a living and with no one to turn to. The thing with this song, as with every other song of its type, is that it wasn't created out of a vacuum but from hard experience, hard living and observation. It's about something real—something people will take into their own hearts and find truth in.

My favourite line in the song is very bitter and true, where it's suggested the character is going to head west to one of the big cities, lie down on the sidewalk and watch people not looking as he dies. We see that every day, a homeless person sleeping on a subway grate, little more than a lump of dirty, smelly clothing. I don't know what's worse—pretending not to see or not seeing anyone at all.

Murray McLauchlan parle de No Change In Me

Un après-midi, Ron [Hynes] s'est pointé chez moi à Toronto avec sa guitare et le mal du pays. C'est mon éditeur de musique de l'époque, Frank Davies, qui nous avait présentés l'un à l'autre. Un « mariage professionnel », en quelque sorte. Nous avons travaillé à la table de la salle à manger jusqu'au soir. Nous avons vidé toute une bouteille de scotch J&B, non pas parce que le thème de la chanson s'y prêtait, mais parce que nous étions deux hommes d'origine celte d'humeur sociable.

Au cours de cette collaboration, Ron a excellé pour imaginer *le lieu* dont traite la chanson. Il savait ce que c'était, s'ennuyer de Terre-Neuve. Il savait comment se sent un homme assis dans un bar quelconque, dans un endroit sûrement nommé « Fort quelque chose », arraché de son chez-soi parce qu'il doit gagner sa vie et ne peut compter sur personne. Ce qu'il y a de particulier avec cette chanson, comme toutes celles du même genre, c'est qu'elle n'a pas été créée à partir de rien, mais s'inspire d'une expérience douloureuse, d'une vie difficile et aussi d'observations. Elle parle de quelque chose de vrai, de quelque chose que les gens transportent dans leur cœur et qui les mène à la vérité.

Mon passage préféré de la chanson est à la fois très amer et très réaliste : c'est celui où l'on raconte que le personnage ira dans une grande ville de l'Ouest, se couchera sur le trottoir et observera les gens qui détournent le regard alors qu'il se meurt. Nous voyons quotidiennement des scènes comme celle-là, un sans-abri endormi près d'une grille de métro, un tas de vêtements sales et puants. Je ne sais pas ce qui est pire : faire semblant de ne rien voir ou bien ne voir personne.

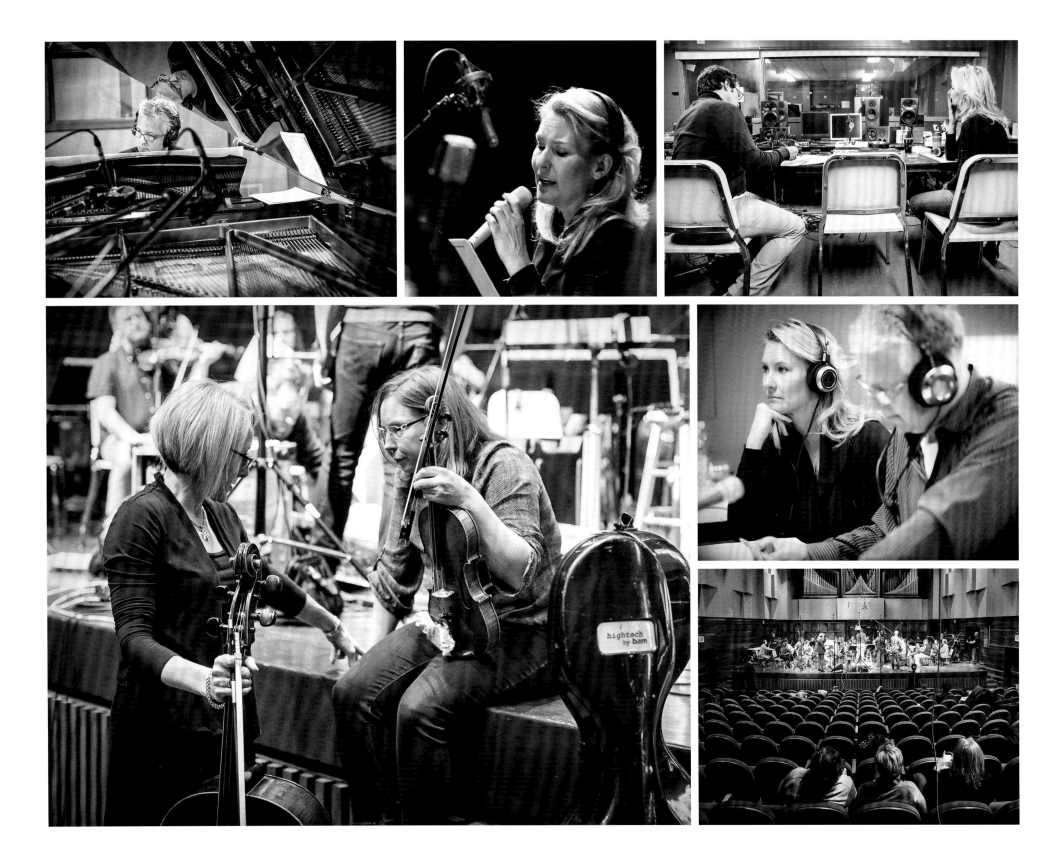

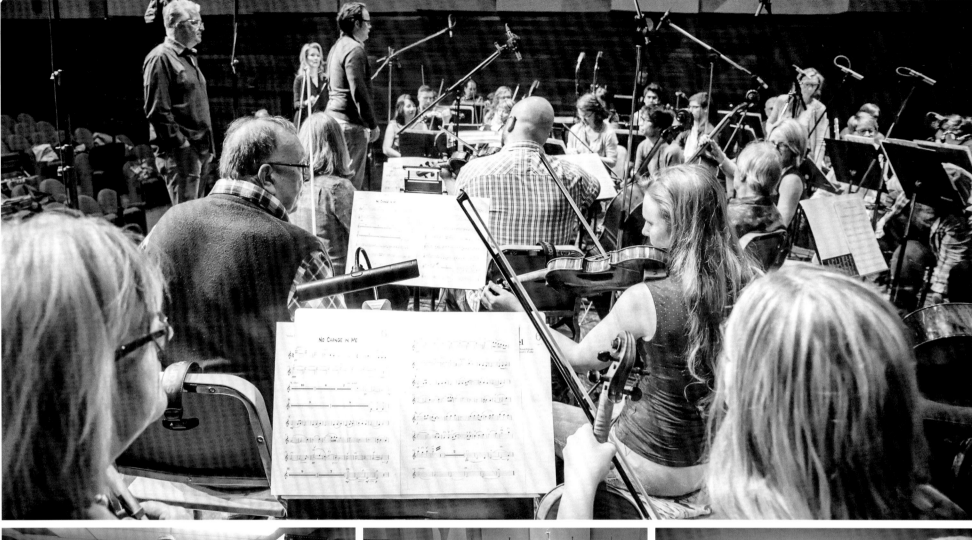

O Siem, we are all family
O Siem, we're all the same
O Siem, the fires of freedom
Dance in the burning flame

Siem O Siyeya
All people rich and poor
Siem O Siyeya
Those who do and do not know
Siem O Siyeya
Take the hand of one close by
Siem O Siyeya
Of those who know because they try
And watch the walls come tumbling down

Siem O Siyeya
All people of the world
Siem O Siyeya
It's time to make the turn
Siem O Siyeya
A chance to share your heart
Siem O Siyeya
To make a brand new start
And watch the walls come tumbling down

O Siem, we are all family
O Siem, we're all the same
O Siem, the fires of freedom
Dance in the burning flame

O Siem

SUSAN AGLUKARK

CHAD IRSCHICK

O Siem, we are all family
O Siem, we're all the same
O Siem, the fires of freedom
Dance in the burning flame

Fires burned in silence
Hearts in anger bleed
The wheel of change is turning
For the ones who truly need
To see the walls come tumbling down

O Siem, we are all family
O Siem, we're all the same
O Siem, the fires of freedom
Dance in the burning flame

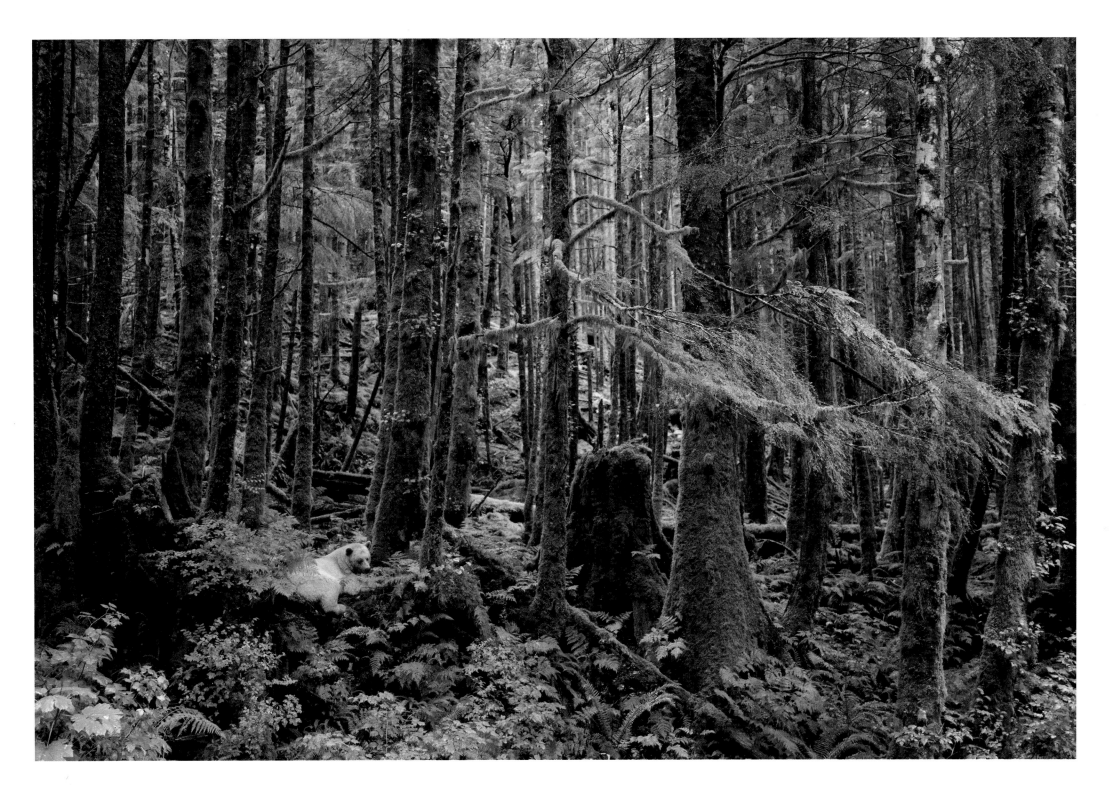

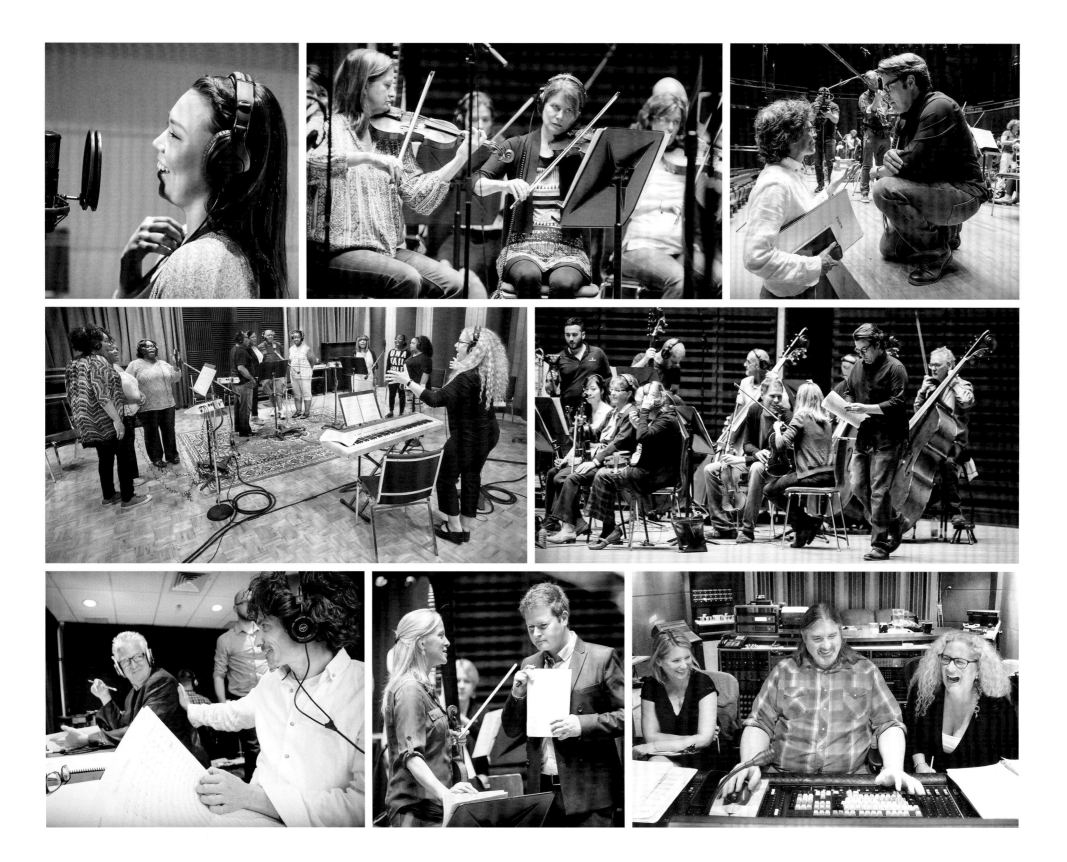

Susan Aglukark on O Siem

It was at a conference in Banff back in 1994. I don't remember what it was about, but I will never forget the two elders who came onto the stage to welcome participants with the traditional gesture—their arms extended in front of them, their hands turned up with palms turned towards them. It was like a reverse wave, as if to say "come closer." They did this as they said, "We welcome and honour the guests."

At the time I was very confused about my career. I was about to record my first major label release, *This Child*, and things were moving fast. I didn't know what the industry was like! But that image of the two men making a welcoming, trusting and all-encompassing gesture to a group of strangers—inviting them into their world—helped me realize that my career is not about an individual but is an opportunity to share a beautiful culture and history *with* the world. That is what "O Siem" means to me.

When I sat down with my co-writer and album producer, Chad Irschick, it was such a natural, effortless process. Every time I sing the song, it brings me back to that place and the feeling that everything is fine.

Susan Aglukark parle de O Siem

J'assistais à une conférence à Banff en 1994. Je ne me souviens pas du thème, mais je n'oublierai jamais les deux anciens qui sont montés sur scène pour souhaiter la bienvenue aux participants avec un geste traditionnel : les bras tendus devant et la paume des mains tournées vers eux. Tout en faisant ce geste qui évoquait une vague inversée, comme s'ils nous incitaient à nous approcher, ils nous ont dit : « Nous accueillons et honorons les invités. »

À l'époque, j'étais partagée au sujet de ma carrière. J'étais sur le point d'enregistrer *This Child*, mon premier disque pour une grande maison, et les choses allaient vite. J'ignorais tout de l'industrie ! Toutefois, cette image des deux hommes faisant un geste d'accueil témoignant de leur confiance devant un groupe d'étrangers, pour les inviter dans leur monde, m'a aidée à comprendre que ma carrière n'appartient pas à une seule personne. Elle me fournit plutôt l'occasion de partager une belle culture et une belle histoire *avec* le reste du monde. C'est ce que signifie *O Siem* pour moi.

La collaboration avec Chad Irschick, coauteur et producteur de l'album, s'est déroulée le plus naturellement du monde et sans effort. Chaque fois que je chante cette chanson, je suis transportée à cette époque et je sens que tout va bien.

I've got a smile on my face and I've got four walls around me
I've got the sun in the sky all the water surrounds me
Oh, ya know
Yeah I'll win now and sometimes I'll lose
I've been battered, but I'll never bruise
It's not so bad

And I say way-hey-hey, it's just an ordinary day
And it's all your state of mind
At the end of the day, you've just got to say
It's all right

ALAN DOYLE

SÉAN McCANN

In this beautiful life, there's always some sorrow
It's a double-edged knife, but there's always tomorrow
Oh ya know
It's up to you now if you sink or swim
Just keep the faith that your ship will come in
It's not so bad

Ordinary Day

Janie sings on the corner, what keeps her from dying
Let them say what they want, she won't stop trying
Oh ya know
She might stumble, if they push her around
She might fall, but she'll never lie down
It's not so bad

And I say way-hey-hey, it's just an ordinary day
And it's all your state of mind
At the end of the day, you've just got to say
It's all right

And I say way-hey-hey, its just an ordinary day
And it's all your state of mind
At the end of the day, you've just got to say
I say way-hey-hey it's just an ordinary day
And it's all your state of mind
At the end of the day, you've just got to say it's all right
It's all right, it's all right

'Cause I've got a smile on my face and I've got four walls around me

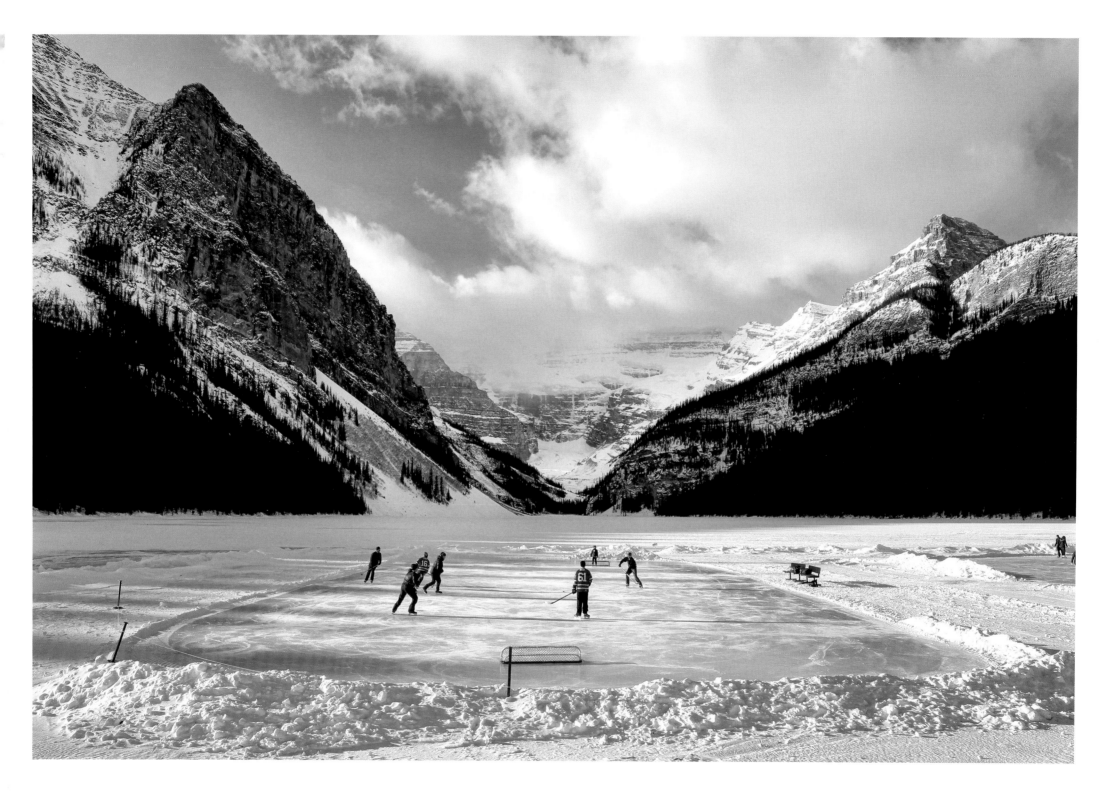

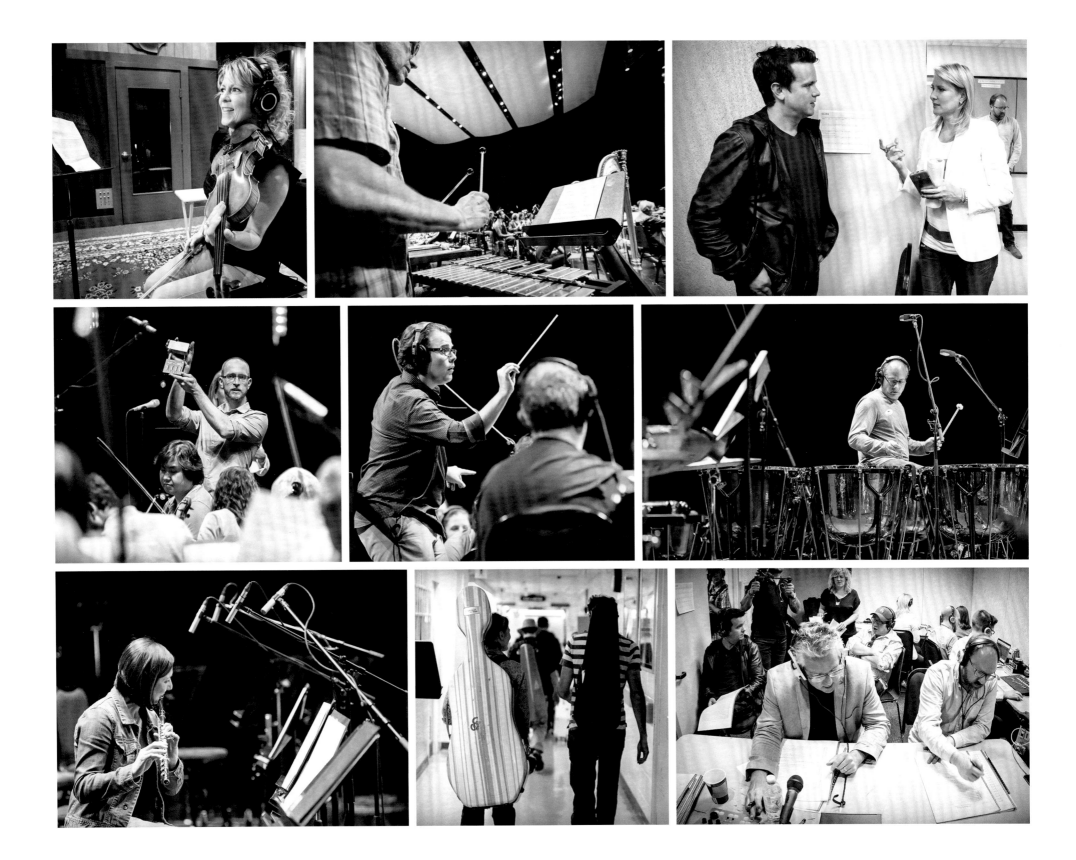

Alan Doyle and Séan McCann on Ordinary Day

ALAN: The chorus of the song was written, and I had the first verse, which was kind of broad. I wanted the second verse to be about a person who embodied the spirit of the song—about dealing with hard times and smiling through them. That very day I was watching TV and saw a story about a singer from Alberta who was mugged while busking in Vancouver. Instead of packing up and going home, she went back the next day to the very same spot and started singing again. In the song I called her Janie, but her real name was Jann Arden.

The whole song is a response to a distress call. That's what the opening beat is: an SOS in Morse code. Then we use a bodhran, or Irish frame drum, as its heartbeat. It's perfect because it's about the attitude of Newfoundlanders—that if you spend your time dwelling on what you have rather than what you don't, it's going to be a good day. I know that from experience. So the whole song was written except the last verse. I had no poetry and it was driving me crazy.

SÉAN: We were in a van during a tour of Ontario. Alan passed the song back to me and I realized what the problem was right away. To know true happiness and joy, you have to experience some darkness, and the song didn't allow for that. You can't hide from the dark. Eventually it will find us all, and without it, "Ordinary Day" would have been far too linear to resonate with anyone.

ALAN: All of a sudden, it was a good day.

Alan Doyle et Séan McCann parlent de Ordinary Day

ALAN : Le refrain et le premier couplet de la chanson étaient écrits, ce qui était déjà pas mal. Dans le deuxième couplet, je voulais parler d'une personne incarnant l'esprit de la chanson, quelqu'un qui vivait des moments difficiles sans perdre le sourire. Un jour, j'ai vu à la télé un reportage sur Jann Arden, une musicienne albertaine qui s'était fait agresser et voler pendant qu'elle chantait dans la rue, à Vancouver. Plutôt que de faire ses valises pour rentrer chez elle, elle est retournée au même endroit le lendemain et s'est remise à chanter. Dans ma chanson, je l'appelle Janie.

L'ensemble de la chanson est une réponse à un appel de détresse. D'ailleurs, le rythme d'ouverture est SOS en morse. Ensuite, nous jouons du bodhrán, un tambour sur cadre irlandais, qui représente des battements du cœur. C'est parfait pour évoquer l'attitude des Terre-Neuviens : si nous nous concentrons sur ce que nous avons, plutôt que sur ce qui nous manque, la journée sera belle. Et je le sais d'expérience. Donc, à part le dernier couplet, la chanson était terminée. Mais je n'avais aucune image poétique en tête et ça me rendait fou.

SÉAN : Nous étions dans une camionnette, en tournée en Ontario. Alan m'a montré la chanson et j'ai tout de suite compris le problème. Pour connaître la joie et le vrai bonheur, il faut vivre des moments sombres, et la chanson ne le montrait pas. On ne peut pas éviter l'obscurité. Elle finit toujours par nous atteindre. Sans son côté sombre, *Ordinary Day* aurait été beaucoup trop linéaire pour toucher quelqu'un. Je pense que j'ai écrit le dernier couplet en quelques secondes.

ALAN : Et tout à coup, ce fut une très belle journée.

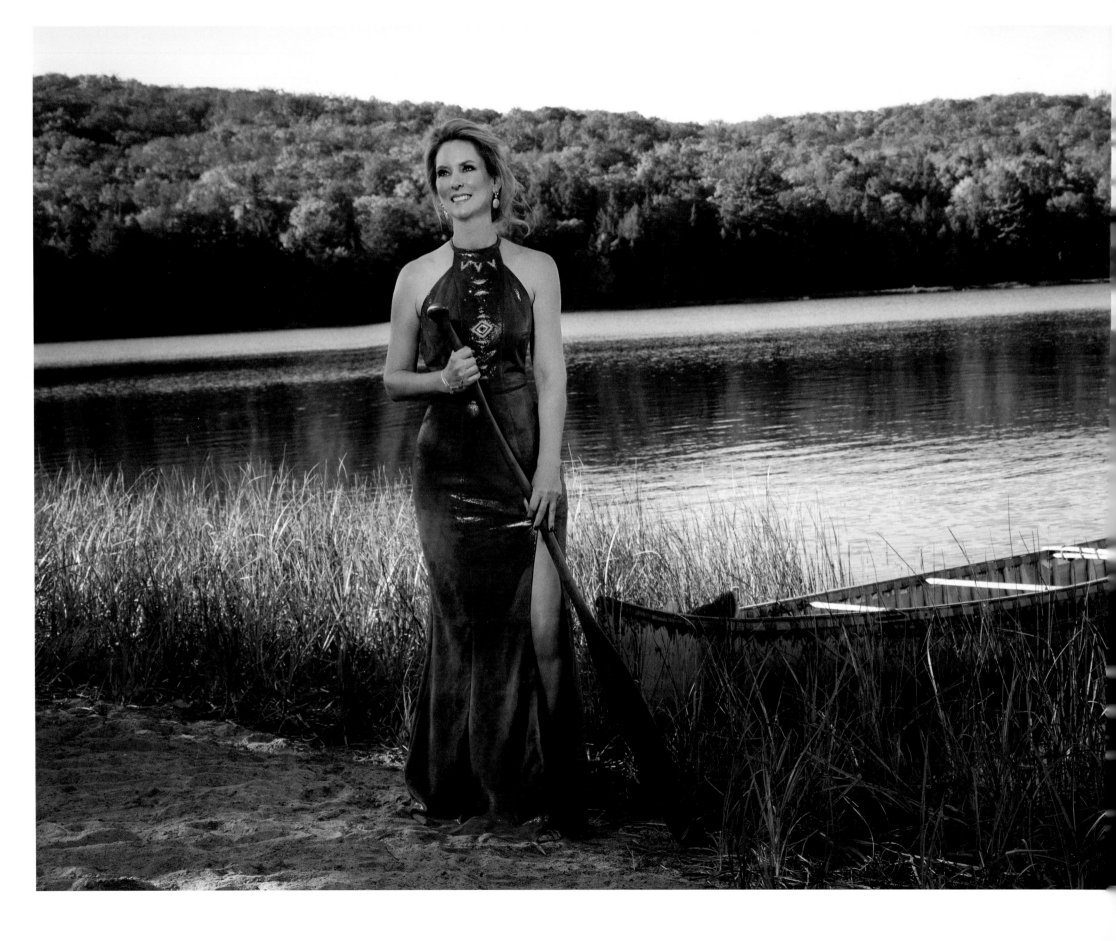

Across the street the river runs
Down in the gutter life is slipping away
Can I still exist in another place
Running under cover of a helicopter blade

The flames are getting higher in effigy
Burning down the bridges of my memory
Love may still be alive somewhere someway
Where they're downing only deer
A hundred steel towns away

Oh I've got lightning in my veins
Shifting like the handle of a slot machine
Love may still exist in another place
But I'm just yanking back the handle
No expression on my face

Oh rhythm of my heart is beating like a drum
With the words "I love you" rolling off my tongue
No never will I roam for I know my place is home
Where the ocean meets the sky
I'll be sailing

Oh the rhythm of my heart is beating like a drum
With the words "I love you" rolling off my tongue
Never will I roam for I know my place is home
Where the ocean meets the sky
I'll be sailing

MARC JORDAN

JOHN CAPEK

Rhythm Of My Heart

Photographs and kerosene light up the darkness
Light it up, light it up
I can still feel the touch of your thin blue jeans
Running down the alley I've got my eyes all over you baby
Oh baby

Oh the rhythm of my heart is beating like a drum
With the words "I love you" rolling off my tongue
Never will I roam for I know my place is home
Where the ocean meets the sky I'll be sailing
I'll be sailing

Oh the rhythm of my heart is beating like a drum
With the words "I love you" rolling off my tongue
No never will I roam for I know my place is home
Where the ocean meets the sky
I'll be sailing

The rhythm of my heart is beating like a drum
With the words "I love you" rolling off my tongue
Never will I roam for I know my place is home
Where the ocean meets the sky
I'll be sailing

Marc Jordan and John Capek on Rhythm Of My Heart

MARC: Before I write a song, I have to see the track as a movie, with a core melody that has its own language and rhythms. Some melodies are about the ache of a heart and some are more forceful. With "Rhythm Of My Heart," I worked on a little music track first, then went to John with it. We made a rough track that we had to write a melody over. In this case I imagined the Maritime folk songs my father loved, with their lilt and longing—songs that filled our home when I was growing up.

JOHN: Throughout our writing partnership, the process was the same for every song. I'd create the background music, almost as if I was scoring a film, for Marc to paint pictures on. He's a visual lyricist, and very poetic. It was always a long process, from the initial idea to finished song, with lots—and lots—of going back and forth.

MARC: I'm dyslexic and never developed a linear sense of storytelling. Notes are black dots that jump off a page at me in a jumble, and my lyrics have gaps in logic that listeners can fill in with their own narrative. Brains are built to make order out of chaos. When you look at clouds in the sky, after a few seconds you'll start seeing shapes. It's the same with music. I want to draw people in and have them make the song their own. That's what you learn as a performer, as a writer and as a grown-up. It's not about the writer. You don't need to fill every space.

Marc Jordan et John Capek parlent de Rhythm Of My Heart

MARC : Avant de composer une chanson, je dois voir la musique comme un film, avec une mélodie centrale qui possède son propre langage et ses propres rythmes. Certains airs évoquent les douleurs amoureuses, tandis que d'autres sont plus puissants. Dans le cas de *Rhythm Of My Heart*, j'ai d'abord travaillé sommairement à une piste musicale, puis je l'ai confiée à John. Nous avons enregistré une première piste rudimentaire sur laquelle nous avons ajouté une mélodie. Dans ce cas, j'ai imaginé les chansons traditionnelles des Maritimes que mon père adorait, avec leur turlutage et leur nostalgie, les chansons qui remplissaient la maison quand j'étais petit.

JOHN : Nous avons procédé de la même façon pour composer ensemble chaque chanson. J'écrivais la musique de fond, presque comme si je composais la trame musicale d'un film, par-dessus laquelle Marc peignait des images. Il est un parolier visuel et très poétique. Pour chaque chanson, de l'idée initiale à l'enregistrement, le processus a toujours été long, avec beaucoup — en fait, énormément — d'allers et de retours.

MARC : Je suis dyslexique et je n'ai jamais développé la capacité de raconter des histoires de manière linéaire. De plus, je vois les notes comme des points noirs qui jaillissent de la partition et se jettent confusément sur moi. Il y a des lacunes dans la logique de mes paroles et le public peut les combler avec ses propres histoires. Le cerveau est conçu pour créer de l'ordre à partir du chaos. Quand on regarde le ciel, au bout de quelques secondes, on finit par voir des formes dans les nuages. C'est la même chose avec la musique. Je veux attirer les gens et les inciter à s'approprier la chanson. C'est ce qu'on apprend comme interprète, comme auteur et comme adulte. L'important, ce n'est pas l'auteur. On n'a pas à remplir tous les espaces.

BRYAN ADAMS

JIM VALLANCE

She says her love for me could never die

But that'd change if she ever found out about you and I

Oh but her love is cold

It wouldn't hurt her if she didn't know

Cuz when it gets too much

I need to feel your touch

She's got a heart of gold, she'd never let me down

But you're the one that always turns me on—ya keep me comin' 'round

I know her love is true

But it's so damn easy makin' love to you

I got my mind made up

I need to feel your touch

Run To You

I'm gonna run to you

I'm gonna run to you

Cuz when the feelin's right I'm gonna run all night

I'm gonna run to you

I'm gonna run to you

I'm gonna run to you

Cuz when the feelin's right I'm gonna stay all night

I'm gonna run to you

Yeah, gonna run to you

Oh when the feelin's right I'm gonna run all night

I'm gonna run to you

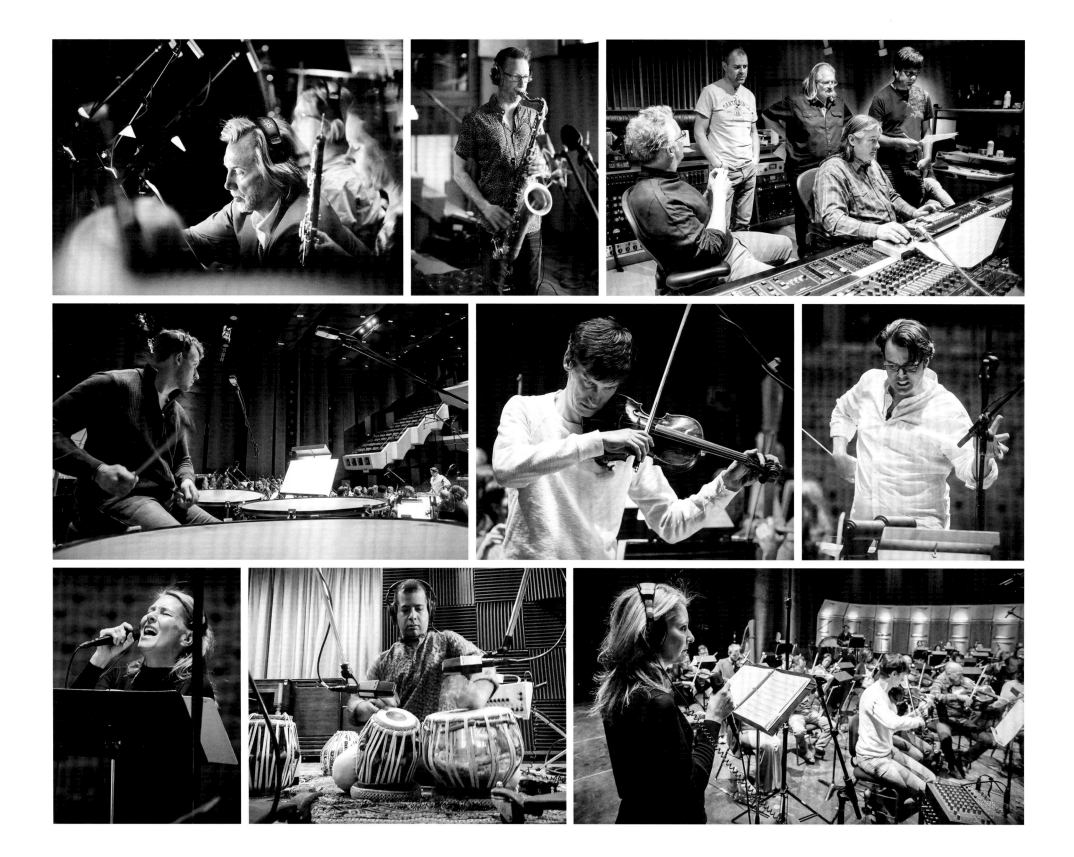

Don Breithaupt on Run To You

It took a little nudging. Eleanor was a bit skeptical about whether she could pull off a song like this. With a voice like hers, which is more nuanced and intimate, you would think it only natural that we'd pick one of Bryan's famous ballads and not a rock anthem. But everyone loves "Run To You," and my feeling was that we could have the song meet Eleanor halfway if I didn't arrange it in a meat-and-potatoes, hard-rock way. So I arrived at an arrangement where there was space for her to be heard, while still getting across the original spirit of the song. Think of it as classic rock, but with a little of that skippy Police feel to it.

At Eleanor's suggestion we layered a tabla, a drum that's indigenous to South Asia, on the song, which helped make it more exotic and distinct from the original version. You hear it poking its head out as part of the groove throughout; then in the instrumental section, it really has its moment. Vineet Vyas was fantastic.

There was only one thing I considered inviolate: the guitar break. After the big, bombastic middle it had to be there, just Justin [Abedin] on guitar, setting up the out-choruses. In the end, it was a balancing act. When you're arranging an iconic, crowd-pleasing, fist-pumping rocker, you don't want to get so delicate or tricky with it that you're betraying its spirit. It still needs that forward momentum and excitement. You just create that excitement in a slightly different way.

Don Breithaupt parle de Run To You

Il a fallu insister un peu. Eleanor doutait de pouvoir interpréter une chanson comme celle-ci. Avec sa voix, plus nuancée et plus intime, il aurait été naturel de choisir une des célèbres ballades de Bryan plutôt qu'un hymne rock. Par contre, tout le monde adore *Run To You*, et j'avais l'impression que la chanson et Eleanor pouvaient se rencontrer à mi-chemin, si je travaillais la chanson dans le style *hard rock* classique. J'ai donc conçu des arrangements qui laissent de l'espace pour entendre Eleanor tout en transmettant l'esprit original de la chanson : un rock classique, avec une petite touche entraînante qui rappelle The Police.

Eleanor a eu l'idée d'intégrer du tabla, un instrument de percussion du sud de l'Asie, ce qui donne à la chanson un air exotique différent de la version originale. On le distingue comme un élément rythmique dans l'ensemble de la chanson, puis il se démarque vraiment dans la partie instrumentale. Vineet Vyas est un interprète formidable.

Il n'y avait qu'une chose intouchable, selon moi : le solo de guitare. Après le milieu explosif, il fallait entendre Justin [Abedin], seul à la guitare, jouer les transitions. Au bout du compte, il s'agissait d'un numéro d'équilibre. Quand on fait les arrangements de la chanson d'un rocker emblématique, adoré des foules et énergique, on ne veut pas en trahir l'esprit en ajoutant de la délicatesse et des effets. Mais il faut tout de même donner un élan et de l'entrain à cette chanson. Alors on recrée simplement cet enthousiasme de façon légèrement différente.

Spread your tiny wings and fly away
And take the snow back with you
Where it came from on that day
The one I love forever is untrue
And if I could you know that I would fly away with you

Beneath its snowy mantle cold and clean
The unborn grass lies waiting
For its coat to turn to green
The snowbird sings the song he always sings
And speaks to me of flowers
That will bloom again in spring

GENE MacLELLAN

The breeze along the river seems to say
That he'll only break my heart again
Should I decide to stay
So little snowbird take me with you when you go
To that land of gentle breezes
Where the peaceful waters flow

Snowbird

When I was young my heart was young then too
And anything that it would tell me
That's the thing that I would do
But now I feel such emptiness within
For the thing that I want most in life's the thing that I can't win

Spread your tiny wings and fly away
And take the snow back with you
Where it came from on that day
The one I love forever is untrue
And if I could you know that I would fly away with you
Yeah, if I could you know that I would fly away with you

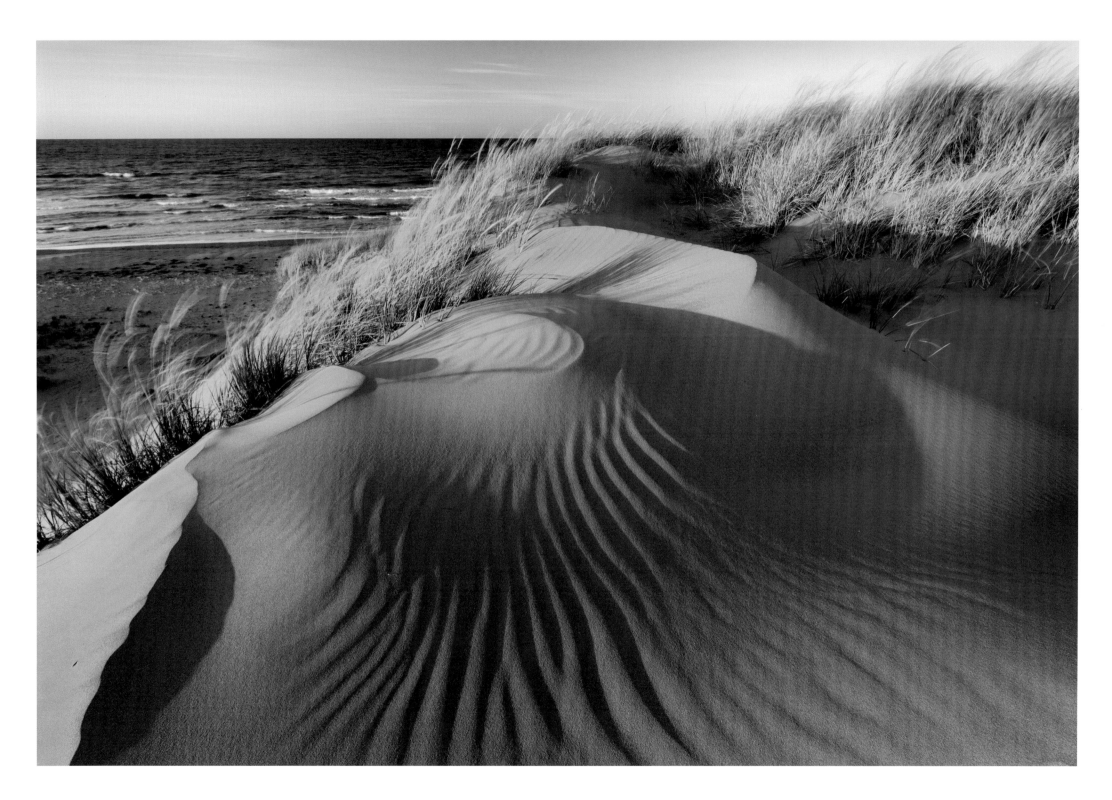

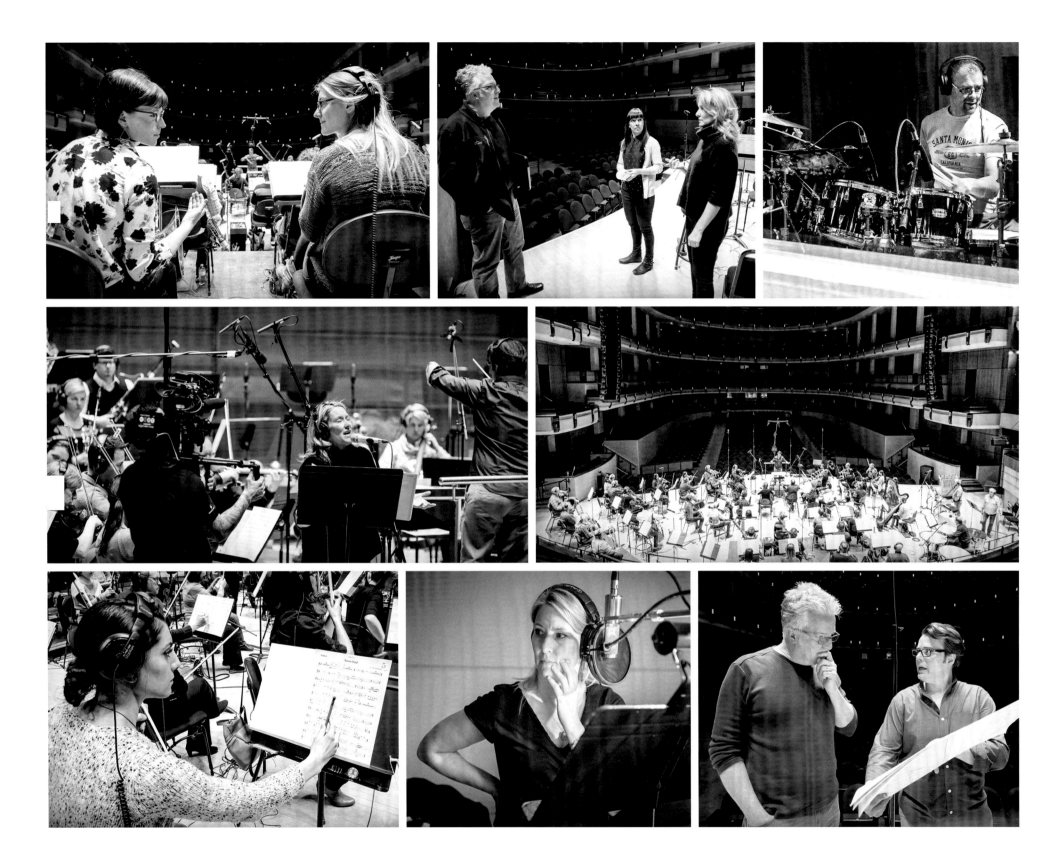

Anne Murray on Snowbird

The first time I heard "Snowbird" was the late '60s in the old CBC building in Halifax. I'd been called to come down right away to hear a singer named Gene MacLellan. There were just three of us in a conference room with a big bank of windows—Bill Langstroth, the host of *Singalong Jubilee*, and Gene with his guitar, and me. I don't think I've ever met anyone more musical than Gene. It oozed from him. He played a couple of songs, "Bidin' My Time" and "Snowbird," and when he finished I said, "Oh my God, I'd love to have a copy."

He handed me a tape. "If you want them, they're yours," he said.

"Yes," I replied. "I do."

I couldn't believe my good fortune. I took the songs home and sang them all summer to my family and then to my producer, Brian Ahern. It was so exciting! Until then I'd been doing only covers. All of a sudden I had original material. We went into the studio and recorded "Bidin' My Time" as the A-side, with "Snowbird" on the B-side. But a DJ at a U.S. radio station flipped it and decided to play "Snowbird" as the A-side. The rest is history.

Once, Gene told me he wrote the song in 20 minutes, having spotted a snow bunting during a walk on a beach in Prince Edward Island. The line "The one I love forever is untrue"—it seemed as though Gene had had his heart broken and wanted the snowbird to carry him away from his pain. It's as simple as listening to the lyrics. That's what the song is about to me.

Anne Murray parle de Snowbird

J'ai entendu *Snowbird* pour la première fois à la fin des années 1960 dans l'ancien édifice de la CBC à Halifax. Quelqu'un m'avait demandé d'y aller pour entendre le chanteur Gene MacLellan. Nous étions seulement trois dans une salle de conférences au mur vitré : Bill Langstroth, l'animateur de l'émission *Singalong Jubilee*, Gene et sa guitare, et moi. Je pense que je n'ai jamais rencontré quelqu'un d'aussi musical que Gene. La musique l'habite. Il a joué deux chansons (*Bidin' My Time* et *Snowbird*) et quand il a eu fini, j'ai dit : « Oh ! mon Dieu, j'aimerais en avoir un enregistrement ! »

Il m'a remis une bande magnétique en me disant : « Si tu veux les chansons, elles sont à toi. »

J'ai accepté.

Je ne pouvais pas croire à ma chance. J'ai apporté l'enregistrement à la maison et j'ai chanté les chansons tout l'été devant les membres de ma famille et mon producteur, Brian Ahern. C'était tellement excitant ! Jusque-là, je n'avais interprété que des reprises et, tout à coup, j'avais du matériel original. Nous sommes entrés en studio et avons enregistré *Bidin' My Time* pour la face A et *Snowbird* pour la face B. Mais l'animateur d'une station de radio américaine a décidé de faire jouer *Snowbird* comme le titre principal du 45-tours. On connaît la suite.

Gene m'a dit un jour qu'il avait composé la chanson en vingt minutes, après avoir aperçu un bruant des neiges sur la plage à l'Île-du-Prince-Édouard. La phrase « *The one I love forever is untrue* » (« Celui que j'aime pour l'éternité est infidèle »), c'est comme si Gene avait eu le cœur brisé et voulait que l'oiseau le transporte loin de sa douleur. Les paroles sont aussi simples que ça. C'est ce que la chanson signifie pour moi.

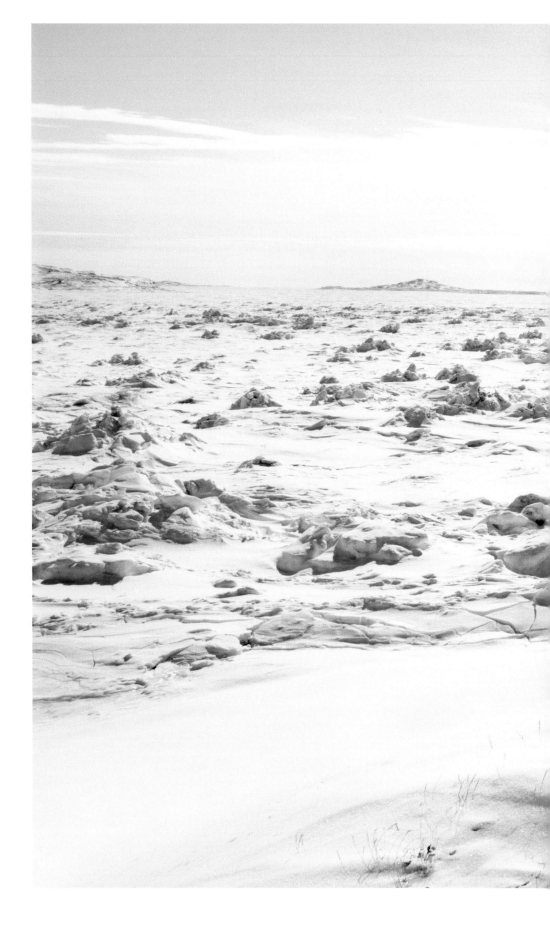

Two sweethearts in a country town, the neighbors say
Lived happily the whole day long
Until one day he told her he must go away
She wondered then what could be wrong

He said "You know it's true I love you best of all
And yet it's best that we should part"
Just as he went away they heard his sweetheart say
Though it 'most broke her heart

He went away, and from that day the world's been sad
He realizes his mistake
He listened to the gossips, and that's always bad
For they don't care whose heart they break

As time went on he longed to see his girl again
And so by chance one day they met
As they met face to face, there was a fond embrace
Though these words haunt him yet

Some Of These Days

SHELTON BROOKS

Some of these days
You'll miss me, honey
Some of these days
You'll feel so lonely
You'll miss my hugging
You'll miss my kissing
You'll miss me, honey
When you're away

I feel so lonely
Just for you only
For you know, honey
You've had your way
And when you leave me
You know, 'twill grieve me
I'll miss my little dad-dad-daddy

Yes, some of these days
Some of these days

Some of these days
You'll miss me, honey
Some of these days
You'll feel so lonely
You'll miss my hugging
You'll miss my kissing
You'll miss me, honey
When you're away

I feel so lonely
Just for you only
For you know, honey
You've had your way
And when you leave me
You know, 'twill grieve me
I'll miss my little dad-dad-daddy

Yes, some of these days
Some of these days

Shelly Berger on Some Of These Days

I tried as the music arranger to do a bit of a big band sound on "Some Of These Days." I love that kind of music from the '40s and '50s, the days of Frank Sinatra and Nelson Riddle, of horn and string sections. It's those cool, suave crooner-type vocals—the kind you can listen to without ever tiring of them.

I have a theory about songs and music in general. It goes like this: you have to wait 100 years to see, really see, if a piece of music is great or not. People will have an emotional attachment to music they've grown up with, no matter what, so in order to tell if a song has staying power, that generation has to die off and a whole new one has to fall in love with the song, no emotional strings attached. Only then can we say that it's "good," that it's an "A" song with something that carries it through the years.

Well, Shelton Brooks wrote this song back in the early 20th century, and in 1910 he gave it to Sophie Tucker, who made it her theme song. Since then it has been recorded again and again, from Ethel Waters and Ella Fitzgerald to Bobby Darin and Serena Ryder. So I'd say "Some Of These Days" has more than proven itself. It's timeless—and it's by a guy who was born in Amherstburg, Ontario!

Shelly Berger parle de Some Of These Days

Pour *Some Of These Days*, j'ai voulu faire un arrangement qui évoquait le son d'un *big band*. J'adore la musique des années 1940 et 1950, l'époque de Frank Sinatra et de Nelson Riddle, des cuivres et des instruments à cordes. Ce sont ces voix suaves de *crooner* que l'on peut écouter sans jamais se lasser.

J'ai une théorie sur les chansons et la musique en général : il faut attendre cent ans pour voir, pour vraiment voir, si une œuvre musicale est bonne ou pas. Les gens s'attachent à la musique qu'ils entendent dans leur jeunesse, peu importe le genre. Alors pour déterminer si une chanson peut durer, il faut que la génération suivante, qui n'a pas de lien émotif avec elle, l'aime aussi. C'est à ce moment seulement qu'on peut dire qu'une chanson est « bonne », qu'elle est de premier ordre et qu'elle a ce qu'il faut pour traverser le temps.

Shelton Brooks l'a composée au début du vingtième siècle et, en 1910, il l'a donnée à Sophie Tucker qui en a fait sa chanson fétiche. Depuis, elle a été enregistrée à répétition, par Ethel Waters, Ella Fitzgerald, Bobby Darin et Serena Ryder, entre autres. Je me permets donc d'affirmer que *Some Of These Days* a largement fait ses preuves. Elle est éternelle et elle a été écrite par un type né à Amherstburg, en Ontario !

ALLISTER
MacGILLIVRAY

Out on the Mira on warm afternoons
Old men go fishing with black line and spoons
And, if they catch nothing, they never complain
I wish I was with them again

As boys in their boats call to girls on the shore
Teasing the ones that they dearly adore
And, into the ev'ning the courting begins
I wish I was with them again

And over the ashes the stories are told
Of witches and werewolves and Oak Island gold
Stars on the river-face sparkle and spin
I wish I was with them again

Can you imagine a piece of the universe
More fit for princes and kings
I'll trade you ten of your cities for Marion Bridge
And the pleasure it brings

Song For The Mira

Can you imagine a piece of the universe
More fit for princes and kings
I'll trade you ten of your cities for Marion Bridge
And the pleasure it brings

Out on the Mira on soft summer nights
Bonfires blaze to the children's delight
They dance 'round the flames, singing songs with their friends
I wish I was with them again

Out on the Mira the people are kind
They treat you to homebrew and help you unwind
And, if you come broken, they'll see that you mend
I wish I was with them again

Now I'll conclude with a wish you go well
Sweet be your dreams and your happiness swell
I'll leave you here, for my journey begins
I'm going to be with them again
I'm going to be with them again

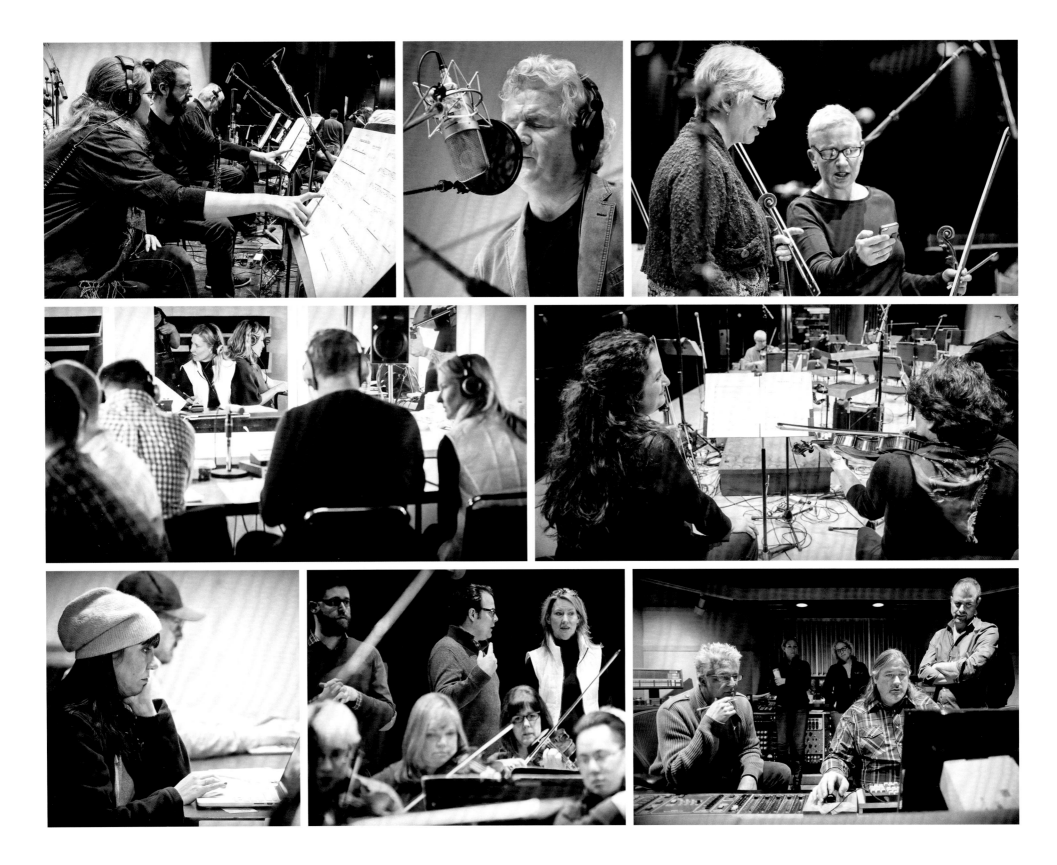

Allister MacGillivray on Song For The Mira

I was on Prince Edward Island in 1973. It was nighttime and I was alone in a cabin outside Charlottetown, listening to the rain pound on the roof as I practised on my guitar. At times like these, when you have a little distance from home, you really feel what you're missing. I was thinking about Marion Bridge and the Mira River. I first saw the Mira when I was less than 10, brought there one August by an uncle. It was where the Cape Breton coal miners took their two-week summer vacation, and it was magic—a meandering place with canoeing, salmon fishing and bonfires around which were told stories of ghosts, werewolves and pirates. For a child there were also the exciting rumours that Captain Kidd or another pirate had buried something on Nova Scotia's Oak Island. For all we knew, it could've been the Holy Grail!

So on that night in 1973, in the dimly lit cabin, the song just came out of me. There was a doctor's appointment book in the next room and I tore a page from it and scribbled everything down. At the time I didn't think it was an important song because it was too personal. Looking at that piece of paper today, I realize that it came out almost the way it's still sung, with no major adjustments—and it became the song that opened doors for me, my family and the region.

Years later I bought a house overlooking the Mira. Now I can see this area through different eyes, with its Celtic farmers, old traditions and sense of community. The magic is still there, as strong as ever.

Allister MacGillivray parle de Song For The Mira

Je me trouvais à l'Île-du-Prince-Édouard en 1973. C'était la nuit et j'étais seul dans une cabane non loin de Charlottetown. J'écoutais la pluie marteler le toit en grattant ma guitare. Dans des moments comme ça, quand on est loin de chez soi, on comprend vraiment ce qui nous manque. Je pensais au pont Marion et à la rivière Mira que j'avais découverts un certain mois d'août, alors que je n'avais pas dix ans, lorsqu'un oncle m'avait emmené en Nouvelle-Écosse. C'est là que les mineurs de charbon du Cap-Breton venaient passer leurs deux semaines de vacances annuelles. C'était magique : un cours d'eau tout en méandres où on faisait du canot, on pêchait le saumon et on se racontait des histoires de fantômes, de loups-garous et de pirates autour du feu de camp. Les rumeurs de trésor enterré quelque part sur l'île Oak par le capitaine Kidd ou un autre pirate excitaient l'imagination des enfants. On pensait même que ça pouvait être le Saint-Graal !

La chanson m'est venue le plus simplement du monde, ce soir-là de 1973, dans une cabane faiblement éclairée. Il y avait un cahier de rendez-vous de médecin dans la pièce d'à côté. J'en ai déchiré une page pour prendre des notes. À l'époque, je trouvais la chanson trop personnelle pour être importante. Aujourd'hui, quand je contemple cette feuille de papier, je me rends compte qu'on la chante presque exactement comme à l'origine, sans ajustements majeurs. C'est la chanson qui m'a ouvert des portes, à moi, mais également à ma famille et à la région.

Des années plus tard, j'ai acheté une maison qui donne sur la rivière Mira. Je vois maintenant les environs d'un œil différent, avec ses fermiers celtes, ses traditions anciennes et un sentiment d'appartenance à la communauté. La musique est toujours là, aussi puissante qu'avant.

She left with all of her clothes and all
She walked with all my CDs
She was too small to take the big screen
So she took all my DVDs, yeah, yeah, oh

I swear the woman went crazy
Cussin and yellin at me
I tell you nothin's gonna break me
As long as I still believe, yeah, yeah
That's why you got to know

I didn't open my mouth at all
There wasn't nothin to say
If it's not written in the stars girl, no, no
I won't beg you to stay
But you know I'm gonna make it 'cause

I still believe in love, yeah you know
I still believe in love, don't you know
I still believe in love
Yes I do, just not with you
I keep it real because

Still Believe In Love

HAYDAIN NEALE

I still believe in love, yeah you know
I still believe in love, girl you know
I still believe in love
Yes I do, just not with you

She call me all kinds of names and all
She cuss me right where I stood
She said she no longer loves me
She call me triflin and no good

I still believe in love, don't you know
I still believe in love, awe, you know
I still believe in love
Yes I do, just not with you

Now, now, now sugar no way
I still believe in love
I still believe in love
I still believe in love
I still believe in love

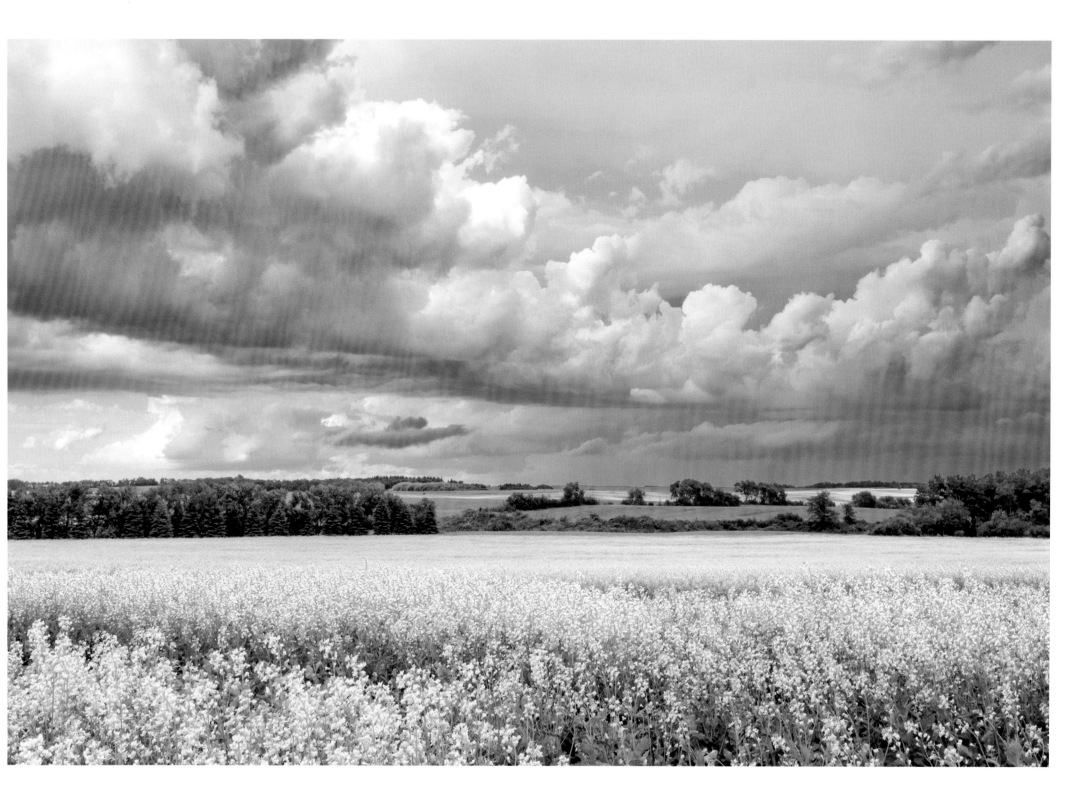

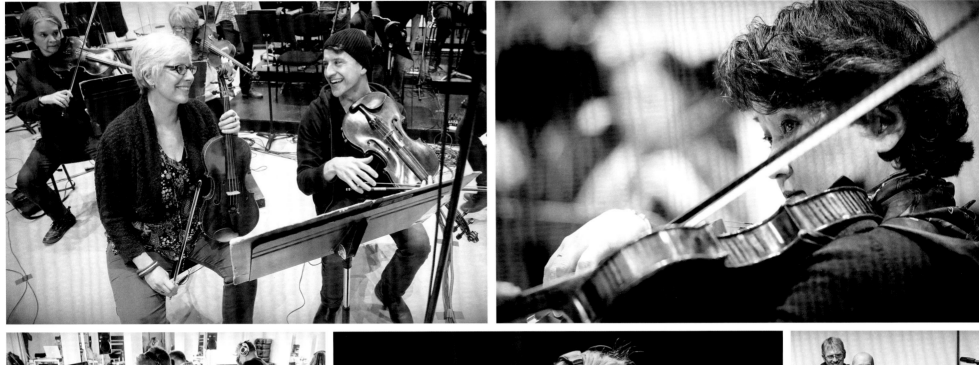
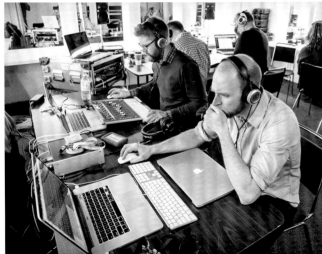
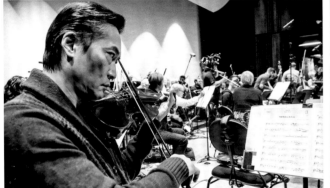
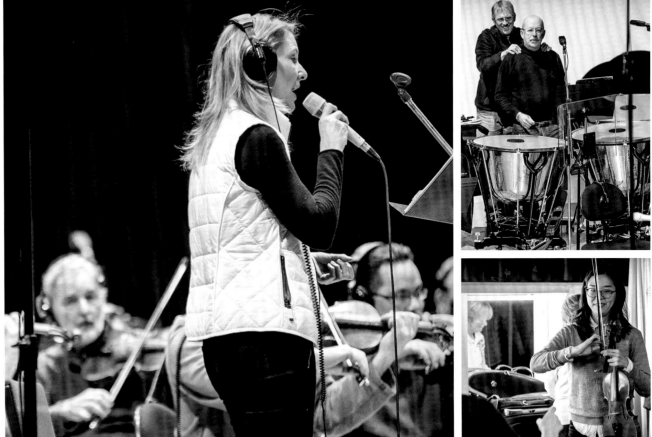

Justin Abedin on Still Believe In Love

When we, Jacksoul, went into the studio to record the song, it was just one among all the others we did for our third album, *Resurrected*. We never thought it would be our flagship song, the biggest of the band's career. Or that it would be the song we played over and again in performance, no matter where we were. No one expected that kind of success. Think of it: on the album it's track number *nine*, a song with a simple structure.

The album was Haydain's way of reclaiming his music. He brought together his favourite musicians and we recorded the whole album in a week! The idea was to pay tribute to soul music while putting our own spin on it, and "Still Believe In Love" was all him. There's hope and innocence in the song, and it gets right to the point with that Al Green–Otis Redding vibe. Haydain still believed in love, cheekily "just not with you." It opened doors for the band and it defined us. That year we had a lot of high-profile gigs and did a lot of touring, including with James Brown, the godfather of soul. After the song became a hit, every show we did, we closed with it.

When I showed up to play guitar for the *True North: The Canadian Songbook* recordings, I had no idea that "Still Believe In Love" was included. I found out only when I picked up the playlist. I was shocked—in a good way. It's an honour for Eleanor to have chosen it. Haydain's legacy lives on.

Justin Abedin parle de Still Believe In Love

Quand je suis entré en studio avec les autres membres de Jacksoul, *Still Believe In Love* n'était pour moi qu'un des morceaux que nous devions enregistrer pour *Resurrected*, notre troisième disque. Nous n'avons jamais cru qu'elle deviendrait notre chanson phare, la plus populaire de notre groupe. Ni que nous allions la jouer lors de presque tous nos spectacles, peu importe l'endroit. Personne ne s'attendait à un tel succès. Pensez-y : c'est la *neuvième* pièce de notre album, une chanson à la structure toute simple.

Le disque a permis en quelque sorte à Haydain de se réapproprier sa musique. Il a réuni ses musiciens préférés et nous avons enregistré tout l'album en une semaine seulement ! Il avait l'intention de rendre hommage à la musique soul à sa façon, et *Still Believe In Love*, c'est tout à fait lui. On y trouve de l'espoir et de l'innocence, et elle va droit au but avec son style qui évoque Al Green et Otis Redding. Haydain croyait encore à l'amour, mais, comme il le disait avec insolence, « pas avec toi » (« *just not with you* »).

La chanson a ouvert des portes à notre groupe. Elle nous a définis. Cette année-là, nous avons donné de nombreux spectacles prestigieux et nous avons fait beaucoup de tournées, notamment avec James Brown, le parrain du soul. Lorsque la chanson est devenue un succès, nous avons pris l'habitude de conclure chacun de nos spectacles en la jouant.

Quand je me suis pointé avec ma guitare pour l'enregistrement de *True North: The Canadian Songbook*, je n'avais aucune idée que *Still Believe In Love* en faisait partie. Je l'ai découvert seulement lorsque j'ai vu la liste des chansons. J'ai eu un choc, mais un choc agréable. C'est un honneur qu'Eleanor l'ait choisie. Le legs d'Haydain survit.

Oh how can I be sure
The sun will shine by and by
And now that I am yours
The world is still for you and I

You love me now
On your life you'll never let me go
But love is strange
And the surest things can change

The things we feel this day
The things we feel in time

GINO VANNELLI

The Surest Things Can Change

We trade moonlight vows
As you bring your lips to mine
But who can say
The things we feel this day
Are the things we feel in time

Oh how can I be sure
The sun will shine in the by and by
And now that I am yours
The world is still in a cloudless sky
But like a burst of rain

The surest things can change
The surest things can change
The surest things can change

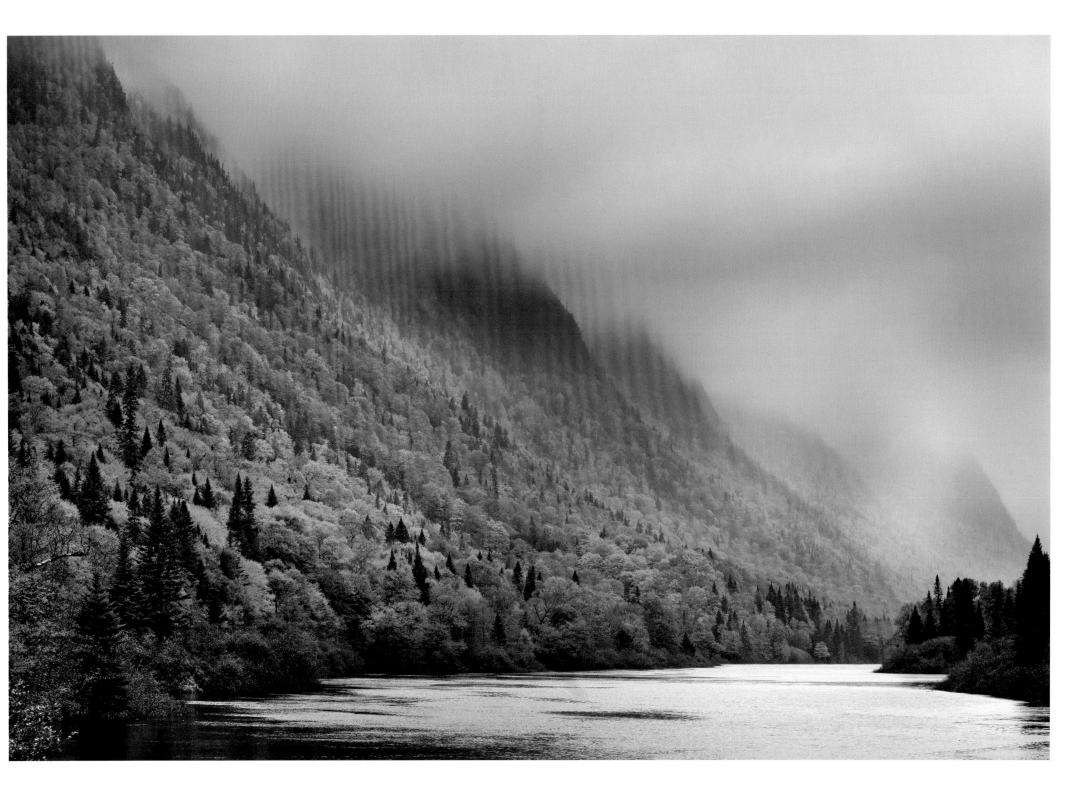

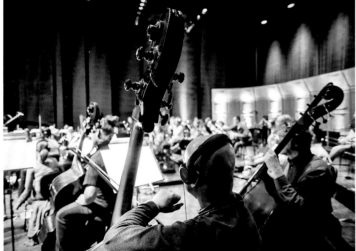

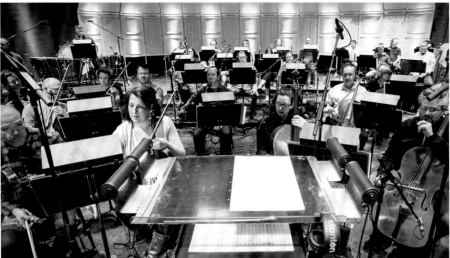

Gino Vannelli on The Surest Things Can Change

When I wrote the original version of this song at the "ripe old age" of 24, I already knew how unpredictable life was. I knew it could change at any moment—even the things you thought solid.

Back then I was already with the woman I would marry. But it took me a while to trust in matters of the heart completely. I reason differently today.

My wife and I depend on each other, yet we know to give each other space. Sometimes you can smother love like you would a fire; pile too much on top of it and it'll drown out. It's a rule you can apply to most anything in life. I believe the version I recorded in 2010, 33 years after the first, makes this theme a bit clearer.

When I decided to revise the song, I was planning to bring in a bunch of musicians to help record it, but when I started demoing it on my own, I felt I hit on something. It was simple, pared down—and left an open window for my voice and the new lines I revised. I love Tim Willcox's alto sax solo and vamp licks.

Gino Vannelli parle de The Surest Things Can Change

Quand j'ai écrit la version originale de cette chanson, à l'âge « vénérable » de vingt-quatre ans, je savais déjà à quel point la vie est imprévisible. J'étais conscient qu'elle pouvait changer à tout moment, même pour les choses que l'on croit immuables.

À l'époque, je fréquentais déjà la femme que j'allais épouser. Mais pour les histoires de cœur, j'ai mis du temps à faire totalement confiance à l'autre. Je ne pense plus de cette façon.

Ma femme et moi comptons l'un sur l'autre. Pourtant, nous savons nous accorder de l'espace. Il arrive parfois qu'on étouffe l'amour, comme on étouffe un feu : si on empile trop de bois, il crépitera, puis s'éteindra. C'est une règle qui s'applique à presque tout dans la vie. Je crois que je l'exprime plus clairement dans la version de la chanson que j'ai enregistrée en 2010, trente-trois ans après la première.

Lorsque j'ai décidé de la retravailler, je voulais m'entourer de plusieurs musiciens en studio, mais j'ai commencé ma maquette seul et j'ai senti que j'avais trouvé quelque chose. C'était simple, léger… et cette nouvelle version ouvrait une fenêtre pour ma voix et les paroles retravaillées. J'adore le solo de saxophone et les phrases sexy de Tim Willcox.

She's come undun
She didn't know what she was headed for
And when I found what she was headed for
It was too late

She's come undun
She found a mountain that was far too high
And when she found out she couldn't fly
It was too late

She's come undun
She found a mountain that was far too high
And when she found out she couldn't fly
It was too late

It's too late
She's gone too far
She's lost the sun
She's come undun

Undun

RANDY BACHMAN

It's too late
She's gone too far
She's lost the sun

She's come undun
She wanted truth but all she got were lies
Came the time to realize
And it was too late

Too many mountains and not enough stairs to climb
Too many churches and not enough truth
Too many people and not enough eyes to see
Too many lives to lead and not enough time

It's too late
She's gone too far
She's lost the sun
She's come undun

Randy Bachman on Undun

My first guitar mentor was Lenny Breau in Winnipeg. He taught me everything and he showed me a lot of jazz chords. I tried to get a melody around them, but I couldn't find words to fit. Then we got a gig in Vancouver with Frank Zappa and the Mothers of Invention, and this guy Zappa had discovered named Alice Cooper. We played there and in Seattle, Portland and San Francisco before coming back to Vancouver, where there was a party for us in the basement of one of those beautiful houses in the University Endowment Lands. Now, I don't smoke or do anything, but someone brought LSD and a very beautiful girl I'll call "M" took it and went into conniptions on the floor. She ended up in a coma.

The next day I was listening to FM radio in my hotel room on Burrard Street, and the DJ played a whole side by a guy named Robert Zimmerman, who changed his name to Bob Dylan. Somewhere in the middle of one of the songs— I think it was "Ballad In Plain D"—he said the words "She's come undone." I thought, "Wow, that's what happened last night at the party. She didn't know what she was headed for." Inspired, I started writing and then played it for Burton [Cummings] in his hotel room. He congratulated me and said, "Pick three verses and we'll record it."

It's called "Undun" because I like the phonetic spelling, like Sly and the Family Stone's "Thank You (Falettinme Be Mice Elf Agin)." It's still one of my favourite songs to perform—free-verse prose with a strong anti-drug message. I took it from Bob Dylan and made it more mainstream!

Randy Bachman parle de Undun

Mon premier mentor a été le guitariste Lenny Breau, à Winnipeg. Il m'a tout appris, entre autres beaucoup d'accords de jazz. J'essayais de créer des mélodies à partir de ces accords, mais je ne trouvais pas de paroles qui s'y harmonisaient.

Plus tard, nous avons donné un spectacle à Vancouver avec Frank Zappa and the Mothers of Invention, et un certain Alice Cooper que Zappa avait découvert. Après ce concert, nous avons joué à Seattle, à Portland et à San Francisco. De retour à Vancouver, quelqu'un a organisé une fête en notre honneur dans le sous-sol de l'une de ces belles maisons des University Endowment Lands (la dotation foncière universitaire). Je n'ai pas fumé et je n'ai consommé aucune drogue, mais quelqu'un avait apporté du LSD et une très belle fille que j'appellerai « M » en a pris. Elle s'est mise à avoir des convulsions sur le plancher et elle a fini par tomber dans le coma.

Le lendemain, j'écoutais la radio FM dans ma chambre d'hôtel sur la rue Burrard. L'animateur a fait jouer une face complète d'un disque de Robert Zimmerman, qui a changé son nom pour Bob Dylan. Au milieu de l'une de ses chansons (je crois qu'il s'agissait de *Ballad In Plain D*), il dit les mots « She's come undone » (« elle est en déroute »). Je me suis dit que c'était exactement ce qui s'était passé la veille, au *party*. La fille ne savait pas ce qu'il adviendrait d'elle. Inspiré par cet incident, j'ai commencé à composer une chanson que j'ai jouée à Burton [Cummings] dans sa chambre d'hôtel. Il m'a félicité et m'a dit : « Choisis trois couplets et on va l'enregistrer. »

Je l'ai intitulée *Undun*, qui a la même prononciation que « undone », parce que j'aime les transcriptions phonétiques — comme le titre de la chanson de Sly and the Family Stone, *Thank You (Falettinme Be Mice Elf Agin),* qui est un homophone de « Thank you for letting be myself again » et qui signifie « Merci de me laisser redevenir moi-même ». *Undun* est encore une des chansons que je préfère interpréter en spectacle avec ses rimes libres et son message anti-drogue très fort. Je me suis inspiré de Bob Dylan et j'en ai fait quelque chose qui a plu au grand public.

Who knows what tomorrow brings
In a world where few hearts survive
All I know is the way I feel
When it's real
I keep it alive

The road is long
There are mountains in the way
But we climb a step every day

The road is long
There are mountains in the way
But we climb a step every day

Love lift us up where we belong
Where the eagles cry
On a mountain high
Love lift us up where we belong
Far from the world we know
Up where the clear winds blow

Up Where We Belong

BUFFY SAINTE-MARIE

WILL JENNINGS

JACK NITZSCHE

Love lift us up where we belong
Where the eagles cry
On a mountain high
Love lift us up where we belong
Far from the world we know
Up where the clear winds blow

Some hang on to used to be
Live their lives looking behind
When all we have is here and now
All our lives
Out there to find

Time goes by
No time to cry
Life's you and I
Alive, today

Love lift us up where we belong
Where the eagles cry
On a mountain high
Love lift us up where we belong
Far from the world we know
Up where the clear winds blow

Lou Pomanti on Up Where We Belong

I've always been a fan of Joe Cocker. I loved the movie *An Officer and a Gentleman* and I love that the great Buffy Sainte-Marie was one of this song's writers. But record production in the 1980s suffered from what I call "new gear syndrome," with the introduction of synthesizers and drum machines. We were all infatuated with the new stuff and kind of took it too far. So when it came to arranging the song for this recording, I said I would do it if I could do something that was absolutely different from the version that was recorded for the film.

This is my process: I shut the door to my studio, I brew a cup of tea and the world goes away. I listen to the song a couple of times on the record, learn it on the piano and never listen to it again. Next I work on a deconstruction, where I take the song down to its barest minimum of piano and voice. Then I build up from there. To me, building it up is the fun part—I can be as creative as I want—and knowing Eleanor's voice, I decided to make it as beautiful as possible.

Under normal circumstances I'll give clients my first version and they may love it but ask for a few changes. Not in this case, though. Don and Eleanor loved it, and that's pretty rare.

Lou Pomanti parle de Up Where We Belong

J'ai toujours aimé Joe Cocker. J'adorais le film *Officier et gentleman* et je me réjouissais que la grande Buffy Sainte-Marie soit l'une des auteurs de cette chanson. Toutefois, dans les années 1980, la production de disques souffrait de ce que j'appellerais le « syndrome de la nouvelle machine » avec l'avènement des synthétiseurs et des batteries numériques. Nous étions tous entichés de ces nouveaux instruments et, d'une certaine façon, nous sommes allés trop loin. Alors quand on m'a demandé de préparer les arrangements de cette chanson pour le disque, j'ai dit que j'accepterais si je pouvais faire une version complètement différente de celle qui avait été enregistrée pour le film.

Voici comment je procède : je ferme la porte de mon studio, je me prépare une tasse de thé et le reste du monde disparaît. J'écoute la chanson à quelques reprises sur disque, j'apprends à la jouer au piano et je ne l'écoute plus jamais. Je commence par déconstruire la chanson : je la ramène à sa plus simple expression pour piano et voix. Ensuite, je la rebâtis. C'est la partie du travail qui m'amuse le plus, parce que je peux être aussi créatif que je le veux. Connaissant la voix d'Eleanor, j'ai décidé de faire les plus beaux arrangements possible.

Dans les circonstances normales, je remets ma première version aux clients. Parfois, ils l'aiment, mais ils me demandent quelques changements. Mais pas dans le cas de cette chanson. Don et Eleanor l'ont adorée dès le départ, ce qui est très rare.

When the light goes dark with the forces of creation
Across a stormy sky
We look to reincarnation to explain our lives
As if a child could tell us why

That as sure as the sunrise
As sure as the sea
As sure as the wind in the trees

We rise again in the faces of our children
We rise again in the voices of our song
We rise again in the waves out on the ocean
And then we rise again

LEON DUBINSKY

When the waves roll on over the waters
And the ocean cries
We look to our sons and daughters to explain our lives
As if a child could tell us why

That as sure as the sunrise
As sure as the sea
As sure as the wind in the trees

We Rise Again

We rise again in the faces of our children
We rise again in the voices of our song
We rise again in the waves out on the ocean
And then we rise again

We rise again in the faces of our children
We rise again in the voices of our song
We rise again in the waves out on the ocean
And then we rise again
And then we rise again

Leon Dubinsky on We Rise Again

I was visiting my father in Cape Breton in 1985, watching him watch a couple of his grandchildren swimming. His health wasn't good at the time—he'd had heart surgery and he passed away a year later. All of a sudden I started to see the world through his eyes, with all the laughter, loss, rebirth, legacy and love.

The first line I wrote was "When the light goes dark with the forces of creation/Across a stormy sky/We look to reincarnation to explain our lives/As if a child could tell us why." That line was inspiration. The rest of the lyrics were perspiration. I sweated them out like crazy, right up to when we performed the song that summer in *The Rise and Follies of Cape Breton Island*, a musical revue.

The song is played at funerals, and a friend of mine had it playing in the delivery room when his child was born. After The Rankin Family recorded it in 1993, my niece went on a trip called March of the Living, an annual event for Jewish teenagers to visit the Holocaust memorial, Yad Vashem, in Jerusalem, and Auschwitz, in Poland. She taught it to the rest of the kids on the trip, and that's what they were singing—"We Rise Again"—as they walked into the concentration camp.

Leon Dubinsky parle de We Rise Again

En 1985, je suis allé rendre visite à mon père au Cap-Breton. Il venait de subir une chirurgie cardiaque et sa santé était précaire. D'ailleurs, il est décédé l'année suivante. Il surveillait ses petits-enfants qui nageaient et, en le regardant, je me suis mis à voir le monde par ses yeux, avec les rires, les pertes, les renaissances, l'héritage et l'amour.

Les premiers vers que j'ai écrits ont été « When the light goes dark with the forces of creation/Across a stormy sky/We look to reincarnation to explain our lives/As if a child could tell us why » (« Quand le ciel s'assombrit sous les forces de la création/Dans le ciel d'orage/Nous nous tournons vers la réincarnation pour savoir pourquoi nous vivons/Comme si un enfant pouvait nous l'expliquer »). Ce sont ces mots qui m'ont inspiré. Les autres paroles me sont venues avec beaucoup d'efforts. J'ai travaillé comme un fou jusqu'au moment où nous avons interprété la chanson pour l'émission de télévision *The Rise and Follies of Cape Breton Island* diffusée plus tard au cours de l'été.

On entend cette chanson à toutes sortes d'occasions. On la joue souvent lors de funérailles, mais un ami l'a aussi fait jouer dans la salle d'accouchement quand son fils est né. La Famille Rankin l'a enregistrée en 1993 et, peu après, ma nièce a participé à la Marche des Vivants, un voyage organisé chaque année pour permettre aux adolescents de visiter Yad Vashem, le mémorial de l'Holocauste à Jérusalem, et Auschwitz en Pologne. Elle a enseigné *We Rise Again* aux autres jeunes de son groupe et ils l'ont tous entonnée en entrant dans le camp de concentration.

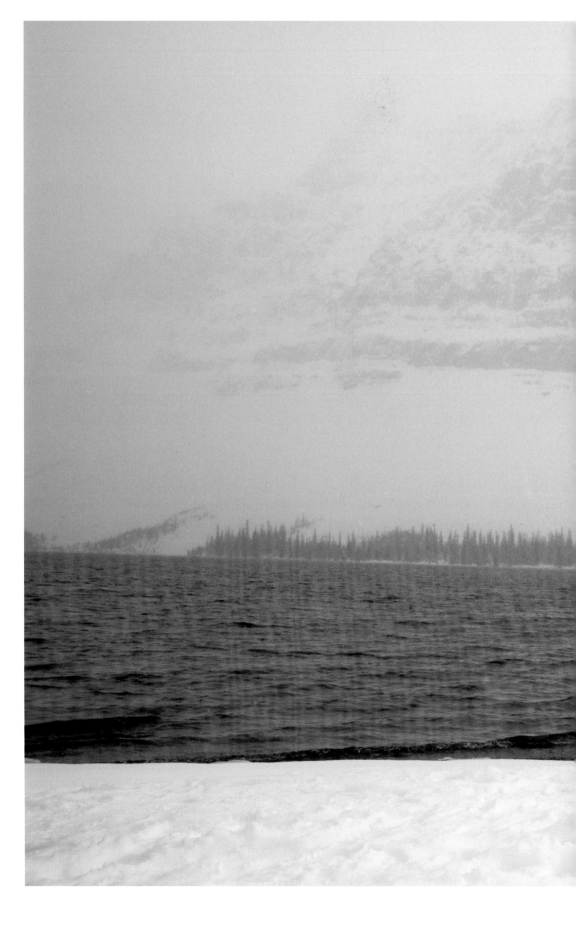

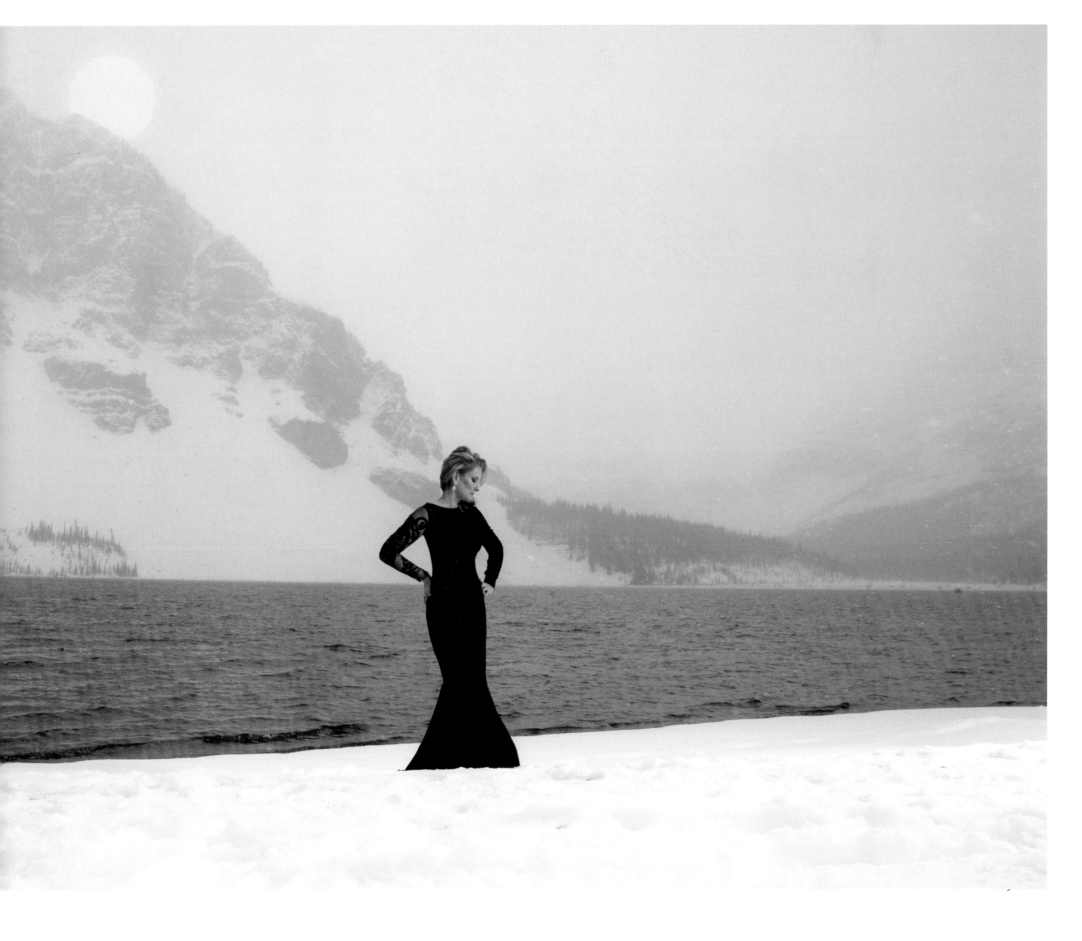

The Making of True North: The Canadian Songbook

FROM THE BEGINNING, the logistics and cost of this project all pointed towards one course of action— don't do it! And yet through 2014, as I listened to my initial playlist of songs (and subjected my daughter to it daily in the car), I couldn't get the idea out of my mind. Common sense told me I was crazy to do this, but my heart could not let the idea go and it propelled me forward. I am so glad I didn't let common sense get in the way.

Saying yes to this project was the beginning of an incredible journey, one I took in the company of countless talented, passionate people. "Canada" is believed to come from the Huron-Iroquois word meaning "village," and it has indeed taken a Canadian village, from coast to coast, to make this project happen. This is the story of the journey and the people, and how together we took *True North: The Canadian Songbook* from concept to reality.

Groundwork

Choosing the perfect producer for the album was a decision I sat with for a long time. The person who kept coming to mind was a man I'd never worked with before and knew only by reputation—Don Breithaupt, a songwriter, arranger, producer, musician and Emmy Award–winning composer. I'd admired his work for years, especially the songwriting he did with his brother, Jeff. Knowing that Don was exceptionally musical and had a wide range of expertise, I felt sure that if anybody could handle the cross-genre aspect of the project, it was him.

Coincidentally, in 2014, just as I was thinking of contacting Don, he emailed me. It seemed like fate had put us in touch. When we met in February 2015 for our first real discussion of the project, Don loved the idea, and in the days that followed, with each email he sent me, his excitement grew. I knew we were on to something special.

Time was of the essence. Don and I met a few times in 2015 to choose the songs and the keys, and to workshop arrangements and research possible arrangers. Rather than shortening the song list, Don's suggestions led us to increase it, from 21 to 31, including an original song written by Don and Jeff. We added the 32rd song, "Get Me Through December," just days before recording the bed tracks with the band in February 2016.

From a lifetime of interpreting songs, I know the importance of an expertly wrought arrangement. While my original thought was to choose arrangers so as to ensure regional representation, something akin to magic happened along the way. We ended up with 14 extraordinary arrangers (including Don, who created nine arrangements). Together they crafted 32 orchestrations, each one uniquely beautiful.

We knew the backbone of this project would be the orchestras. With an orchestra, an arranger has a palette of 40 to 60 musicians to draw on rather than only a few instruments in a band. Knowing we wanted to be truly pan-Canadian—a point I wasn't willing to give on, having considered and decided against using only one orchestra—Neil Edwards, then CEO of the Newfoundland Symphony

Orchestra, helped me reach out to organizations across the country to gauge their interest. Neil, whom I knew through my concerts with the NSO, quickly became one of my closest friends and was, so to speak, instrumental in exploring relationships with orchestras. By the end of the year 10 had signed on, from St. John's to Victoria.

When it came to choosing a conductor, my discussion with Neil was brief. We had both worked with the acclaimed young Canadian conductor Martin MacDonald, and we both knew he was the man for the job. We were right. A couple of hours later, the deal was done. Marty was in.

The team

Throughout 2015 and 2016 there was an unbelievable amount of work to do. In the early days my confidants and advisors were Don and Neil, as well as Susan Abramovitch, my trusted lawyer and friend for over a decade. All have continued to be key members of the team throughout the project. Their expertise has been invaluable to me.

We knew from the start that the project I'd proposed was mammoth and would take an extensive team of exceptional people to see it through. While I had recorded five prior albums, the projects and teams for them were much smaller. I knew I didn't have access on my own to the infrastructure I would need to pull this off.

With each day, my stress level increased exponentially over the mounting details. But thanks to Susan and Neil, our team eventually grew into one of the most impressive groups of people I have ever known or had the pleasure

of working with. Each member was an expert in their field and each brought true passion and dedication to *True North: The Canadian Songbook*. I have loved every moment of working with these individuals, and I will be eternally grateful for all they have dedicated to this project.

Starting in the fall of 2015, we held monthly team meetings to assess every aspect of the project in detail. Susan, along with her team at Gowling WLG—including René Bissonnette, Sean Gill and her assistant Heidi Umstadt—expertly negotiated the many contracts and developed the overall business strategy. Her dedication to this project and her wisdom have been invaluable. (I think the file for this project takes up considerable real estate on her office window ledge.) Neil, aside from fostering the initial relationships with orchestras, reached out to many of the guest artists and is the key contact for my 2017–2018 concert tour. Justin West, founder of Secret City Records and our lead business consultant, brought a wealth of knowledge about the music business that guided our process and strategic planning from beginning to end.

Through Susan I met PR expert Deb McCain, who creatively built awareness of the project along with her colleague Wonjay Chang on the social media side. Through Justin's extensive network, we brought the amazing Olivier Sirois (and his wonderful Montréal-based team at Opak including Laurie Mathieu-Bégin, Alexandre Jacques, Rémi Marsan, and Sébastien Paquin) and Mélanie Vaugeois into the fold. For months they worked tirelessly to set up our complex cross-country orchestra recording tour and our

BEFORE WE EVER worked together, I had a personal connection to Don Breithaupt, producer of this album. His mother, Myra, and my mother went to university together and have remained best friends ever since. It's odd, really, that the friendship between our mothers never brought us together… until this project.

In a twist of fate, in December 2014, at the same time I was thinking of contacting Don about my idea for a pan-Canadian recording project, he emailed me out of the blue. He wanted, as he put it, to "hang out his shingle" and he asked if we might collaborate sometime, somehow. I couldn't believe the timing. It had to be a sign. I told him I did have something in mind and that, believe it or not, I'd been planning to contact him. Though I didn't go into detail (Christmas was around the corner), I did tell him that the idea involved Canadian music and orchestras and was for Canada's 150th birthday.

Early in 2015 my marriage ended, abruptly and heartbreakingly. Within days of this emotional event, Don reached out again to see if I was ready to discuss the "Canadian idea." This solidified my sense that fate was at play and we were meant to work together.

J'AVAIS UN RAPPORT personnel avec Don Breithaupt, le producteur de cet album, avant de travailler avec lui. Sa mère, Myra, et la mienne sont amies depuis qu'elles se sont connues à l'université. C'est vraiment étrange que l'amitié de nos mères ne nous ait pas amenés à collaborer bien avant ce projet.

En décembre 2014, je projetais de communiquer avec Don pour lui parler de mon projet. À la même époque, il m'a écrit un courriel parce qu'il voulait « faire sa marque ». Son message tombait vraiment bien, c'était incroyable ! Cela devait être un signe. Je lui ai dit que j'avais un projet en tête et que j'avais songé à l'approcher. Sans lui donner de détails (Noël arrivait à grands pas), j'ai quand même ajouté que mon projet concernait la musique et les orchestres du pays et qu'il soulignerait le 150ᵉ anniversaire du Canada.

Au début de 2015, mon mariage a pris fin de manière abrupte. J'avais le cœur brisé. Quelques jours après cet événement bouleversant, Don est revenu vers moi en me demandant si j'étais prête à lui parler de mon « idée canadienne ». Son approche m'a confirmé que c'était un signe du destin et que nous étions faits pour travailler ensemble.

THE PERFORMANCE OF one guest artist in particular will always move me to tears, that of my daughter, Laura David. "We Rise Again," by Leon Dubinsky, was written with the idea that we rise again in the faces of our children. Who better to communicate this than Laura? She is my pride, joy and reason for being. She sang her part beautifully along with the Saskatoon Children's Choir.

IL Y A une interprétation d'une artiste invitée en particulier qui m'émeut aux larmes : c'est celle de ma fille, Laura David. Leon Dubinsky a composé *We Rise Again* pour exprimer la nécessité de garder courage pour nos enfants. Qui pouvait rendre cette idée mieux que Laura ? Elle est mon bonheur, ma fierté et ma raison d'être. Elle a fait une magnifique interprétation avec le Saskatoon Children's Choir.

guest artist recording sessions, and dealt with 14 arrangers to make sure we were set for the sessions. (Olivier also provided me with the blue M&M's I'd joked I wanted for my gigs.) Jackie Paré, the tour manager, looked after all the details on the road.

As the recording ramped up, the team of Jeremy Tusz, James Clemens-Seely, Christopher Johns and, on a couple of stops, Carl Talbot, stepped in with their unique mobile recording system. They planned and executed the intricate details of recording 10 orchestras in a range of venues, with a limited schedule for each session. The always-prepared Marty MacDonald spent weeks studying 32 new scores and audio files to make sure the recording sessions were as efficient and radiant as possible when he hit the podium. And Don Breithaupt's talented musicianship shone throughout—his producing, his beautiful piano performances and his gorgeous arrangements.

John Bailey, arguably one of the best recording engineers in Canada, captured my vocals and many guest performances at Phase One Studios. All of these sessions were assisted by Milan Sarkadi and Darren McGill. Taylor Kernohan provided key additional engineering on the album. Some guest artists performed in their own cities; their contributions were expertly recorded by engineers from coast to coast. And for the final stage of the recording process, John, along with Don, went over every minute of music, to make each arrangement shine as he mixed what is essentially three albums' worth of songs squeezed onto two discs—a daunting task that he met heroically.

For my own part, Lorraine Lawson, my vocal coach and one of our gifted background singers, worked with me on the songs for a year before we entered the studio to create the final vocals. For over a month, several days a week, Lorraine pushed me and inspired me. Her expert ideas and unflagging enthusiasm helped me take my singing to places I'd never been before.

Choreographer Karren Hammond spent many a sleepless night with her creative mind racing with ideas about the flow and design of the live show. Shelley Bunda kept my hectic life chugging along effortlessly. Paul Campbell spearheaded the details for the CD release party along with event planner Jeffry Roick. And Tracy Finkelstein began planning the marketing strategy for the release of the album.

At the centre of us all was the truly amazing project manager Darlene Sawyer, whose years in the entertainment field (working closely with Anne Murray) enabled her to manage every single business detail (and these "details" were enormous), in several areas of the project—not to mention all of us!—with remarkable professionalism and always-positive energy.

Beyond the music

As the album planning shifted into high gear, I began actively pursuing the idea of a book. For advice I turned to the one photographer I knew well and whose work I greatly admired—nationally recognized portrait photographer V. Tony Hauser. After we met in May 2015, he asked for the summer to

think about recommendations. In September he not only shared his ideas but, to my great surprise and delight, offered to help curate the book. To me, knowing nothing about creating a book (whereas Tony had created many), this was an incredible gift and yet another sign that I was meant to do the project. I was thrilled to have a partner for this component, and even more so that it was Tony Hauser.

Over the next while, Tony thoughtfully researched more than 400 images by photographers from all regions of the country, and we set out on a journey to find photos that matched the sentiment of each song, ultimately choosing 32 landscape photographs by 23 photographers from coast to coast.

Tony's own brilliant work (uncharacteristically in colour) appears in this book in what I jokingly call a Where's Waldo?–like series of portraits in various settings—from British Columbia's towering Douglas firs to Newfoundland and Labrador's majestic (and freezing) Cape Spear—of me wearing the creations of Canadian designers. The success of these images is due not only to Tony but to a group of talented people I've worked with for years: my longtime hairstylist (and friend) Paul King, talented makeup artist Vanessa Jarman, and stylist and design maven Wendy Natale. As we shot the photos in different settings, the laughter I shared with this group was as indelibly imprinted on my soul as was the beauty of the landscape.

To make the book a reality, we searched for a publisher who could understand the passion and vision behind it. After much research, we connected with Vancouver-based publisher Page Two, whose professionalism and support have been invaluable. Co-founder Jesse Finkelstein, designer Peter Cocking, publishing services manager Gabrielle Narsted, editor Frances Peck, and translator Rachel Martinez have been amazing in bringing the project's many elements together to create this beautiful book.

As we continued with the book, the concept expanded to include lyrics, to showcase the poetry of each song, as well as notes from the songwriters and other artists connected with the songs. These notes, thanks to a stroke of genius by Justin West and an incredible amount of follow-up by Darlene and interviewer/writer Lisa Fitterman, offer wonderful insight into the inspiration behind the songs and had a huge impact on how I approached them. I am very grateful to the artists for their generosity and the personal stories they shared with us.

Finally, we felt it was important to capture images of the recordings as the reimagined arrangements were brought to life. Through Neil Edwards and my concerts with the NSO, I had come to know their photographer, Greg Locke, and admire his work. To my delight, Greg agreed to photograph the orchestra recording sessions and some of the guest artist sessions. His photos show the energy of every session so beautifully. I am thankful that his work, along with pictures from additional photographers, is featured in this book.

Then—just because we didn't have enough on our plate already—we decided to create a documentary. How could you go on such a journey and not capture (and share) this experience on film? While many people contributed footage

along the way, Keith Chang and his team at Silverpoint Media beautifully filmed all of the orchestra sessions and many of the guest artist recording sessions, as well as commentary from people involved in the project.

Recording

By February 2016 it was time to put a full year of intense planning into action.

The studio sessions were our first window into seeing where the arrangements would go. Some of Canada's finest musicians gathered at Phase One Studios in Toronto for six full days of recording the bed tracks for each song: Don Breithaupt on piano (apart from the three Lou Pomanti arrangements, which Lou played himself), Justin Abedin on guitar, Mark Kelso on drums and Pat Kilbride on bass. It was a thrilling and exhausting week that I will never forget. A few months down the road, Lorraine and Quisha Wint added their gorgeous background vocals to the mix. These musicians created magic at every turn and set the foundation for the recording sessions to come.

One month later the recording tour took flight. The first week was a true test: we started in Edmonton and moved east to Halifax and Saint John in the span of six days. Would the equipment all arrive on schedule and work as planned? Had we booked enough recording time? We were all more than a little nervous. By the time the first week ended, we breathed a collective sigh of relief—we'd made it through with virtually no mishaps. When I look back, it was probably best that we started with three dates in a row (and at opposite ends of the country) to get the routine down to a science.

I cannot begin to say how impressed I was, and still am, at the expertise of this group.

As expected, between March and the end of the tour in June, there were some hiccups, but we managed to live with them. A freezing rainstorm in Atlantic Canada that cancelled all flights, forcing us to make the trip from Halifax to Saint John in rental cars. Mechanical problems that grounded the engineering crew not in St. John's, where they needed to be, but across the province in Deer Lake, where they scrambled to find a vehicle so they could drive seven hours through heavy fog to reach their destination. A video camera that we used for streaming each session that was lost and never found. Rushing with Darlene and arranger Peter Cardinali to Winnipeg's Centennial Concert Hall to catch the last half of rehearsal with the Winnipeg Symphony Orchestra after another storm seriously delayed our arrival. All in a day's work, right?

These are not the memories, however, that come first to mind. It is nigh on impossible to describe the energy and excitement of meeting musicians from coast to coast. Sharing an evening of stories and laughter with Cape Breton songwriter Allister MacGillivray and his wife Beverly at their home on the Mira River, for which the song is named. Watching team members reunite with musicians they hadn't seen in ages. Reconnecting with symphonies and players I know and love. Witnessing Marty skillfully work with the arrangements and with each orchestra to achieve incredible results. Seeing Don deftly execute his producer duties and Jeremy, James, Christopher and Carl record every note. Admiring Mélanie with her perfect pitch make sure that

all was in tune. Relying on Jackie and Darlene to organize every detail. And experiencing the emotion and magic as the gifted orchestras brought the music to life. To sing with orchestras—always a love of mine— and hear the arrangements come to life was a great privilege. The feeling of doing this from city to city, over the course of three months, will remain in my heart forever. I am grateful to every orchestra for bringing its talent to this project.

I will also treasure working with the fine guest artists who graced this album with their musicianship. Every session blew me away listening to the extraordinary talent of every artist. Of special note, I was not only moved by the depth of Jan Lisiecki's performance, but his participation in this project marked his first recording outside the genre of classical music. And meeting the Men of the Deeps and learning from three original members how the coal miner singing group began 50 years earlier was a memorable moment on this journey. Their performance gave me goosebumps, as did so many performances on this album. I am in awe of the gifts of all our guest artists, whose performances spotlight the enormous talent in our country.

To cap it off, all of the arrangers were able to hear at least one of their arrangements come to life, either in person or by video stream. It's rare that arrangers get to be part of the recording process, and they were thrilled, as were we, to be in on the journey.

The friendships that were established on this tour, full of music and laughter—lots of laughter—are ones we will cherish forever.

Hope

I would like to thank the entire team of *True North: The Canadian Songbook*, and countless others, for joining me on this incredible journey and for so freely giving their extraordinary talent and passion to this Canadian project.

I'd also like to say a special thank you to Don and his brother Jeff, the Breithaupt Brothers, whose song "I Can See Hope From Here" was written especially for this album. The beginnings of the song occurred when their brother Ross woke up one morning in Georgian Bay, saw Hope Island in the distance and spoke these very words. When Don shared the possible song title and idea with me, I said yes without a second's thought.

This is what *True North: The Canadian Songbook* signifies for me. My heart has healed through the music and the people involved in this epic project. Because of you all, I truly can see hope from here.

Coda : les coulisses de la création de True North: The Canadian Songbook

DÈS LE DÉPART, la logistique et les coûts de ce projet nous orientaient vers une direction : ne le faites pas ! Et pourtant, durant toute l'année 2014, pendant que j'écoutais ma liste préliminaire de chansons (et que je l'infligeais quotidiennement à ma fille dans la voiture), je n'arrivais pas à chasser cette idée de mon esprit. Le gros bon sens me disait que j'étais folle d'entreprendre un tel projet, mais mon cœur ne parvenait

RENOWNED PORTRAIT photographer V. Tony Hauser took pictures of me across Canada wearing the creations of Canadian designers. My love for fashion goes back many years, as my mother will attest. That said, I'm a study in contrasts. When I'm not in an evening gown, my go-to outfit always includes a comfy pair of sweatpants.

Believe me when I say that the efforts of my hairstylist Paul King, makeup artist Vanessa Jarman and stylist Wendy Natale, and of course Tony, are largely responsible for the success of these images. As we shot the photos in the selected settings, the beauty of the landscape was indelibly imprinted on my soul, as was the laughter with this group along the way.

V. TONY HAUSER, portraitiste renommé, m'a photographiée aux quatre coins du pays. Sur ses photos, je porte des créations de designers canadiens. Mon amour pour la mode remonte à de nombreuses années. Ma mère vous le confirmera ! Cela dit, j'aime les contrastes. Quand je ne suis pas en robe de soirée, ma tenue de prédilection comporte toujours un pantalon en coton ouaté confortable.

Croyez-moi quand je vous dis que les talents de mon coiffeur Paul King, de ma maquilleuse Vanessa Jarman et de ma styliste Wendy Natale, et bien entendu de Tony, sont en grande partie responsables de la beauté de ces photos. Ils ont déployé beaucoup d'efforts pour associer chaque lieu à une création vestimentaire unique. Et nous avons beaucoup rigolé !

pas à l'abandonner. C'est ce qui m'a poussée vers l'avant. Je suis tellement heureuse de ne pas avoir laissé la logique entraver mes plans !

Je me suis donc lancée dans une aventure incroyable, accompagnée d'innombrables personnes talentueuses et passionnées. On dit que « Canada » vient d'un mot huron-iroquois signifiant « village ». Et il a fallu en effet tout un village canadien, d'un océan à l'autre, pour rendre possible ce projet. Voici l'histoire d'une aventure et de ses protagonistes, et de la façon dont *True North: The Canadian Songbook* est passé du rêve à la réalité.

Travail préparatoire

J'ai longtemps mûri la décision de choisir le producteur idéal. Le nom qui me venait constamment à l'esprit était celui d'un homme avec qui je n'avais jamais travaillé et que je connaissais de réputation seulement : Don Breithaupt, un auteur-compositeur, arrangeur, producteur, musicien et compositeur, lauréat d'un prix Emmy. J'admirais son travail depuis des années, particulièrement les chansons qu'il a écrites avec son frère Jeff. Sachant que Don avait des talents musicaux exceptionnels et une longue expérience, j'étais sûre que, si quelqu'un pouvait être à l'aise avec le genre mixte de ce projet, c'était bien lui.

En 2014, par pure coïncidence et au moment même où je songeais à l'approcher, Don m'a écrit un courriel. J'ai eu l'impression que le destin nous avait mis en contact. Lorsque nous nous sommes rencontrés en février de l'année suivante pour amorcer les discussions, Don a adoré l'idée. Les jours suivants, je sentais son enthousiasme augmenter dans chacun de ses courriels. Je savais que nous avions élaboré un projet unique.

Le temps était compté. Don et moi nous sommes rencontrés à quelques reprises en 2015 pour choisir les chansons et les tonalités. Nous avons commencé à travailler aux adaptations pour orchestre et à chercher des arrangeurs pour chaque chanson. Plutôt que de raccourcir, la liste s'allongeait avec les suggestions de Don. Elle est passée de vingt et une à trente et une chansons, notamment un titre original composé par Don et Jeff. Nous avons ajouté la dernière, *Get Me Through December*, quelques jours à peine avant d'enregistrer les pistes maîtresses avec quelques musiciens, en février 2016.

Moi qui chante depuis toujours, je connais l'importance des arrangements signés par un expert. Mon intention de départ était de choisir des musiciens pour assurer une représentation régionale sur l'album, et quelque chose qui ressemble à un miracle s'est produit : nous avons déniché quatorze arrangeurs exceptionnels (incluant Don qui a signé neuf adaptations). Ensemble, ils ont concocté trente-deux orchestrations, et chacune est d'une beauté unique.

Nous savions que les orchestres constitueraient la colonne vertébrale de l'album. Ils permettent à un arrangeur d'exploiter les talents de quarante à soixante musiciens, plutôt que de quelques instruments. Sachant que nous tenions à être vraiment représentatifs de l'ensemble du Canada — un critère que je n'étais pas près de laisser tomber, puisque j'avais abandonné l'idée de faire appel à un seul orchestre —, Neil Edwards m'a aidée à tâter le pouls des autres formations. Je l'avais rencontré

à l'occasion de concerts que j'avais donnés avec l'Orchestre symphonique de Terre-Neuve qu'il dirigeait, et il est rapidement devenu un de mes meilleurs amis. Il a joué un rôle capital pour solliciter les orchestres. À la fin de l'année, dix orchestres s'étaient engagés, de St. John's à Victoria.

Quand est arrivé le temps de choisir un chef d'orchestre, ma discussion avec Neil a été des plus brèves. Nous avions tous les deux travaillé avec le brillant jeune maestro canadien Martin MacDonald et nous étions persuadés qu'il était l'homme de la situation. Nous ne nous sommes pas trompés. Quelques heures plus tard, l'affaire était conclue.

L'équipe

Nous avons abattu énormément de travail en 2015 et 2016. Au début, mes confidents et mes conseillers étaient Don et Neil, ainsi que mon avocate Susan Abramovitch qui est aussi mon amie depuis plus de dix ans. Tous sont demeurés des membres clés de l'équipe. Leur expertise a une valeur inestimable pour moi.

Nous savions dès le départ qu'il nous faudrait réunir une équipe considérable de gens exceptionnels pour mener à bien ce projet d'une envergure inouïe. J'avais cinq albums à mon actif, mais il s'agissait de réalisations et d'équipes beaucoup plus modestes. Cette fois, je savais que je ne pouvais pas, à moi toute seule, avoir accès à l'infrastructure nécessaire pour concrétiser mon rêve.

Devant la montagne de détails à régler, mon stress augmentait de manière exponentielle. Toutefois, grâce à Susan et à Neil, notre équipe est devenue l'un des groupes de personnes les

plus impressionnantes que j'ai connues ou avec qui j'ai eu le plaisir de travailler. Chacun était un expert dans son domaine, et chacun nous a fait profiter de sa passion et de sa générosité pour mener à bien *True North: The Canadian Songbook*. J'ai adoré chaque moment passé en leur compagnie et je leur serai éternellement reconnaissante pour leur dévouement.

À partir de l'automne 2015, nous avons organisé des réunions mensuelles pour passer au crible chaque aspect du projet. Susan a négocié les nombreux contrats de main de maître avec le soutien de son équipe chez Gowling WLG, dont faisaient aussi partie René Bissonnette, Sean Gill et leur adjointe Heidi Umstadt, et elle a élaboré la stratégie d'affaires. Son dévouement et sa sagesse ont été inestimables. (Je pense que les dossiers occupent beaucoup d'espace sur le rebord de la fenêtre de son bureau.) En plus de solliciter les orchestres, Neil a approché une bonne partie des artistes invités et il est la personne clé pour la tournée de concerts de 2017–2018. Justin West, fondateur de Secret City Records et notre principal conseiller d'affaires, a partagé ses précieuses connaissances de l'industrie de la musique, ce qui nous a guidés au cours du processus de création et de la planification stratégique, du début à la fin.

Par l'entremise de Susan, j'ai rencontré la spécialiste des relations publiques Deb McCain qui a fait preuve d'une créativité remarquable pour faire connaître ce projet, avec l'aide de son collègue Wonjay Chang pour les médias sociaux. Grâce au vaste réseau de Justin, nous avons recruté le formidable Olivier Sirois (et sa merveilleuse équipe chez Opak à Montréal qui réunissait Laurie Mathieu-Bégin, Alexandre Jacques, Rémi Marsan et Sébastien Paquin) ainsi que Mélanie Vaugeois. Ils ont travaillé

FROM TIME TO TIME we'd have guests visit the sessions, including my mother and my brother, Scott. I loved watching their reactions. No matter how many times I described what I was doing, nothing compared to having them be part of a session. Then they could see how special the project was, the complex logistics involved and the incredible people who made it happen.

DES INVITÉS VENAIENT à l'occasion me voir en studio, entre autres ma mère et mon frère Scott. J'adorais observer leurs réactions. Peu importe le nombre de fois où je leur ai expliqué ce que je faisais, assister à des séances d'enregistrement leur a vraiment permis de constater à quel point le projet était exceptionnel. Ils ont compris la complexité de la logistique et, surtout, ils ont rencontré les personnes hors du commun qui ont rendu tout ça possible.

sans relâche pendant des mois pour organiser la très complexe tournée d'enregistrement avec les orchestres et les artistes invités. Ils ont communiqué avec quatorze arrangeurs pour s'assurer qu'ils étaient prêts pour les séances. (Olivier m'a fourni les bonbons m&m bleus dont j'avais prétendu à la blague avoir besoin pour mes spectacles.) La directrice de tournée, Jackie Paré, voyait à tous les détails lorsque nous étions en déplacement.

À l'approche de l'enregistrement, Jeremy Tusz, James Clemens-Seely, Christopher Johns et, à certains endroits, Carl Talbot sont venus nous prêter main-forte avec leur studio mobile. Ils ont planifié et réglé la foule de détails nécessaires pour enregistrer dix orchestres dans les lieux les plus divers, et ce, en respectant un horaire limité pour chaque séance. Marty MacDonald, toujours prêt, a passé des semaines à étudier trente-deux partitions et fichiers audio pour s'assurer que les séances d'enregistrement étaient aussi efficaces et lumineuses que possible quand il montait sur son podium. Et les qualités exceptionnelles de Don Breithaupt transparaissaient partout : dans son travail de producteur, ses magnifiques interprétations au piano et ses arrangements élégants.

John Bailey, qui est probablement l'un des meilleurs ingénieurs du son au pays, a enregistré ma voix et les prestations de nombreux invités aux studios Phase One, avec l'aide de Milan Sarkadi et de Darren McGill. Taylor Kernohan a aussi apporté une contribution importante aux enregistrements. Certains artistes invités se sont produits dans leur propre ville et leur interprétation a été enregistrée par des experts des quatre coins du pays. Et à l'étape finale du processus d'enregistrement, John (aidé de Don) a repassé chaque minute de musique de

façon à ce que tous les arrangements s'illustrent. Il a en fait mixé l'équivalent de trois albums sur deux disques : une tâche titanesque qu'il a abattue avec héroïsme.

Lorraine Lawson, une de nos talentueuses choristes et ma professeure de chant, a travaillé les chansons avec moi pendant un an avant l'enregistrement final des voix en studio. Durant plus d'un mois, plusieurs jours par semaine, Lorraine m'a poussée à aller plus loin et m'a inspirée. Ses idées géniales et son enthousiasme à toute épreuve m'ont aidée à améliorer ma technique davantage que je n'aurais osé l'espérer.

La chorégraphe Karren Hammond a passé de nombreuses nuits d'insomnie à réfléchir au déroulement des concerts et à la mise en scène. Shelley Bunda a permis à ma vie mouvementée de suivre son cours comme si de rien n'était. Paul Campbell a élaboré la fête de lancement du coffret avec l'aide du planificateur d'événements Jeffry Roick, tandis que Tracy Finkelstein se chargeait d'élaborer la stratégie marketing.

Et au centre de nous tous régnait la merveilleuse directrice de projet Darlene Sawyer qui, avec ses longues années passées dans le milieu du spectacle et de la musique (elle a collaboré étroitement avec Anne Murray), a réussi à gérer le moindre détail d'affaires (et ces « détails » étaient énormes) dans plusieurs domaines du projet — sans compter nous tous ! — avec un professionnalisme admirable et, toujours, une énergie positive.

Au-delà de la musique

Tandis que la planification de l'album passait en vitesse supérieure, j'ai commencé à songer sérieusement à faire un livre. Je me suis tournée vers le seul photographe que je connaissais bien et dont j'admirais le travail : le portraitiste de renommée

nationale V. Tony Hauser. Après notre rencontre en mai 2015, il m'a demandé de lui laisser l'été pour y réfléchir. En septembre, non seulement il a partagé ses idées avec nous, mais il a aussi, à ma surprise et pour mon plus grand bonheur, proposé de nous aider à coordonner la publication. Pour moi qui ne connais rien à l'édition d'un livre (alors que Tony en avait publié de nombreux), ce fut un cadeau exceptionnel et un autre signe que j'étais destinée à mener à bien cette aventure. J'étais enthousiaste à l'idée d'avoir un partenaire pour cette partie du projet, et plus encore que cette personne soit Tony Hauser.

Tony a passé un bon moment à sélectionner soigneusement plus de quatre cents photographies de toutes les régions du Canada. Puis nous avons entrepris une longue recherche pour trouver des photos exprimant les sentiments de chaque chanson. Nous avons finalement choisi trente-deux paysages réalisés par vingt-trois photographes d'un peu partout au pays.

Ce livre met aussi en valeur le talent exceptionnel de Tony dans une série en couleur, alors qu'il est reconnu pour le noir et blanc. Il s'agit de photos du type « Où est Charlie? » — comme je le dis à la blague —, c'est-à-dire des portraits de moi portant des créations de designers canadiens dans les paysages les plus divers, au milieu des gigantesques pins Douglas de la Colombie-Britannique, ou sur le majestueux (et froid !) cap Spear au Labrador. Mais la beauté de ces images est aussi le fruit du travail d'un groupe de gens talentueux qui collaborent avec moi depuis des années : mon coiffeur (et ami de longue date) Paul King, la très douée maquilleuse Vanessa Jarman, ainsi que la styliste et designer par excellence Wendy Natale. Les fous rires que nous avons eus tous ensemble sont aussi profondément gravés dans mon âme que la splendeur des paysages.

Pour faire de ce livre une réalité, nous nous sommes mis en quête d'un éditeur qui comprendrait la passion et la vision qui nous ont animés. Après de longues recherches, nous avons arrêté notre choix sur Page Two de Vancouver dont le professionnalisme et le soutien ont été inestimables. La cofondatrice Jesse Finkelstein, le concepteur graphiste Peter Cocking, la directrice des services de publication Gabrielle Narsted, l'éditrice Frances Peck et la traductrice Rachel Martinez ont été formidables pour réunir les nombreux éléments du projet, en vue de créer cet ouvrage magnifique.

En progressant avec le livre, nous avons élargi le concept : nous avons inclus les paroles afin de mettre en évidence la poésie de chaque chanson, et nous les accompagnons de messages des auteurs-compositeurs et des autres artistes associés à leur création. Grâce à une idée de génie de Justin West et à l'énorme travail de suivi de Darlene et de l'auteure et intervieweuse Lisa Fitterman, ces messages nous permettent d'en savoir davantage sur la source d'inspiration de chacun des titres. Inutile de dire que ces textes ont influencé ma façon d'aborder les chansons. Je suis reconnaissante aux artistes pour leur générosité et les histoires personnelles qu'ils ont partagées avec nous.

Enfin, nous avons jugé important d'immortaliser les séances d'enregistrement au moment où nos arrangements donnaient une nouvelle vie aux chansons. Grâce à Neil Edwards et aux concerts que j'ai donnés avec l'Orchestre symphonique de la Nouvelle-Écosse, j'avais fait la connaissance du photographe de l'ONÉ, Greg Locke, dont j'admirais le travail. J'ai été très heureuse d'apprendre que Greg acceptait de photographier les orchestres et certains artistes invités en studio. Ses photos

témoignent de belle façon de l'énergie qui régnait à chaque séance. Je lui suis reconnaissante pour son œuvre, ainsi que pour celles des autres photographes qui enrichissent cet ouvrage.

Et puis (comme si nous n'en avions pas déjà assez à faire), nous avons décidé de tourner un documentaire. Comment pourrait-on entreprendre une telle aventure sans la filmer (et la partager) ? Plusieurs personnes nous ont envoyé des images au cours du projet, et Keith Chang et son équipe chez Silverpoint Media ont magnifiquement filmé toutes les séances d'enregistrement en studio avec les orchestres et bon nombre des artistes invités, sans oublier des témoignages des gens qui ont participé à l'aventure.

L'enregistrement

En février 2016, après une longue année de planification, le moment était venu de passer à l'action.

Les séances d'enregistrement en studio nous ont donné un premier aperçu de la direction que prendraient les arrangements. Certains des plus grands musiciens au pays se sont réunis aux studios Phase One à Toronto durant six longues journées pour enregistrer les pistes maîtresses de chaque chanson : Don Breithaupt au piano (sauf pour les arrangements de Lou Pomanti que ce dernier interprète lui-même), Justin Abedin à la guitare, Mark Kelso à la batterie et Pat Kilbride à la basse. Ce fut une semaine excitante et épuisante que je n'oublierai jamais. Quelques mois après le début de l'aventure, les merveilleuses choristes Lorraine Lawson et Quisha Wint ont ajouté leurs voix. Ces musiciens ont créé de la magie et ont jeté les bases des séances d'enregistrement suivantes.

Un mois plus tard, la tournée d'enregistrement démarrait. La première semaine a été un vrai test : nous commencions à Edmonton, puis nous sommes allés à Halifax et à Saint John en six jours seulement. Nous étions tous très nerveux. L'équipement arriverait-il à temps et le travail se déroulerait-il au rythme prévu ? Avions-nous réservé suffisamment de temps en studio ? À la fin de cette première semaine, nous avons poussé un soupir de soulagement collectif : nous avions réussi presque sans incident. Quand j'y repense, nous avons probablement pris la bonne décision de commencer par trois villes situées aux deux extrémités du pays : nous avons pu raffiner la logistique au quart de tour. Je ne peux pas expliquer à quel point j'ai été impressionnée (je le suis toujours, d'ailleurs) par l'expertise de notre groupe.

Comme nous nous y attendions, il y a eu quelques accrocs entre le mois de mars et la fin de la tournée d'enregistrement en juin, mais rien pour enrayer la machine. Une tempête de verglas dans la région Atlantique qui a cloué tous les avions au sol et nous a obligés à louer des voitures pour nous rendre de Halifax à Saint John. Des ennuis mécaniques qui ont forcé les ingénieurs du son coincés à Deer Lake à trouver un véhicule pour ensuite conduire sept heures sous la pluie battante afin d'atteindre St. John's, où ils étaient attendus, à l'autre bout de Terre-Neuve. La perte d'une caméra vidéo que nous utilisions pour filmer en continu chaque séance d'enregistrement. Et moi qui me précipite avec Darlene et l'arrangeur Peter Cardinali au Centennial Concert Hall de Winnipeg pour participer à la seconde moitié de la répétition avec l'Orchestre symphonique de Winnipeg lorsqu'une autre tempête a longuement retardé notre arrivée. Des journées de travail normales, en somme.

Toutefois, ce ne sont pas ces souvenirs qui me viennent en tête de prime abord. Il est pratiquement impossible de décrire l'énergie et l'enthousiasme que j'éprouvais en rencontrant des musiciens de partout au pays. Passer une soirée à rire et à raconter des histoires avec l'auteur-compositeur Allister MacGillivray et sa femme Beverly à leur maison de l'île du Cap-Breton, au bord de la rivière Mira qui a donné son nom à une chanson. Assister aux retrouvailles des membres de notre équipe avec des collègues qu'ils n'avaient pas vus depuis des années. Renouer avec des orchestres et des musiciens que je connais et que j'aime. Observer Marty qui obtient des résultats extraordinaires avec les arrangements et avec chaque orchestre. Regarder Don assurer ses tâches de producteur avec tact, tandis que Jeremy, James, Christopher et Carl enregistrent tout. M'ébahir devant l'oreille absolue de Mélanie qui détecte la moindre fausse note. Me fier à Jackie et Darlene qui veillent aux plus petits détails de logistique. J'ai eu le privilège de me produire avec un grand orchestre — ce que j'ai toujours adoré — et d'entendre les arrangements prendre forme. Je chérirai à jamais les précieux moments vécus de ville en ville pendant trois mois. Je suis profondément reconnaissante aux orchestres qui ont partagé avec nous leur talent pour mener à bien ce projet.

Je conserve aussi un souvenir impérissable des grands artistes invités qui ont partagé leurs talents musicaux extraor-dinaires. Ils m'ont renversée à chaque séance d'enregistrement. L'intensité du jeu de Jan Lisiecki m'a particulièrement émue. De plus, c'est avec nous qu'il a pour la première fois enregistré un autre genre que le classique. Et j'ai vécu des moments mémorables avec les Men of the Deeps. J'ai eu la chance de discuter avec trois des premiers membres de cette chorale de mineurs qui m'ont raconté leurs débuts il y a cinquante ans. Je suis épatée par les dons de tous nos invités qui font honneur au talent des artistes canadiens. J'ai eu la chair de poule à répétition en les écoutant.

Pour couronner le tout, les arrangeurs ont pu assister à la « naissance » d'au moins une de leurs « réinterprétations », soit en studio, soit par transmission vidéo. Ces musiciens, qui ont rarement l'occasion de faire partie du processus d'enregistrement, ont pris part à l'aventure avec autant d'enthousiasme que nous.

Je chérirai à jamais les amitiés qui se sont nouées lors de la tournée, riche en musique et en éclats de rire (*beaucoup* d'éclats de rire !).

L'espoir
J'exprime ma plus vive gratitude à toute l'équipe de *True North: The Canadian Songbook* et aux innombrables personnes qui ont accepté de rallier notre aventure pancanadienne en partageant si librement leur talent et leur passion.

J'aimerais remercier plus particulièrement les frères Breithaupt, Don et Jeff, qui ont composé *I Can See Hope From Here* spécialement pour cet album. Cette chanson est inspirée de la phrase prononcée par leur frère Ross lorsqu'il a aperçu l'île Hope au large de la baie Georgienne un matin à son lever : « Je peux voir Hope (l'espoir) d'ici » (*I can see Hope from here*). Quand Don m'a fait part de son idée, j'ai accepté sans la moindre hésitation.

Tout ça, c'est ce que *True North: The Canadian Songbook* signifie pour moi. Mon cœur a guéri grâce à la musique et aux gens qui ont participé à ce projet épique. Et grâce à vous tous, j'arrive vraiment à voir l'espoir d'ici . . .

Producer's Note

ONGWRITING IS SOMETHING at which Canadians excel. It's like improvisational comedy that way. From the current pop crop all the way back to the so-called "great folk scare of the early '60s," Canada has produced a statistically improbable number of world-beating songwriters. An argument can be made that, per capita, over the past half-century, Canada has been the world's most successful and prolific songwriting hub.

When Eleanor and I had our first production meeting for *True North: The Canadian Songbook*, back in early 2015 (in Hollywood, of all places), I was overwhelmed by the possibilities. She had the whole concept ready: the national arranging team, the coast-to-coast orchestral approach, thematic threads, ideas for hall-of-fame guests, even a short list of songs. We began playing and singing our way through the repertoire almost immediately. Of course, a whole country's songbook is an unruly beast, and over the next few months the list was both tightened and added to substantially (mostly added to—that's how we wound up with over 150 minutes of music).

Across four and a half time zones, with an army of distinguished collaborators that eventually numbered in the hundreds, we kept our heads down and just kept working. The intention was simple: to stitch together some of the disparate musical strands of our homeland. Through all of it, the constant has been Eleanor's lovely, nuanced voice, one of my favourite musical instruments. The spoils of her supreme act of cultural patriotism are now yours to enjoy and, I hope, be proud of.

DON BREITHAUPT

LES CANADIENS SONT d'excellents auteurs-compositeurs. Ils se démarquent aussi dans le domaine de l'improvisation en humour. Depuis les chanteurs de la grande mouvance folk du début des années 1960 jusqu'aux vedettes pop d'aujourd'hui, on trouve au pays un nombre statistiquement invraisemblable d'auteurs-compositeurs d'envergure internationale. On peut prétendre que, au prorata de la population, notre pays est celui où a été écrit le plus grand nombre de chansons remarquables.

Au début de 2015, lorsque Eleanor et moi nous sommes rencontrés la première fois pour discuter de *True North: The Canadian Songbook* (à . . . Hollywood !), j'ai été renversé par l'éventail de possibilités. Tout son concept était prêt : la

constitution d'une équipe d'arrangeurs provenant d'un peu partout au Canada, l'idée de faire appel à des orchestres d'un océan à l'autre et à des invités renommés, les liens thématiques et même une liste de chansons. Nous avons commencé sur-le-champ à interpréter les titres de sa liste. Il va sans dire qu'un recueil de chansons représentant tout un pays est une bête difficile à dompter. Au cours des mois qui ont suivi, les critères de choix ont été resserrés, tandis que la liste s'allongeait considérablement (c'est ainsi que nous sommes arrivés à plus de 150 minutes de musique).

Nous nous sommes attelés à la tâche sans relâche, avec le soutien d'une armée de centaines de collaborateurs distingués, dispersés dans quatre fuseaux horaires et demi. Le but était simple : réunir les fils musicaux disparates de notre pays. Durant toute cette aventure, la constante a été la jolie voix nuancée d'Eleanor, un de mes instruments de musique préférés. Vous pouvez maintenant profiter du fruit de son entreprise patriotique culturelle. J'espère que vous en serez fiers.

DON BREITHAUPT

Photographer's Note

MUCH OF CANADA, our country, our landscape, has been gazed upon in awe by our forebears, including the Aboriginal inhabitants and protectors of the land. Like they did, we all try to live from the abundance that the earth provides, we cultivate what is possible and we aspire to preserve what uplifts us spiritually.

They too, those ancestors and First Nations peoples, had songs of joy and sorrow in their hearts as they walked upon the plains and through the ancient forests and as they climbed the mountains and crossed the rivers and lakes, and the seas that embrace Canada from the east, the west and the north. They laughed and danced to the music they made, they cried and loved, they lived and died. We remember them all, and we honour them and the land—our Canada—as we celebrate 150 years of Confederation.

New and long-established citizens of all ethnic and cultural backgrounds call Canada their homeland. It is these citizens and all new arrivals, together with future generations, who will respect and protect our environment and our landscapes, which the world regards as among the most beautiful on the planet.

Each of the 32 songs in this collection prominently features a photographic landscape. There are many beautiful images that could have illustrated the lyrics and music of these Canadian writers and composers. From the thousands of images I viewed, and the hundreds generously submitted by photographers from across Canada, a handful were selected for this book. It was not an easy task—and a very subjective one. I tried to choose images that allow viewers to at least glimpse the richness, diversity and vastness of the Canadian landscape. Eleanor sought out the emotional connection of these vistas—the visual interpretation of the iconic songs she performs—an equally subjective and personal notion.

We hope that you enjoy the songs and the photographs, and that you treasure this book, which celebrates Canada and many of its creative artists at this pivotal time in our country's history.

V. TONY HAUSER

UNE GRANDE PARTIE du Canada, de notre pays et de nos paysages a fait l'admiration de nos ancêtres, notamment des peuples autochtones qui sont les véritables protecteurs du territoire. Comme eux, nous essayons tous de vivre de l'abondance de ce que la terre nous donne, nous la cultivons et nous cherchons à préserver ce qui nous élève spirituellement.

Et comme nous aujourd'hui, ces ancêtres et les Premières Nations avaient des chants de joie et de peine dans leur cœur, pendant qu'ils arpentaient les plaines, parcouraient les forêts anciennes, gravissaient les montagnes, traversaient les rivières, les lacs, les mers et les fleuves qui sillonnent le Canada d'est en ouest, du nord au sud. Ils riaient et dansaient au son de leur propre musique, ils pleuraient et aimaient, ils ont vécu et sont morts. En célébrant de cette façon le 150e anniversaire de la Confédération, nous nous souvenons d'eux et nous leur rendons hommage ainsi qu'à notre territoire, le Canada.

Les nouveaux arrivants tout comme les citoyens établis au pays depuis longtemps, quel que soit leur bagage culturel et ethnique, ont fait du Canada leur patrie. Ce sont eux, et aussi les générations à venir, qui respecteront et protégeront notre environnement et nos paysages, que les gens du monde entier considèrent comme les plus beaux de la planète.

Chacune des trente-deux chansons emblématiques de cette collection est accompagnée d'un paysage. Une multitude de photos magnifiques auraient pu illustrer les paroles et la musique de ces auteurs-compositeurs canadiens. J'ai dû faire un choix parmi les milliers de clichés que j'ai regardés et des centaines d'autres généreusement fournis par des photographes des quatre coins du pays. Ce fut une tâche ardue,

et des plus subjectives. J'ai tenté de choisir des paysages qui donneront au lecteur un aperçu de la richesse, de la diversité et de l'étendue de notre territoire. Pour sa part, Eleanor recherchait dans ces photos le contact émotionnel créé par l'interprétation visuelle des chansons, une notion tout aussi subjective que personnelle.

Nous espérons que vous aurez du plaisir à écouter les chansons en contemplant les photos qui les accompagnent, et que vous chérirez cet ouvrage qui rend hommage au Canada et à bon nombre de ses créateurs en cette période charnière de notre histoire.

V. TONY HAUSER

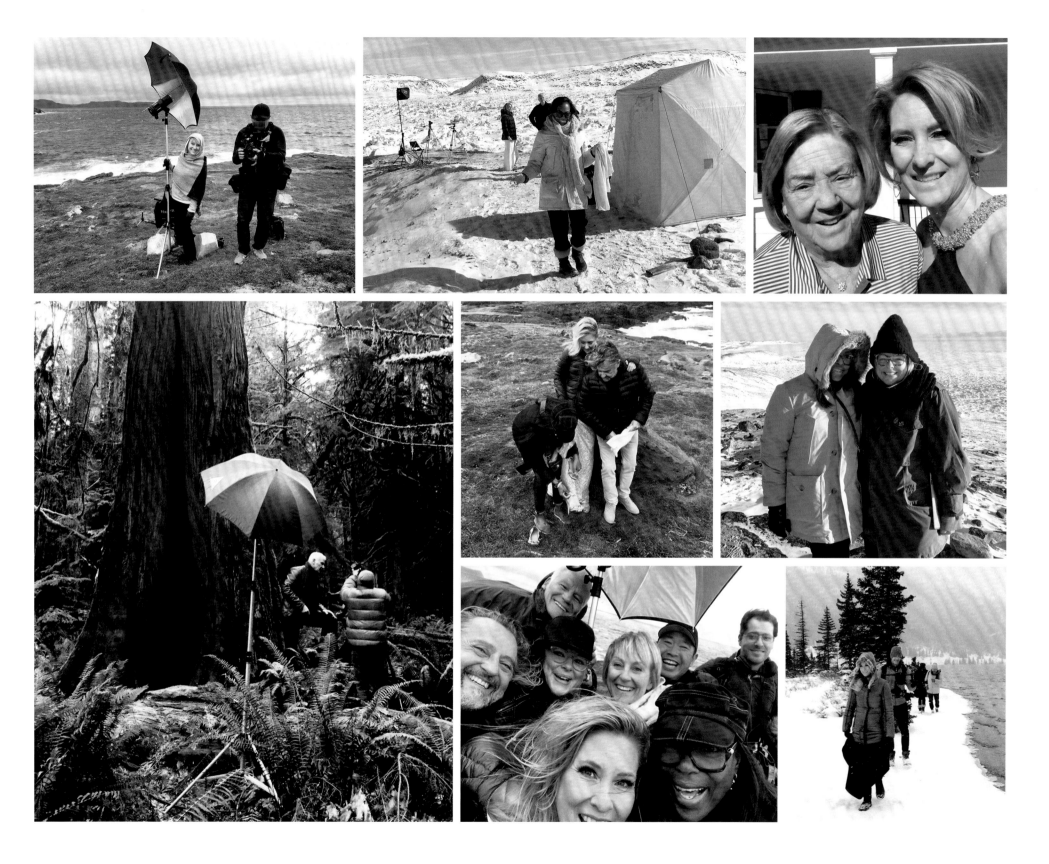

The Band

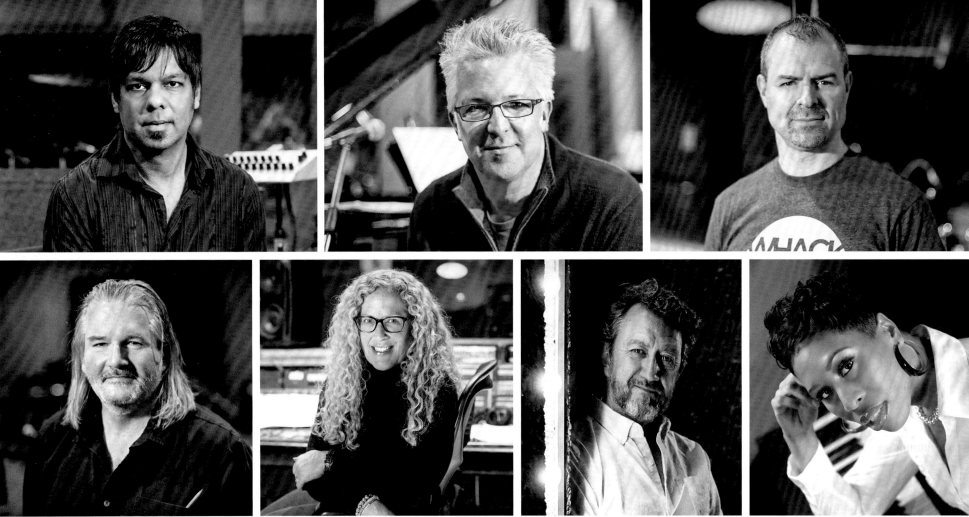

JUSTIN ABEDIN GUITAR

DON BREITHAUPT PIANO

MARK KELSO DRUMS

PAT KILBRIDE BASS

LORRAINE LAWSON BACKGROUND VOCALS

LOU POMANTI PIANO

QUISHA WINT BACKGROUND VOCALS

Guest Artists

NATASHIA ALLAKARIALLAK

GUIDO BASSO

LIONA BOYD

THE COLLEGE OF PIPING

FRANÇOIS D'AMOURS

LAURA DAVID

DENISE DJOKIC

MATT DUSK

ELMER ISELER SINGERS

RIK EMMETT

RON KORB AND DONALD QUAN

JENS LINDEMANN

JAN LISIECKI

NATALIE MacMASTER

BILL McBIRNIE

JOHN McDERMOTT

THE MEN OF THE DEEPS

PAUL PIKE

PRO CORO CANADA

DON ROSS

SASKATOON CHILDREN'S CHOIR

SHARON RILEY AND THE FAITH CHORALE

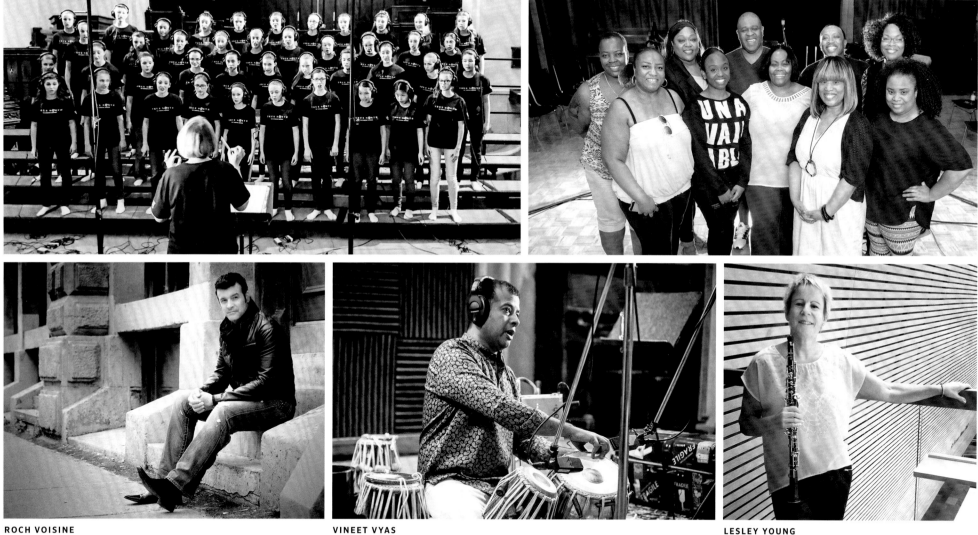

ROCH VOISINE

VINEET VYAS

LESLEY YOUNG

Arrangers

SHELLY BERGER

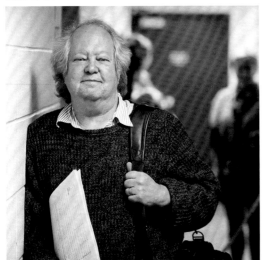

DON BREITHAUPT

PETER CARDINALI

BILL COON

AARON DAVIS

DARREN FUNG

BENOIT GROULX

SCOTT MACMILLAN

CHRIS PALMER

BRIGHAM PHILLIPS

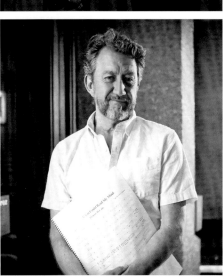

LOU POMANTI

KEITH POWER

DONALD QUAN

CAMERON WILSON

The True North: The Canadian Songbook Team

SUSAN ABRAMOVITCH JOHN BAILEY RENÉ BISSONNETTE SANDY BLOOS DON BREITHAUPT

SHELLEY BUNDA PAUL CAMPBELL WONJAY CHANG JAMES CLEMENS-SEELY NEIL EDWARDS LISA FITTERMAN

TRACY FINKELSTEIN

KARREN HAMMOND

VANESSA JARMAN

CHRISTOPHER JOHNS

V. TONY HAUSER

TAYLOR KERNOHAN

PAUL KING

LORRAINE LAWSON

GREG LOCKE

MARTIN MacDONALD

DEB McCAIN RÉMI MARSAN WENDY NATALE JACKIE PARÉ MILAN SARKADI

DARLENE SAWYER OLIVIER SIROIS BEVERLY SOLOMON CARL TALBOT JEREMY TUSZ HEIDI UMSTADT

MÉLANIE VAUGEOIS

JUSTIN WEST

OPAK Left to right: Sébastien Paquin, Olivier Sirois, Alexandre Jacques, Laurie Mathieu-Bégin

PAGE TWO Clockwise from bottom left: Jesse Finkelstein, Gabrielle Narsted, Frances Peck, Ruth Wilson, Peter Cocking, Trena White

SILVERPOINT MEDIA Left to right: Alan Wild Guerro, Alexander Bullen-Genis, Keith Chang, Nathan Haynes, Stanley Yamashita

SILVERPOINT MEDIA
Timon Leung

AMY T. DOG

PRINCESS AUDREY

Landscape Photographers

PETER BLAHUT

DR. ROBERTA BONDAR

CLAUDE BOUCHARD

SIGITA VAN BRUCHEM

ROMAN BUCHHOFER

JOE CHASE

MARK DUFFY

MATHIEU DUPUIS

RON ERWIN

GEORGE FISCHER

SCOTT FORSYTH

ANGELA GZOWSKI

SARAH HAUSER

THADDEUS HOLOWNIA

GREG LOCKE

CURTIS JONES

IAN McALLISTER

PETER MATHER

PAUL NICKLEN

TOMAS NEVESELY

JERRY SPIERENBURG

JOHN SYLVESTER

The Recordings

Executive Producer: Eleanor McCain
Producer: Don Breithaupt
Conductor: Martin MacDonald
Vocal Producer: Lorraine Lawson

Recorded and Mixed by: John "Beetle" Bailey at Phase One Studios, Scarborough, Ontario, and The Drive Shed Studios, New Hamburg, Ontario
Additional Engineering: Taylor Kernohan
Assistant Studio Engineers: Milan Sarkadi, Darren McGill
Orchestras Recorded by: Diapason Mobile
Lead Orchestral Recording Engineer: Jeremy Tusz
Orchestral Recording Engineer: Carl Talbot
Assistant Orchestral Recording Engineers: James Clemens-Seely, Christopher Johns
Mastered by: Greg Calbi and Steve Fallone at Sterling Sound, New York, NY

Vocals: Eleanor McCain
Piano: Don Breithaupt, Jan Lisiecki (track 13 on disc 1), Lou Pomanti (tracks 5 and 6 on disc 1; track 12 on disc 2)
Guitar: Justin Abedin
Bass: Pat Kilbride
Drums/Percussion: Mark Kelso
Background Vocals: Lorraine Lawson, Quisha Wint

Music Librarians: Gary Corrin, Andrew Harper
French Language Coach: Roger St-Denis
Piano Technician: Glen Beard

Don Breithaupt appears courtesy of ALMA Records. Mark Kelso plays Yamaha drums, Headhunters sticks, Evans drumheads and Paiste cymbals.

Orchestras

Edmonton Symphony Orchestra
Recorded at the Winspear Centre, Edmonton, Alberta
Concertmaster: Joanna Ciapka-Sangster
Violin I: Richard Caldwell, Jim Cockell, Yue Deng, Susan Flook, Anna Kozak, Broderyck Olson, Alison Stewart, Neda Yamach, Christine Yu
Violin II: Dianne New, Heather Bergen, Lauren Dykstra, Robert Hryciw, Zoe Sellers, Kate Svrcek, Murray Vaasjo, Tatiana Warszynski
Viola: Stefan Jungkind, Jeannette Comeau, Rhonda Henshaw, Clayton Leung, Charles Pilon, Martina Smazal
Cello: Rafael Hoekman, Julie Amundsen, Gillian Caldwell, Derek Gomez, Ronda Metszies, Amy Nicholson
Bass: Jan Urke, Rob Aldridge, Janice Quinn, Rhonda Taft, John Taylor
Flute: Elizabeth Koch, Shelley Younge
Oboe: Lidia Khaner, Dan Waldron

Clarinet: David Quinn, Echo Mazur
Bassoon: Edith Stacey, Matt Nickel
Horn: Allene Hackleman, Megan Evans, Gerald Onciul, Donald Plumb
Trumpet: Robin Doyon, Frederic Payant
Trombone: John McPherson, Kathryn Macintosh
Bass Trombone: Chris Taylor
Tuba: Scott Whetham
Harp: Nora Bumanis
Percussion: Brian Jones, Brian Thurgood
Timpani: Barry Nemish

Kitchener-Waterloo Symphony
Recorded at the Centre in the Square, Kitchener, Ontario
Concertmaster: Bénédicte Lauzière
Violin I: Peter Carter, Angela Cox-Daley, Julia Dixon, Paul Earle, Anna Luhowy, Lance Ouellette, Nora Pellerin
Violin II: Sophie Drouin, Elspeth Durward, Vicky Dvorak, Sheilanne Lindsay, Michael Steinberg, Leslie Ting, Roxolana Toews
Viola: Natasha Sharko, Brandon Chui, Judith Davenport, Martha Kalyniak, Tracy Poizner, David Wadley
Cello: John Helmers, Catherine Anderson, Ben Bolt-Martin, Laura Jones, Rebecca Morton, Nancy Wharton
Bass: Ian Whitman, George Greer, Bruce McGillivray, Milos Petrak
Flute: Thomas Kay, Kaili Maimets
Oboe: James Mason, Faith Levene
Clarinet: Ross Edwards, Barbara Hankins
Bassoon: Ian Hopkin, Michael Macaulay
Horn: Martin Limoges, Jessie Brooks, Katherine Robertson, Deborah Stroh
Trumpet: Larry Larson, Mary Jay, Daniel Warren
Trombone: Joseph Castello, Allistar Gaskin, Michael Polci
Bass Trombone: Doug Lavell
Tuba: Jane Maness
Harp: Angela Schwarzkopf
Percussion: Lori West
Timpani: Ron Brown

National Arts Centre Orchestra
Recorded at Southam Hall, National Arts Centre, Ottawa, Ontario
Concertmaster: Yosuke Kawasaki
Violin I: Mark Friedman, Elaine Klimasko, Carissa Klopoushak, Jessica Linnebach, Manuela Milani, Noémi Racine-Gaudreault, Leah Roseman, Karoly Sziladi, Emily Westell
Violin II: Winston Webber, Andréa Armijo-Fortin, Brian Boychuk, John Corban, Lauren DeRoller, Marc Djokic, Martine Dubé, Jeremy Mastrangelo,

Heather Schnarr, Edvard Skerjanc
Viola: David Marks, Paul Casey, David Goldblatt, Sonya Probst, Nancy Sturdevant, David Thies-Thompson
Cello: Blair Lofgren, Fanny Marks, Timothy McCoy, Thaddeus Morden, Peter Rapson, Leah Wyber
Bass: Joel Quarrington, Hilda Cowie, Vincent Gendron, Paul Mach
Flute: Joanna G'froerer, Camille Churchfield, Christian Paquette
Oboe: Charles Hamann, Anna Petersen
Clarinet: Kimball Sykes, Sean Rice
Bassoon: Christopher Millard, Vincent Parizeau
Horn: Laurence Vine, Julie Fauteux, Nicholas Hartman, Jill Kirwan, Elizabeth Simpson
Trumpet: Karen Donnelly, Steven van Gulik, Heather Zweifel
Trombone: Donald Renshaw, Colin Traquair
Bass Trombone: Douglas Burden
Tuba: Nicholas Atkinson
Harp: Manon Le Comte
Percussion: Kenneth Simpson, Jonathan Wade
Timpani: Feza Zweifel

Newfoundland Symphony Orchestra
Recorded at the D.F. Cook Recital Hall, Memorial University School of Music, St. John's, Newfoundland
Concertmaster: Heather Kao
Violin I: Maggie Burton, Maria Cherwick, Samuel Clarke, Jennifer Johnson, Andy Kao, Brittany Pike
Violin II: Nancy Case-Oates, Natalie Finn, Peter Gardner, Susan Quinn, Lauren Smee, Kalen Thompson
Viola: Kate Read, Alex Burdock, Peter Cho, Chantelle Jubenville, Asdrubal Loredo
Cello: Theo Weber, Laura Ivany, Sandra Pope, Paul Rodermond
Bass: Frank Fusari, Denise Lear
Flute: Grace Dunsmore, Sarah Comerford
Oboe/English Horn: Valerie Holden, Catherine Conway-Ward
Clarinet: Glenn Rice, Brenda Gatherall
Bassoon: Grant Etchegary, Kiera Galway
Horn: Emily Dunsmore, Douglas Vaughan
Trumpet: Katie Sullivan, Alan Klaus
Trombone: Darren MacDonald
Bass Trombone: Andrew Cooper
Percussion: Rob Power

Orchestre symphonique de Québec
Recorded at Palais Montcalm, Québec City, Québec
Concertmaster: Catherine Dallaire
Violin I: Caroline Béchard, Simon Boivin, Élise Caron, Benoit Cormier, Jany Fradette, Diane Létourneau, Michiko Nagashima, Mireille St-Arnauld, Julie Tanguay, France Vermette

Violin II: Pierre Bégin, Estel Bilodeau, Eline Brock, Mélanie Charlebois, Nobuko Kawamura, Inti Manzi, Brett Molzan, Joanne St-Jacques, Louise-Marie Trothier-Hébert
Viola: Frank Perron, Jean-François Gagné, Claudine Giguère, Sébastien Grall, François Paradis, Marie-Claude Perron, Mary-Kathryn Stevens-Toffin, Véronique Vanier
Cello: Blair Lofgren, Marie Bergeron, Jean-Christophe Guelpa, Julie Hereish, Diliana Momtchilova, Suzanne Villeneuve
Bass: Jean Michon, Étienne Lépine-Lafrance, François Morin, Ian Simpson
Flute: Jacinthe Forand, Marie-Violaine Ponte
Oboe: Lindsay Roberts, Philippe Magnan
Clarinet: Stéphane Fontaine, Marie-Julie Chagnon
Bassoon: Richard Gagnon, Mélanie Forget
Horn: Levente Varga, Julie-Anne Drolet, Marjolaine Goulet, Thom Gustavson, Anne-Marie Larose
Trumpet: Geoff Thompson, Trent Sanheim
Trombone: Nick Mahon, Nate Fanning
Bass Trombone: Scott Robinson
Tuba: Lance Nagels
Harp: Isabelle Fortier
Percussion: René Roulx
Timpani: Robert Slapcoff

Symphony New Brunswick
Recorded at the Imperial Theatre, Saint John, New Brunswick
Concertmaster: David Adams
Violin I: Nadia Francavilla, Catherine Gagné, Karen Graves, Hok Kwan, Ali Leonard, Vivian Ni
Violin II: Danielle Sametz, Danielle Girard, Monique Girouard, Sara Liptay, Katherine Moller, Sabrina Perry
Viola: Christopher Buckley, Jeffrey Bazett-Jones, Stephen Mott, Robin Streb
Cello: Sonja Adams, Ellen Buckley, Van Burdon, Michael DePasquale
Bass: Andrew Reed Miller, Louis Garson
Flute: Sally Wright, Karin Aurell
Oboe: Christie Goodwin, Chelsey Hiebert
Clarinet: James Kalyn, Jennifer Shea
Bassoon: Patrick Bolduc, Yvonne Kershaw
Horn: Ulises Aragón, Jonathan Fisher
Trumpet: Robert Dutton, Kate Clarke
Trombone: Jim Tranquilla, Peter Bye
Percussion: Jonathan Kipping, Olivier Martel
Timpani: Joël Cormier

Symphony Nova Scotia
Recorded at the Rebecca Cohn Auditorium, Dalhousie Arts Centre, Halifax, Nova Scotia
Concertmaster: Renaud Lapierre
Violin I: Lysa Choi, Celeste Jankowski, Jennifer Jones, Jihye Joelle Kee, Karen Langille, Mark Lee, Yi Lee, Kirsty Money, Peter Stryniak

Violin II: Isabelle Fournier, Simon-Philippe Allard, Janet Dunsworth, Lauren Klein, Anita Gao Lee, Ken Nogami, Émilie Paré, Anne Simons
Viola: Susan Sayle, Binnie Brennan, Yvonne DeRoller, Kerry Kavalo
Cello: Norman Adams, Hilary Brown, Catherine Little, Ben Marmen, Shimon Walt
Bass: Max Kasper, David Langstroth, Lena Turofsky
Flute: Patricia Creighton, Christine Feierabend
Oboe: Suzanne Lemieux, Brian James
Clarinet: Dominic Desautels, Eileen Walsh
Bassoon: Ivor Rothwell, Christopher Palmer
Horn: David Parker, Julie Cuming, Mary Lee, Randal Ulmer
Trumpet: Richard Simoneau, Curtis Dietz, Timothy Elson
Trombone: Eric Mathis, Laura Chan, Bob Nicholson
Tuba: Mark Bonang
Percussion: D'Arcy Gray, Clare MacDonald
Timpani: Michael Baker

Vancouver Symphony Orchestra
Recorded at Studio 1, CBC Production Facilities, Vancouver Broadcast Centre, Vancouver, British Columbia
Concertmaster: Nicholas Wright
Violin I: Mary Sokol Brown, Nancy Dinovo, Calvin Dyck, Naomi Guy, Kimi Hamaguchi, Jennie Press, Sunny She, Xue Feng Wei, Cam Wilson, Su Fan Yiu, Yi Zhou
Violin II: Jason Ho, Adrian Chui, Anne Cramer, DeAnne Eisch, Byron Hitchcock, Daniel Norton, Ann Okagaito, Jeanette Singh, Erin Wong
Viola: Andrew Brown, Katrina Chitty, Tegen Davidge, Emilie Grimes, Isabelle Roland, Marcus Takizawa, Ian Wenham, Stephen Wilkes
Cello: Janet Steinberg, Harold Birsten, Olivia Blander, Ben Goheen, Charles Inkman, Peggy Lee, Zoltan Rozsnyai, Min Jee Yoon
Bass: Dylan Palmer, David Brown, Evan Hulbert, Chris Light, Warren Long, Noah Reitman
Flute: Nadia Kyne, Rosanne Wieringa
Clarinet: Jenny Jonquil, David Lemelin, Alexander Morris
Oboe: Roger Cole, Beth Orson, Karin Walsh
Bassoon: Julia Lockhart, Sophie Dansereau, Gwen Seaton
Horn: Oliver de Clercq, David Haskins, Andrew Mee, Rich Mingus
Trumpet: Larry Knopp, Marcus Goddard, Vincent Vohradsky
Trombone: Gregory Cox, Ellen Marple
Tuba: Peder MacLellan
Harp: Joy Yeh

Percussion: Vern Griffiths, Robin Reid
Timpani: Aaron McDonald
Piano: Linda Lee Thomas

Victoria Symphony
Recorded at Farquhar Auditorium, University of Victoria, Victoria, British Columbia
Concertmaster: Terence Tam
Violin I: Müge Büyükçelen-Badel, Courtney Cameron, Tyson Doknjas, Christi Meyers, Julian Vitek
Violin II: Emily Salmon, Cory Balzer, Tina Park, Misako Sotozaki, Christopher Taber
Viola: Kenji Fuse, Stacey Boal, Kay Cochran, Mieka Michaux
Cello: Brian Yoon, Martin Bonham, Joyce Ellwood, Perry Foster
Bass: Mary Rannie, Darren Buhr
Flute: Richard Volet, Sally Harvey
Oboe: Michael Byrne, Russell Bajer
Clarinet: Keith MacLeod, Jennifer Christensen
Bassoon: Anne Marie Power, Nancy van Oort
Horn: Alana Despins, Michael Oswald, Dan Moses, Janet Parker
Trumpet: Ryan Cole, Alastair Chaplin, David Michaux
Trombone: Brad Howland, Marcus Hissen
Bass Trombone: Bob Fraser
Tuba: Paul Beauchesne
Harp: Annabelle Stanley
Percussion: Corey Rae
Timpani: William Linwood

Winnipeg Symphony Orchestra
Recorded at Centennial Concert Hall, Winnipeg, Manitoba
Concertmaster: Karl Stobbe
Violin I: Chris Anstey, Jeremy Buzash, Mona Coarda, Rodica Jeffrey, Hong Tian Jia, Mary Lawton, Meredith McCallum, Julie Savard, Jun Shao
Violin II: Darryl Strain, Karen Bauch, Calvin Cheng, Teodora Dimova, Jonathan Garabedian, Bokyung Hwang, Takayo Noguchi, Elation Pauls, Jane Radomski-Pulford, Claudine St-Arnauld
Viola: Daniel Scholz, Laszlo Baroczi, Richard Bauch, Margaret Carey, Greg Hay, Anne Elise Lavallée, Michael Scholz
Cello: Yuri Hooker, Alex Adaman, Arlene Dahl, Carolyn Nagelberg, Leana Rutt, Emma Quackenbush
Bass: Meredith Johnson, Andrew Goodlett, Travis Harrison, Paul Nagelberg, Bruce Okrainec, Daniel Perry
Flute: Jan Kocman, Martha Durkin
Oboe/English Horn: Robin MacMillan
Clarinet: Micah Heilbrunn, Michelle Goddard
Bassoon: Kathryn Brooks
Horn: Patricia Evans, Ken MacDonald, Caroline Oberheu, James Robertson, Michiko Singh

Trumpet: Isaac Pulford, Paul Jeffrey, Brian Sykora
Trombone: Steven Dyer, Keith Dyrda
Bass Trombone: Julia McIntyre
Tuba: Chris Lee
Harp: Richard Turner
Percussion: Frederick Liessens
Timpani: Mike Kemp

The College of Piping
James MacHattie, Director of Education
Peter Allen
Ian Juurlink
Ian Luddington

Choirs
Elmer Iseler Singers
Lydia Adams, Artistic Director, Conductor
Jessie Iseler, General Manager
Anne Bornath, Joan Campbell, Amy Dodington, Alexander Jozefacki, David King, Gisele Kulak, Claudia Lemke, Nelson Lohnes, Andrea Ludwig, Laura McAlpine, Eric MacKeracher, Claire Morley, Mitchell Pady, Cathy Robinson, Graham Robinson, Alison Roy, Michael Sawarna, Michael Thomas, Ed Wiens

Sharon Riley And The Faith Chorale
Sharon Riley, Conductor
Grace Clarke, Jason Duncan, Ermine Gittens, Michelle Hanson, Lloyd Lawrence, Jr., Jean Lawrence-Scotland, Trinity Lewis, Heather Picart, Teena Riley

Pro Coro Canada
Michael Zaugg, Conductor
Russell Ault, John Brough, Kyle Carter, Rob Curtis, Casey Edmunds, Ben Ewert, David Fraser, Michael Kurschat, Brett Ludwig, Peter Malcolm, David McCune, Oliver Munar, Caleb Nelson, Simon Noster, Knut Ulsrud, John Wiebe, Russ Wilkinson, Nathan Willis, Anthony Wynne, Roddy Bryce

Saskatoon Children's Choir
Phoebe Voigts, Artistic Director
Braelyn Anderson, Arieanna Barsi, Brynja Bayda, Janice Bell, Miriam Corlan, Sarah Edgar, Sydney Ehr, Meeka Fast, Kajsa Felstrom, Britney Feng, Emma Fish, Teagan Fish, Alexandra Golding Delgado, Samantha Graham, Forrest Hiebert, Lauren Hill, Sophia James-Cavan, Maya Kliewer, Eileen Knox, Darryne Laturnus, Emily Lyons, Rhianne Magotiaux, Rachel McConnell, Jessica McBride, Lorelei McEwen, Lauren McIntosh, Aiden McRorie-Wilson, Molly Moors, Ava Penry, Abbagale Persson, Julia Ramsay, Renee Robles, Sophia Scott, Olivia Scrimshaw, Quinn Smith, Kate Stachyruk, Danielle Sweet, Maxine Taon, Sarah ter Velde,

Bronwyn Thomson, Sydney Tom, Katharyn Walker, Danni Willems

The Men of the Deeps
Jack O'Donnell, Conductor
Stephen Muise, Assistant Director
Tony Aucoin, Bob Burke, Gerald Burke, Kevin Edwards, Bruce Gillis, Mat Hawley, Ray Holland, Jude Kelly, Ernie Kliza, Mickey MacIntyre, Jim MacLellan, John MacLeod, Nipper MacLeod, Shane MacLeod, Billy MacPherson, Jack MacQueen, Alf Matheson, Gary Micholsky, Melvin Mugford, Yogi Muise, John Pendergast, Bobby Roper, Kevin Steiger, Sen White

Song Credits
Hallelujah
Leonard Cohen
Bad Monk Publishing
Shelly Berger, arranger
National Arts Centre Orchestra

A Case Of You
Joni Mitchell
Joni Mitchell Publishing Corp
Shelly Berger, arranger
National Arts Centre Orchestra

Helpless
Neil Young
Broken Arrow Music Corp. (BMI)
Peter Cardinali, arranger
Winnipeg Symphony Orchestra

Run To You
Bryan Adams, James Douglas Vallance
Irving Music Inc/Almo Music Corp./
Adams Communications/Testatyme Music
Don Breithaupt, arranger
Winnipeg Symphony Orchestra
François D'Amours, saxophone
Vineet Vyas, tabla
François D'Amours recorded by Pascal Shefteshy at Studio PM in Montréal, Québec.
Vineet Vyas recorded by John Bailey at Phase One Studios, Scarborough, Ontario

I'll Always Be There
David Foster, Roch Voisine
Peermusic III Ltd/RV International Les Editions
Lou Pomanti, arranger
National Arts Centre Orchestra
Roch Voisine, vocals
Sharon Riley And The Faith Chorale
Roch Voisine recorded at Planet Studio, Montréal,

Québec, and appears courtesy of RV. International. Inc.
Sharon Riley And The Faith Chorale recorded by John Bailey at Phase One Studios, Scarborough, Ontario

If You Could Read My Mind
Gordon Lightfoot
WB Music Corp
Lou Pomanti, arranger
National Arts Centre Orchestra
Liona Boyd, guitar solo
Liona Boyd's performance was produced and engineered by Peter Bond at the Rose Room, Toronto, Ontario

Angel
Sarah Ann McLachlan
Tyde Music (SOCAN) administered by Peermusic
Darren Fung, arranger
Edmonton Symphony Orchestra
Denise Djokic, cello
Pro Coro Canada
Denise Djokic recorded by John D. S. Adams at Stonehouse Sound, Mahone Bay, Nova Scotia
Pro Coro Canada recorded by Diapason Mobile at Studio 96, Edmonton, Alberta

The Surest Things Can Change
Gino Vannelli
Almo Music Corp./Giva Music
Don Breithaupt, arranger
Winnipeg Symphony Orchestra
Guido Basso, flugelhorn
Guido Basso recorded by John Bailey at Phase One Studios, Scarborough, Ontario

Good Mother
Jann Arden, Robert Foster
Lyrics by Jann Arden Richards
Music by Jann Arden Richards and Robert Foster
Copyright © 1994 UNIVERSAL MUSIC PUBLISHING CANADA, GIRL ON THE MOON MUSIC and PANNAL ASH PUBLISHING All Rights for GIRL ON THE MOON MUSIC in the United States and Canada Administered by UNIVERSAL—POLYGRAM INTERNATIONAL PUBLISHING, INC. All Rights Reserved Used by Permission
Don Breithaupt, arranger
Victoria Symphony

Constant Craving
k.d. lang, Ben Mink
Universal-Polygram Int'l Tunes Inc/Bumstead Productions US Inc/Zavion Enterprises Inc
Don Breithaupt, arranger
Vancouver Symphony Orchestra

Jens Lindemann, trumpet
Jens Lindemann recorded by Gary Lux at Tubby Tunes Music Inc., Oak Park, California

Get Me Through December
Gordie Sampson, Fred Lavery
Southside Independent Music Publishing/ No Such Music/Music of Windswept/Old Shore Road Music
Aaron Davis, arranger
National Arts Centre Orchestra

Undun
Randy Bachman
Shillelagh Music Company
Don Breithaupt, arranger
Vancouver Symphony Orchestra
Bill McBirnie, flute
Bill McBirnie recorded by John Bailey at Phase One Studios, Scarborough, Ontario, and appears courtesy of Extreme Flute

I Will Play A Rhapsody
Burton Cummings
Shillelagh Music Company
Darren Fung, arranger
National Arts Centre Orchestra
Jan Lisiecki, piano
Jan Lisiecki recorded by Bruce Gigax at Audio Recording Studio, Cleveland, Ohio
Jan Lisiecki is an exclusive Deutsche Grammophon artist

Le monde est stone
Michel Berger, Luc Plamondon
Plamondon Publishing/Universal M B M SARL
Benoit Groulx, arranger
Orchestre symphonique de Québec
Elmer Iseler Singers
Elmer Iseler Singers recorded by Diapason Mobile at Eglinton St. George's United Church, Toronto, Ontario

I Can See Hope From Here
Don Breithaupt, Jeff Breithaupt
Music: Don Breithaupt
Lyrics: Jeff Breithaupt
Green Dolphin Music (SOCAN)
Don Breithaupt, arranger
Newfoundland Symphony Orchestra
Denis Bluteau, alto flute
Éveline Grégoire-Rousseau, harp
Lesley Young, English horn and oboe
Denis Bluteau, Éveline Grégoire-Rousseau recorded by Pascal Shefteshy at Studio PM in Montréal, Québec

Lesley Young recorded by John Bailey at Metalworks Studios, Mississauga, Ontario, assisted by Wayne Cochrane

O Siem
Susan Aglukark, Chad Irschick
Written by Susan Aglukark and Chad Irschick
Publishing: Aglukark Entertainment Inc and Chad Irschick
Benoit Groulx, arranger
Orchestre symphonique de Québec
Natashia Allakariallak, throat singer
Sharon Riley And The Faith Chorale
Natashia Allakariallak, Sharon Riley And The Faith Chorale recorded by John Bailey at Phase One Studios, Scarborough, Ontario

Ordinary Day
Alan Doyle, Séan McCann
Alan Doyle, Darrell Power, Bob Hallett, Séan McCann
Skinners Hill Music Ltd./Olde Tyme Music/Kilbride Music Ltd./Lean Ground Music Ltd.
© ℗ Great Big Sea 1995 Ltd
Keith Power, arranger
National Arts Centre Orchestra
Natalie MacMaster, fiddle
Natalie MacMaster recorded by John Bailey at Phase One Studios, Scarborough, Ontario

Four Strong Winds
Ian Tyson
Slick Fork Music
Cameron Wilson, arranger
Victoria Symphony
Rik Emmett, guitar solo and vocals
Rik Emmett's guitar solo recorded by John Bailey at Metalworks Studios, Mississauga, Ontario, assisted by Wayne Cochrane
Rik Emmett's vocal recorded by Taylor Kernohan at Metalworks Studios, Mississauga, Ontario, assisted by David Johnson
Rik Emmett appears courtesy of Provogue Records/ Mascot Label Group

All The Diamonds In The World
Bruce Cockburn
Rotten Kiddies Music LLC
Bill Coon, arranger
Victoria Symphony

Gold In Them Hills
Ron Sexsmith
Ronboy Rhymes Inc
Shelly Berger, arranger
Kitchener-Waterloo Symphony

Aujourd'hui, je dis bonjour à la vie
Serge Fiori
Prime Quality Music
Don Breithaupt, arranger
Orchestre symphonique de Québec
Don Ross, guitar solo
Don Ross recorded by John D. S. Adams at Stonehouse Sound, Mahone Bay, Nova Scotia

We Rise Again
Leon Dubinsky
Words and music by Leon Dubinsky
Shag Rock Sound Limited
Brigham Phillips, arranger
Symphony New Brunswick
Laura David, vocals
Denise Djokic, cello
Saskatoon Children's Choir
Laura David recorded by John Bailey at Phase One Studios, Scarborough, Ontario
Denise Djokic recorded by John D. S. Adams at Stonehouse Sound, Mahone Bay, Nova Scotia
Saskatoon Children's Choir recorded by Diapason Mobile at Knox United Church, Saskatoon, Saskatchewan

Broken Arrow
Robbie Robertson
Medicine Hat Music
Don Breithaupt, arranger
Edmonton Symphony Orchestra
Paul Pike, Native American flute
Paul Pike recorded by Louis McDonald at Corner Brook Arts and Culture Centre, Corner Brook, Newfoundland

Some Of These Days
Shelton Brooks
Will Rossiter Publishing
Shelly Berger, arranger
Symphony Nova Scotia
Matt Dusk, vocals
Matt Dusk recorded by John Bailey at Phase One Studios, Scarborough, Ontario

Song For The Mira
Allister MacGillivray
Cabot Trail Music
Chris Palmer, arranger
Symphony Nova Scotia
John McDermott, vocals
John McDermott recorded by John Bailey at Phase One Studios, Scarborough, Ontario
John McDermott appears courtesy of Bunnygee Music

Heart Like A Wheel
Anna McGarrigle
Garden Court Music Company
Donald Quan, arranger
Newfoundland Symphony Orchestra
George Gao, erhu
Ron Korb, wooden flute
Donald Quan, guzheng
Vincent L. Pratte, orchestrator
Ron Korb, Donald Quan recorded by Gary Honess
at Kuhl Muzik, Toronto, Ontario
Ron Korb appears courtesy of Humbledragon
Entertainment

Still Believe In Love
Haydain Neale
Ole Media Management LP I/Tanjola Inc II
Peter Cardinali, arranger
Symphony Nova Scotia
Don Breithaupt, organ
Don Breithaupt recorded by John Bailey at Phase
One Studios, Scarborough, Ontario

Up Where We Belong
Wilbur H Jennings, Jack Nitzsche, Buffy Sainte-Marie
Sony/ATV Harmony/Sony/ATV Melody
Lou Pomanti, arranger
Vancouver Symphony Orchestra

Snowbird
Gene Phillip MacLellan
Beechwood Music of Canada
Don Breithaupt, arranger
Edmonton Symphony Orchestra

No Change In Me
Ron Hynes, Murray McLauchlan
McLauchlan Music/ Fat Baby Publishing
Brigham Phillips, arranger
Newfoundland Symphony Orchestra
Éveline Grégoire-Rousseau, harp
Éveline Grégoire-Rousseau recorded by Pascal
Shefteshy at Studio PM in Montréal, Québec

Rhythm Of My Heart
Marc Jordan, John Joseph Capek
WB Music Corp./Jamm Music/Universal-
Polygram Int'l Pub Inc
Bill Coon, arranger
Kitchener-Waterloo Symphony
The College of Piping
The College of Piping recorded by John D. S. Adams
at Stonehouse Sound, Mahone Bay, Nova Scotia

The Island
Kenzie MacNeil
Scott Macmillan, arranger
Symphony New Brunswick
The Men of the Deeps
The Men of the Deeps recorded by Michael Shepherd,
assisted by Fred Lavery, at Lakewind Sound Studios,
Point Aconi, Nova Scotia

Executive Team
Lead Legal Counsel: Susan Abramovitch,
Gowling WLG (Canada) LLP
Associates: René Bissonnette and Sean Gill,
Gowling WLG (Canada) LLP
Legal Administrative Assistant: Heidi Umstadt,
Gowling WLG (Canada) LLP

Project Manager: Darlene Sawyer
Lead Business Consultant: Justin West
Project Consultant/Concert Engagements: Neil Edwards
Executive Personal Assistant: Shelley Bunda

Production: Opak
Production Executive: Olivier Sirois
Production Coordinators: Laurie Mathieu-Bégin,
Alexandre Jacques
Production Accountant: Sébastien Paquin
Content Coordinator: Mélanie Vaugeois
Tour Managers: Rémi Marsan, Jacinthe (Jackie) Paré

Lead Media and Communications Director:
Deb McCain
Marketing Consultant: Tracy Finkelstein
Social Media: Wonjay Chang

Concert Choreographer and Movement Coach:
Karren Hammond

Event Co-ordinator: Paul Campbell

Book Production
Curators: V. Tony Hauser, Eleanor McCain
Produced by: Page Two Strategies
Principal: Jesse Finkelstein
Art Director/Book Designer: Peter Cocking
Publishing Services Manager: Gabrielle Narsted
Writer: Lisa Fitterman
Copy Editor: Frances Peck, West Coast
Editorial Associates
Proofreader: Ruth Wilson, West Coast
Editorial Associates
French Translator: Rachel Martinez
French Copy Editor/Proofreader: Lise Duquette
Office Manager for V. Tony Hauser: Sarah Faulkner

Landscape Photography
Peter Blahut, Dr. Roberta Bondar, Claude Bouchard,
Sigita van Bruchem, Roman Buchhofer, Joe Chase,
Mark Duffy, Mathieu Dupuis, Ron Erwin, George
Fischer, Scott Forsyth, Angela Gzowski, Sarah Hauser,
Thaddeus Holownia, Curtis Jones, Greg Locke,
Peter Mather, Ian McAllister, Paul Nicklen, Tomas
Nevesely, Jerry Spierenburg, John Sylvester

Recording Session Photography
Lead Session Photographer: Greg Locke
Session Photographer: Sándor Fizli
Additional Photography: Matthew Baird, Don
Breithaupt, Kyle Cassidy, Keith Chang, Scott Grant,
V. Tony Hauser, Jean-François Hétu, Katy Hopkins
(The Picture House), Vanessa Jarman, Jean-Charles
Labarre, Saúl Lederman, Dean Marrantz, Eleanor
McCain, Cristina Mittermeier, Wendy Natale,
Carlyle Routh, Tomo Saito
Makeup Artists: Marie-Guylaine Auclair, Carly Flint,
Nicole Harvie, Vanessa Jarman
Hairstylists: Sandy Bloos, Paul King

Portrait Photography
Photographer: V. Tony Hauser
Stylist: Wendy Natale
Makeup Artist/Hairstylist: Vanessa Jarman
Hairstylist: Paul King
Tailor: Gala Klukach
Location Scouts: Donald Bell, Graham Dickson, Dan
Evans, Caroline Fletcher, Anton Hauser, Evan Hauser,
Sarah Hauser, Tom King, Dolena Matthews, Mary
Sexton, Marie-Andree Thiffault
Canoe: The birch bark canoe featured in Algonquin
Park (page 124) is courtesy of Wayne Parker. It is a
precise replica by John Lindman called *wabanaki
tciman* in Algonquin.
Cover photo and p. 168 filmed with the permission
of Parks Canada in Banff National Park.

Wardrobe Designers
Algonquin Park, Lake of Two Rivers, Ontario
(page 124): gown, Angela De Montigny; bracelet
and ring, Lisa Corbo; earrings, John De Jong
**Banff National Park, Lake Minnewanka and Bow Lake,
Alberta** (cover, page 168): gown, Mikael D; earrings
and ring, Jaleh Farhadpour; shoes, Ron White
Cape Spear, Newfoundland (page 38): gown, Romona
Keveza, bracelet and earrings, Jaleh Farhadpour
Cathedral Grove, Vancouver Island, British Columbia
(page 18): gown, Denis Gagnon

Florenceville, New Brunswick (page 62): gown, Lucian
Matis; bracelet, earrings and ring, Dean Davidson
Île d'Orléans, Québec (page 100): gown, Mikael D;
earrings, Lisa Corbo; ring, Ona Chan
Iqaluit, Nunavut (page 138): gown, Greta Constantine;
mink jacket, Cosmopolitan Fur
Rouleau, Saskatchewan (page 82): gown, Mikael D;
earrings, Lisa Corbo; ring, Myles Mindham

Video
Lead Cinematographer: Keith Chang,
Silverpoint Media
Cinematographers: Alexander Bullen-Genis,
Alan Wild Guerrero, Nathan Haynes, Timon Leung,
Stanley Yamashita, Silverpoint Media
Sound Operators: Alexander Bullen-Genis, Antoine
Caron, Danny Chodirker, Marco Dölle, Philip
Dransfeld, Bruce LeGrow, Timon Leung, Gilles
Maillet, Christopher O'Brien, Simon Paine,
Matthew J. Thompson
Additional Video: Kyle Cassidy, Dan Evans, Sándor
Fizli, Scott Grant, V. Tony Hauser, Jean-François Hétu,
Katy Hopkins (The Picture House), Saúl Lederman,
Lester Lightstone, Greg Locke, Parce Que Films Inc.,
Olivier Picard, Oliver Ward
Promotional Video Editing: Corinne Beaumier,
Gabriel Ledoux, Victor Saliba, L'Hibou

eOne Music Canada
President Entertainment One Music: Chris Taylor
General Manager: Chris Moncada
VP Marketing: Mark Costain

Support Team
Catering: Beverly Solomon
Copywriter: Nick Krewen
Event Planners: Jeffry Roick, Kathleen Nakonechny
Logo Design: Jason Darbyson, re:form
Travel: Maria Karagioules, Exectravel; Roger Kershaw,
Roger Kershaw Executive Travel
Transport: Sophie Ratelle, Cargo Artists Inc.
Runners: Chris Comely, David Davies, Chris Duke,
Rich Dumais, Maxime Fiset, Chriss Holloway,
Holland Kerr, Kerry LeBlanc, Gary Northup, Sharyn
Rosinke, Daz Scott, Shauna Sirockaman, Rhodie
Smith, Karen Speers

Retriever Records Limited
President and CEO: Amy T. Dog
CFO (Chief Fun Officer): Princess Audrey

Acknowledgements

THERE ARE NO WORDS to truly express my appreciation and respect for everyone who brought this project to life, and no space to say all I would like to say. So I begin by offering my deepest, most sincere thanks to every one of you—whether mentioned here, in the coda or in the credits—for taking this journey with me, not only professionally but as friends. I have loved and will always cherish every moment.

Don, our partnership was meant to be. You were perfect for this project, with your exceptional musicianship, vast knowledge and ability to work in a multi-genre environment. Thank you for your friendship and for taking this leap of faith with me—and for penning, with your brother Jeff, an original song that is both gorgeous and personal for me.

Tony, your design and photo expertise, and your research, curation and outreach to photographers, were invaluable to making this book. So were your own gorgeous contributions. It was wonderful to collaborate with you, and I so enjoyed the friendship we built.

Susan, our long professional relationship has grown into a treasured friendship. You've been at the helm of this project with me from the beginning, navigating the plentiful legal work and helping to build the team and steer the strategic plan. I so admire your integrity, hard work, strength and steadfastness. I am so grateful to you, René, Sean and Heidi.

Neil, you instantly became key to this team—promoting the project, connecting with symphonies and guest artists, consulting with us about orchestras, even writing and editing. But it is your moral support and dear friendship throughout this journey for which I am most grateful.

Darlene, I can't imagine having done this without you. Your industry experience and ability to circle the wagons and keep everything on track allowed me to back away from the day-to-day details of the business side and focus on the creative. I thank my lucky stars every day for you.

Justin, I am grateful for your exceptional leadership and wisdom on the business side, and for your dedication, vision and expertise. Apart from being an amazing person to work with, you were our rudder every step of the way.

Olivier, you, along with everyone at Opak including Laurie, Remi, Alexandre and Sébastien, made sure every aspect of the production was dealt with. Mélanie, you diligently coordinated with arrangers and orchestras. Jackie, you expertly managed the many logistics of the cross-country recording sessions. Because of all of you, everything rolled out without a hitch—or you dealt with the hitches so well we didn't even know about them!

Building the communications and marketing strategies for this project was no small feat. Deb, you created unique ways to build awareness around the project. I am profoundly grateful for your vital support and passion, and for the friendship we have developed. Tracy, your marketing expertise brought the discussions to a new level and helped us bring the final product to Canada. Thank you for your leadership. Jay, your social media savvy was essential. I truly appreciate your support and patience, especially since social media is not top of mind for me.

John, this is our fifth album together. I've always had the utmost respect for your abilities in the studio, and this project is no exception. You are a miracle worker and a dear friend. Thanks, as well, to Taylor, Milan, Darren, everyone at Phase One Studios, and the engineers and studios that welcomed guest artists across the country, and to Greg Calbi and Steve Fallone at Sterling Sound for the final touches on the masters.

Jeremy, your unique mobile engineering kit for recording orchestras on location relieved one of the biggest logistical

difficulties and allowed this project to move forward. Your professionalism shone at every location, and working with you, Christopher, James and Carl was incredible.

Marty, what a joy it was to work with you during the orchestra sessions, to see all of your preparation come to life as you conducted each session and to see the amazing rapport you developed with each orchestra. Most of all, you were so much fun to work with and get to know.

Justin, Mark, Pat, Lou, and of course Don: thank you for six memorable, laughter-filled days together creating the bed tracks for every song. You are some of our country's finest musicians and the most wonderful people to make music with. I am in awe of your exceptional gifts.

Lorraine, you are a remarkable vocal coach and producer. I am so grateful for your contributions from helping me prep the songs to your vocal production in the studio and especially for your positive encouragement, support and friendship. Thank you also to you and Quisha for adding your gorgeous vocals to the album.

Karren, you are an inspiring choreographer and movement coach. You make sure that every movement comes from a meaningful place, and because of you, I feel more grounded and comfortable on stage. Thank you for your support and friendship.

Thank you, Shelley, for being an incredible executive assistant during the busiest time of my entire life. You have taken care of every detail expertly and with your usual radiant attitude.

Andrew and Gary, you were incredible orchestra librarians with exceptional attention to detail. You were stealth members of our team, working hard behind the scenes, but every aspect of your work was felt at every recording session.

I have always felt blessed to work not just in music but especially with symphonies. There are so many people to thank for making opportunities for me and for participating in this mission to showcase Canada's finest. To everyone at the 10 orchestras whose moving performances make this album, my deepest thanks.

Thank you to the Edmonton Symphony Orchestra (William Eddins, Annemarie Petrov, Rob McAlear, Eric Filpula, Aaron C. Hawn), Kitchener-Waterloo Symphony (Edwin Outwater, Daniel Bartholomew-Poyser, Andrew Bennett, Olga Mychajluk, Laurie Castello, Lori Anderson, Meaghan McCracken, Andrew Mellanby, Nancy Wharton), Newfoundland Symphony Orchestra (Marc David, Neil Edwards, Heather McKinnon, Grant Etchegary, Valerie Holden), Orchestre symphonique de Québec (Fabien Gabel, Astrid Chouinard, Joël Brouillette, Jean Letarte, Emmanuelle Pequin, Tristan Lemieux, Mélanie Charlebois, Danièle Michaud, Gilbert Deshaies), Symphony New Brunswick (Michael Newnham, Jennifer Grant, Christopher Buckley, Peter Mears, Reid Parker, Elsa Paterson), Symphony Nova Scotia (Bernhard Gueller, Christopher Wilkins, Eric Mathis, James Eager), Vancouver Symphony Orchestra (Bramwell Tovey, Kelly Tweeddale, Joanne Harada, Sarah Boonstra, DeAnne Eisch, Minella F. Lacson), Victoria Symphony (Tania Miller, Mitchell Krieger, Peter Burris, Eric Gallipo, Ronald Comber) and Winnipeg Symphony Orchestra (Alexander Mickelthwate, Trudy Schroeder, Jean-François Phaneuf, James Manishen, Chris Lee, Evan Klassen, Sheena Sanderson, Raymond Chrunyk).

And to Canada's remarkable National Arts Centre Orchestra, thank you so much for being the thread that tied all the symphonies together. Thank you, Peter Herrndorf, for having faith in me, for supporting this endeavour and for making the collaboration possible. Through Peter, the idea for this project was explored with NACO Managing Director Christopher Deacon, General Manager Marc Stevens, Orchestra Manager Nelson McDougall, and Manager of Artistic Planning Daphne Burt, all of whose guidance

and support were pivotal. Thank you also to Nancy Elbeck and Meiko Taylor at NACO and Jayne Watson, CEO, National Arts Centre Foundation.

Thank you to the celebrated group of guest artists who brought their unique talents to this project and created one goosebump moment after another. Thank you to Natashia Allakariallak for your gifted throat singing and beautiful spirit; Guido Basso for your soulful flugelhorn; Liona Boyd for your always exquisite guitar, friendship and support; James, Ian, Peter, and Ian from The College of Piping for your precision and hair-raising Scottish piping; François D'Amours for your rocking sax solo; Denise Djokic for your warm, lyrical cello; Matt Dusk for your beautiful "crooning," the laughter and of course your friendship; Lydia Adams, Jessie Iseler and the Elmer Iseler Singers for your magnificent vocals; Rik Emmett for your amazing guitar solo and beautiful vocals; George Gao for your stunning erhu; Ron Korb for your evocative flute; Jens Lindemann for your dazzling trumpet playing (and your participation in the funniest email exchanges of this project); Jan Lisiecki for the inspiring depth of your piano performance and for taking a chance with this project outside your genre of classical music; Natalie MacMaster for your iconic, heartfelt fiddle playing; Bill McBurnie for your "extreme" flute acrobatics; John McDermott for your unmistakable dulcet tenor voice, friendship and support; Steve Muise and the Men of the Deeps for your moving performance and heartwarming recording session; Paul Pike for your haunting Native American flute; Donald Quan for your ethereal guzheng; Sharon Riley And The Faith Chorale for your roof-raising, inspired vocals; Don Ross for your awe-inspiring and nimble finger-style guitar playing; Phoebe Voigts and the Saskatoon Children's Choir for your sweet angelic voices; Roch Voisine for your gorgeous vocals and for fulfilling my dream of singing a duet with my fellow New Brunswicker; Vineet Vyas for your virtuosic tabla playing; Lesley Young for the warmth of your English horn and oboe; Michael Zaugg and Pro Coro for your rich male chorus vocals; and last but not least, my favourite guest artist of all, my daughter, Laura David, for your sweet, innocent voice, which brings tears to my eyes every time you sing. Thank you all for bringing beautiful Canadian magic to this album with your extraordinary talents. I am in awe of your musicianship and your respective roles in Canadian music history.

To the arrangers—Aaron, Benoit, Bill, Brigham, Cameron, Chris, Darren, Don, Donald, Keith, Lou, Peter, Scott, and Shelly—I am in awe of how you can each express emotion through well-crafted orchestrations. Thank you for your ability to paint beautiful musical landscapes through your vision and talent. Thank you for sharing your gifts with this project.

I can't move on from the music without once more acknowledging the exceptional songwriters whose talent is the beating heart of this project. Your work gives voice to Canadians' depth of character, inherent values and national pride. And on a personal note, your songs have taken me on a cathartic journey for which I am immensely grateful. Thank you.

My deepest appreciation to all of the songwriters and artists who shared their intimate thoughts and stories throughout these pages: Susan Aglukark, Jann Arden, Randy Bachman, Don Breithaupt, Jeff Breithaupt, John Capek, Bruce Cockburn, Alan Doyle, Leon Dubinsky, Serge Fiori, David Foster, Marc Jordan, Fred Lavery, Allister MacGillivray, Kenzie MacNeil, Séan McCann, Anna McGarrigle, Sarah McLachlan, Murray McLauchlan, Anne Murray, Ben Mink, Ian Tyson, Gordie Sampson, Ron Sexsmith, and Gino Vannelli. Your words deepen the meaning of this book immeasurably, and they inspired me when crafting the vocals for the album.

I am grateful to the project's talented image-makers: Greg, Sándor and the others who shot the recording sessions, Keith and the Silverpoint team, and all the other photographers and

videographers who captured this amazing journey. My thanks to the portrait session team for so much creativity, laughter and friendship—Wendy Natale, Paul King, Vanessa Jarman, Sandy Bloos, Tony (again)—and to the designers for their inspiring creations, produced specifically for this project. Thank you also to Gala Klukach for your expert tailoring for every gown.

Thank you to the incredible landscape photographers whose work is showcased in this book: Peter Blahut, Dr. Roberta Bondar, Claude Bouchard, Sigita van Bruchem, Roman Buchhofer, Joe Chase, Mark Duffy, Mathieu Dupuis, Ron Erwin, George Fischer, Scott Forsyth, Angela Gzowski, Sarah Hauser, Thaddeus Holownia, Curtis Jones, Greg Locke, Peter Mather, Ian McAllister, Paul Nicklen, Tomas Nevesely, Jerry Spierenburg, and John Sylvester. Your photographs capture the majestic, rugged and diverse beauty of this country and prove how fortunate we are to live here.

Thank you, Lisa Fitterman, for your thoughtful interviews and wonderful writing. Page Two Strategies, you were supportive and patient, and you're nothing short of amazing to work with. Nick Krewen, thank you for helping me tell the story of the recording process through the journal. Thank you Don Gorman and Heritage Group Distribution for believing in the project and helping us distribute the book throughout Canada.

Thank you to Chris Taylor, Chris Moncada, Mark Costain and everyone at eOne Music Canada. I am thrilled to work with you again and am grateful for your belief in this project.

Thank you to Paul Campbell, Jeffry Roick and Kathleen Nakonechny for your expert event planning. Thank you Beverly Solomon for nourishing us throughout our studio dates. Thank you Roger St-Denis for making sure my French was authentic—merci beaucoup!

Thank you to Allan Reid, Kristy Fletcher, Marie Desmarteau, Olivia Cummings and everyone at MusiCounts for partnering with us. We are pleased to support the work you do to encourage music education for children, our future musical ambassadors.

Thank you to the wonderful staff at all of the recording venues where we recorded. Because of you, every session was a huge success.

Thank you to Mike Milligan, source of sage, grounded advice for everything in my life. Thanks to McCain Financial staff for guidance and support throughout this complex project: Laurie Tucker, Dianne Clouse, Peter Murphy, Alecia Robinson, Nadine Samuels and Stephen Wong.

Thank you, Don Jack, Pam Miehls, Kevin Sartorio and Jacquie Mills, for your expert advice, support and guidance and for encouraging me every step of the way.

Thank you to Katherine Carleton and Sarah Thomson at Orchestras Canada for your support of this project and for helping us connect with arrangers.

Thank you, Ron White, for being a wonderful ambassador for the project, and for helping me find the perfect Ron White boot for the Banff photo shoot!

Thank you, Wayne Parker, for generously sharing your beautiful canoe, a replica of those used by the Algonquin.

Thank you to all of my beautiful family and friends—you have been so supportive of me, both personally and professionally. Thank you to Yoo-Mi Astley, Andrea Bell, Sarah Dyack, Jenny Seto, Heather Creighton Spriet and Cindy Townsend for being the best friends I could ever be blessed to have. For over 30 years, through ups and downs, tears and laughter, you have always been there.

Thank you to Debra Silverman for your incredible insight, support and wisdom for the last couple of years. Thank you for helping me celebrate "fire."

Thank you to Merida Campos, Jim Damberger, Brenda Gianan, Jackie MacKay, and Debbie Saunders who supported me throughout the recording process.

Thank you to my cuddly fur babies Retriever Records CEO Amy T. Dog and CFO Princess Audrey. Their unconditional canine love relieved considerable stress.

Guidance and support for this project came from so many directions. My profound gratitude and heartfelt thanks to the following people for their support: Bernie Alcubilla, Shelley Ambrose, Cathy Beehan, Ann Binsted, Angela Birdsell, Linsey Blakely, Alexandra Blum, Sheila Boone, Scott Brison, Boris Brott, Shelagh Carnegie, Drew Coles, Patricia Courtney, Stuart Coxe and Antica Productions, Lisa Dalholt, Beverly Daniels, Geoffrey Dawe, Delta St. John's, Dave Dysart and Norman Verrall at HHB Canada, Colin Elliott, Evoke Solutions, Sandra Faire, Vic Florencia, Eric Friesen, Laurie Gelfand, Shinan Govani, Gupta Media, Peter Hall, Bob Hammond, Bonnie Hillman, Anne Ingram, Maria Karagioules, Roger Kershaw and everyone at Roger Kershaw Custom Travel, Killarney Lodge, Rob Lanni, Eric Lawrence, Bernard LeBlanc, Mario Lefebvre, Carl Lenox, Steve MacDonald, Allister MacGillivray, Beverly MacGillivray, Matt MacPherson, Alan Maddox, Richard Maslove, Frank Mazzuca, Frank McKenna, Jacqui Szeto Meiers, Jeff Melanson, Ron Moore, Anne Murray, Susan Murray, Parks Canada, Jack Petch, Olivier Picard, Ross Porter, Sarah Quadri, Heather Reisman, Andrea Rose, Bridget Saulnier, Shawn Saulnier, Sarah Scott, Robert Sirman, Michelle Smith-Antle, Max St. Pierre, Geoff Stradling, Mike Taylor, Kathy Tempesta, Bradley Thachuk, Janice Tulk, Terry Underhill, Ross Vannelli, Moya Walsh, Jorn Weisbrodt, Alan Willaert, Steve Wingfield and Gary Yee.

And last but by far not least … to my beautiful daughter, Laura, and my dear mother, Margaret. This book is dedicated to both of you. You are both at the centre of my world and mean everything to me. Mom, your unconditional love is one of the greatest blessings of my life. I will be eternally grateful for your belief in me, your support during the most difficult times, and your encouragement of me, every step of the way, to pursue this project. Laura, you are my greatest blessing, pride and joy. Thank you not only for singing so beautifully on this album but also for being so supportive of me taking on this huge project. I love you both more than words can say.

ELEANOR McCAIN

Acknowledgements from Don Breithaupt

Don Breithaupt thanks: his beautiful, inspiring wife Maureen; his amazing brothers Jeff and Ross; his true-believer parents Myra and Herb; his brilliant sons Miles and Cameron (who are already at work on this century's Canadian songbook); his longtime audio co-conspirator John "Beetle" Bailey; the fine men of Monkey House; and of course Eleanor, for this truly extraordinary opportunity!

Acknowledgements from Tony Hauser

I would like to thank all the photographers who submitted their beautiful images of Canadian landscapes for consideration. It was one of my most difficult assignments to narrow down the selection.

Thank you to my assistant, Sarah P. Faulkner, for patiently organizing and cataloguing endless correspondence and spreadsheets.

Thank you to everyone who helped me scout locations and assisted me with the environmental portraits I made of Eleanor: my children, Sarah and Evan Hauser, at Cathedral Grove, British Columbia; my son Anton Hauser in Algonquin Park, Ontario; Graham Dickson and Dolena Matthews in Iqaluit, Nunavut; Caroline Fletcher and Donald Bell in Florenceville, New Brunswick; Tom King in Regina, Saskatchewan; Marie-Andrée Tiffault in Île d'Orléans, Québec; Mary Sexton in St. John's, Newfoundland and Labrador; and Dan Evans in Banff, Alberta.

TRUE NORTH